SIENESE PAINTING

IN THE AGE OF

THE RENAISSANCE

Bruce Cole

SIENESE PAINTING

IN THE AGE OF

THE RENAISSANCE

INDIANA UNIVERSITY PRESS

Bloomington

The reproduction of the color plates in this book was assisted by
a grant from the Samuel H. Kress Foundation.

Library of Congress Cataloging in Publication Data

Cole, Bruce, 1938–
 Sienese painting in the age of the Renaissance.

 Bibliography: p.
 Includes index.
 1. Painting, Renaissance—Italy—Siena. 2. Painting,
Italian—Italy—Siena. I. Title.
ND621.S6C66 1985 759.5′58 84-48246
ISBN 0-253-18130-5
1 2 3 4 5 89 88 87 86 85

For Cass Canfield, Jr.

CONTENTS

Illustrations

Preface

In an earlier book on painting in Siena from its origins to the Renaissance, I called the fourteenth century the Golden Age of Sienese art. I am not sure that I still believe that statement, for as I increasingly turned my attention to Sienese painting of the fifteenth and sixteenth centuries I began to feel as if I had wandered into Ali Baba's cave itself.

Without doubt the Trecento, especially the early part of the century, was a rare period of quality and abundant inventiveness. Several Sienese artists of the time—Duccio, Simone Martini, and Pietro and Ambrogio Lorenzetti—rank among the major figures of European painting, and many fascinating artists of slightly lesser ability were also active throughout those fertile decades.[1] Yet, the astounding number, range, and variety of Sienese painters at work from the first half of the fifteenth century until the last vestiges of Sienese independence in the 1550s, make this later art, in my opinion, the most interesting and vital of Siena's long history.

No doubt this view will be read with a skeptical eye by those who have been taught that the first half of the fourteenth century is the only period of Sienese art worth considering. This received idea about the relative worth of the periods of Sienese painting is taught by omission rather than by example, for the years of Sienese painting after 1350 are simply absent from most histories of art; Sienese art gets a brief notice for the first half of the Trecento and is then ignored.

The reasons for this neglect are not hard to find. Sienese art after the middle of the fourteenth century has not been thought worthy of study because it is considered an art historical dead end; the school and its artists did not, it has been widely assumed, leave a legacy in the way that so many Florentines did— Giotto and Michelangelo, for example. This view of Sienese art was formulated in the sixteenth century by Vasari and the Florentines, who deliberately plumped their own art while devaluating Siena's.

Moreover, the idiosyncratic imagery of the later Sienese painters, with its constant reference to the past, especially to the early Trecento, was judged negatively by many critics of the nineteenth and early twentieth centuries; artists who relied so heavily on their past were not, it was thought, progressive or inventive.

The strange, unreal narratives and protagonists of Sienese painting were disturbing and unwholesome to many writers. Sienese artists paled in comparison to the idols of the Victorians: the virile Florentine painters of the same period. Difficult to understand and somehow decadent, the paintings of the later Sienese were best forgotten. Terms now out of fashion, such as *decline, decadence,* and *exhaustion,* were used for Sienese painting after 1350.

In spite of several excellent pioneering studies, later Sienese painting is still often viewed as an uninteresting backwater in the history of Renaissance art.[2] To see how little Sienese art is appreciated, one has only to visit Siena at the peak of the summer tourist season and witness the nearly empty galleries of the Pinacoteca, the most important museum of Sienese art. That is sad, because many paintings in the Pinacoteca and elsewhere in and around Siena have recently been liberated from disfiguring overpaint and cleaned. These newly displayed and properly lit paintings once again reveal the chromatic splendor of Sienese art. In numerous cases, restoration has added to our understanding both of the individual paintings and of the artists who made them.

The paintings discussed in this book, I firmly believe, are unjustly neglected; unjustly because their art is of the highest order, worthy to rank with anything from that remarkable period called the Renaissance. If, after reading this book, the reader is willing just to cast a sympathetic eye toward later Sienese painting, I will feel rewarded. Moreover, even the attempt to rescue many of these painters and their works, which have long been confined to the dusty corners of scholars' studies, has been a pleasant task.

This book is arranged in roughly chronological order and divided into chapters centering around certain artists or periods. The periodization and classification of the history of art are not scientific; artists do not work in neat patterns. In truth, the same material could have been organized in several ways (typologically, iconographically, by decade), although the story would have remained the same. The organizational principles that I finally decided to employ are not graven in stone but seemed the most sensible of the lot.

I make no claim for definitiveness. There will never be a definitive history of Sienese painting for any period, for such a thing is manifestly impossible. To write readable history one has to be selective and exercise a healthy subjectivity. I have picked those artists and paintings that seemed to me to be the most important or the best—the two are not necessarily synonymous—and I have excluded works I believed added little or nothing to my narrative. Also, I have chosen to discuss a limited number of works in some detail rather than a great many superficially.

I have written this book for that ideal phantom who has been looking over

my shoulder for several years: the intelligent general reader willing to explore some of the less-frequented byways of Renaissance art. The reader whose interest is piqued and who wishes to engage in more-detailed investigation of subjects covered here may consult the Notes and Bibliography for further readings.

This book owes much to friends. As always, Heidi Gealt was an unwavering source of inspiration, advice, and encouragement. I am also beholden to Julia and Peter Bondanella, Cynthia Coté, Patricia Harpring, Gloria Middeldorf, Charles Mitchell, Leslie Schwartz, Diane Vatne, and the staff of Indiana University Press. My work was also aided by Judith Hook, whose untimely passing has deprived the study of Sienese art and society of one of its most intelligent and original minds. Doreen, Stephanie, and Ryan furnished various forms of material and spiritual support. Funds from the John Simon Guggenheim Foundation and then from the American Council of Learned Societies made research and writing in Italy possible. The color illustrations in this book were underwritten by a generous grant from the Samuel H. Kress Foundation; I am grateful to Marilyn Perry, the foundation's executive vice-president, and to Lisa Ackerman, its program coordinator.

SIENESE PAINTING
IN THE AGE OF
THE RENAISSANCE

ONE

TRANSFORMATIONS

1375–1430

T HAT PAST IS PROLOGUE is nowhere more applicable in the history of art than in the century and a half of Sienese Renaissance painting. All Sienese artists, from the least significant to the most remarkable, revered and utilized their past; for them it was never a hindrance, but rather a constant source of inspiration and instruction, a wondrous treasure house. Throughout the history of Sienese art the past propelled the present; the stylistic, iconographic, and emotional boundaries marked by the founders of the Sienese school were both wide and elastic. Originality and invention were fostered by a rich history.

The city of Siena was probably founded by the Etruscans. It was a flourishing Tuscan center by 1186, when it was given the right of self-government by Emperor Frederick Barbarossa. For defense, Siena had been settled on a series of hills; in the middle ages, the time of the city's first importance, the plains and valleys were too unprotected and dangerous for urban life. As in a number of other Tuscan hill towns, the streets evolved into a chaotic maze. Even today the stranger finds a tangle of narrow curving dark streets punctuated by light open piazzas. Siena's streets rise so steeply that it is often possible to glimpse other streets across the narrow valleys of the hilly city.

Modern-day Siena presents a pleasing and harmonious whole, highlighted by the massive cathedral and the Palazzo Pubblico, with its tall, elegant bell tower. The city is a well-preserved urban center, relatively unchanged since the sixteenth century, when Siena lost the last vestiges of its independence to Florence. A city of beautiful brick, red roof tile, and grey stone, it fits perfectly with the wavelike cultivated hills surrounding it. Serene and ancient, within its nearly intact circle of fifteenth- and sixteenth-century walls, the city now seems to be more a natural phenomenon than a man-made construction.

By the early fourteenth century, the two principal foci of Sienese life were well established. The gleaming white and black cathedral, or Duomo, occupied the highest elevation in the city. This center of religious life and the pride of the Sienese stood across from one of the city's most-venerable institutions, the hospital of Santa Maria della Scala. The Scala, as it is often called, was Siena's principal charitable organization as well as an orphanage and a hospital. Still in existence today, the Scala was also the location of numerous important works of art by major artists over several centuries.

Siena's second great focus is in the shell-shaped piazza of the Campo. Here many momentous civic events occurred, including the famous Palio, the wild horse race that is still run annually. Here also rises the massive brick bulk of the Palazzo Pubblico, the town hall, which was the center of much artistic attention, some of which is discussed in this book. Rooms were decorated with a particularly Sienese blend of religious and civic imagery, often highly didactic and exhortatory in nature. Here also are a series of famous frescoes, which span the entire history of Sienese art from Simone Martini and the Lorenzetti to Domenico Beccafumi.

During the fifteenth and sixteenth centuries, the period covered by this book, the city was further graced by the palazzos of many of the aristocratic and wealthy families who lived both in the city and in lovely villas—some of them built by famous architects and decorated with frescoes and statues—scattered over the surrounding countryside. The urban palaces and distinguished Renaissance churches clearly demonstrate that there was considerable architectural patronage during this period. In fact, the fifteenth and early sixteenth centuries in Siena saw the flowering of a humanistically influenced society that fostered both a notable university and an interest in antiquity. Because of scholars' almost total concentration on Siena before 1400, this culture and the literature and art it influenced have often been ignored. Yet, the Sienese were, without doubt, active participants in the movements and fashions characterized by the word *Renaissance*.

During most of its history, Siena was sharply divided into a number of ex-

tended families, clans, and neighborhoods. These various units were often in po-
litical and physical battle for economic and governmental power. (Some of this
nearly constant internecine rivalry is still reflected in the fierce factionalism of the
Palio.) Siena was a corporate city-republic, with many of its citizens participating
in the government. Because of the numerous civic and religious organizations,
much of the artistic patronage was also corporate.

Many of the families who paid for the impressive buildings and for the
paintings decorating them earned their money from banking and commerce.
The Sienese were not blessed with abundant raw materials or plentiful water,
two necessary ingredients for manufacturing. They had no navigable rivers or
lakes, nor were they near a major port. Although the city was on several of the
major north-south roads of the Italian peninsula, it was in a rather remote part of
Tuscany. With many economic avenues blocked, the Sienese turned to finance
and business, and for years they were important European bankers and mer-
chants. But the height of the city's wealth and political power came early. By the
beginning of the fourteenth century Siena was already in economic decline, a
condition that did not, however, prevent it from remaining one of the most in-
ventive and creative urban centers in Tuscany.

Throughout the centuries of independence a particular Sienese character
developed, which is expressed in the city's language, customs, and communal
structure as well as in its religious sensibility. A strange combination of the mys-
tical and the practical, the famous Sienese religious figures, including St. Cather-
ine of Siena and St. Bernardino, both developed out of the city's social world and
changed that world by their lives and teaching. Of course, Siena's substance and
style were also reflected and influenced by the visual arts. From their earliest
times, they bore the Sienese stamp, which remained clear until the end of the
period covered by this book.

Siena's influence extended far beyond its walls, into the Tuscan countryside
below the city. The Senese, the area under the domination of the city-state of
Siena, extended deep into southern and western Tuscany, where many towns
came under the political, economic, and social influence of the city. Sienese gov-
ernment officials, farmers, engineers, architects, and artists turned many of the
dependent cities into colonies.

Sienese vitality remained strong, even throughout the period of economic
and institutional decline after the fourteenth century. Until the early sixteenth
century, Siena, despite its remote location, small size, poor economic base, and
shrinking wealth, jealously preserved many of its values, myths, traditions, and
institutions. As its Renaissance painting attests, Siena originated and nurtured a
very specific and original identity.

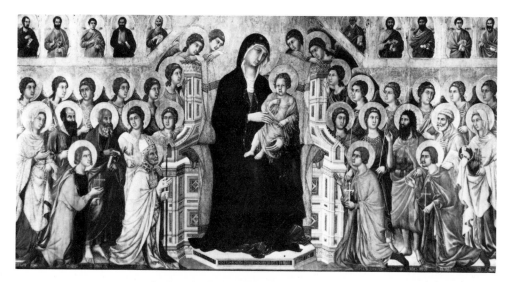

1. Duccio di Buoninsegna, *Maestà*. Siena,
Museo dell'Opera del Duomo.

A burst of creative activity nearly unmatched in the fourteenth century oc-
curred in Siena a century before our period begins.[1] It was to a considerable
extent fostered and directed by the painter Duccio di Buoninsegna, whose works
span the years 1280–1319. It was he who launched the Sienese style and gave it
much of the shape it was to assume for the following centuries.[2] His most fa-
mous work, and one of the most renowned paintings of its time, is the large
Maestà (Madonna and child with saints and angels) (Fig. 1). It was painted for
the high altar of the cathedral of Siena and was installed in 1311. The *Maestà* is a
work of remarkable formal elegance. Throughout the panel the emphasis is on
delicacy and grace. Its many narratives have a fluidity of action that is nearly bal-
letic; everywhere line forms dancing shapes.

Duccio's work and much of subsequent Sienese painting is often wistful, a
pervasive melancholy characterizing its holy protagonists. Intense spiritual long-
ing, repressed fervor, and religious ecstacy are the emotional threads that weave
through the complex fabric of Duccio's paintings. Duccio was the most brilliant
Sienese colorist. His *Maestà* is filled with hues so original and radiant that they
cannot be named satisfactorily. This painting is the source of the long Sienese
infatuation with color.

The artist who best carried out Duccio's ideals was Simone Martini (active
c.1320–1344).[3] He was probably trained in Duccio's workshop and soon devel-
oped into a popular and prolific painter with a distinctive, ultrarefined style. He

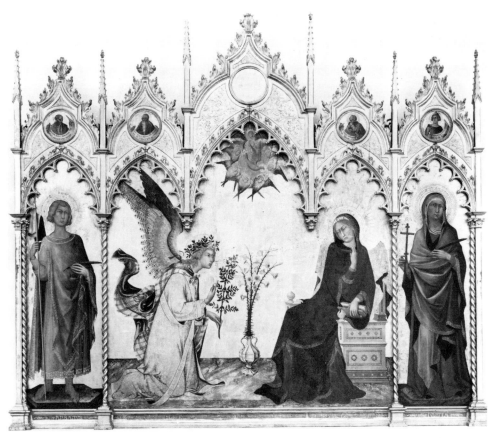

2. Simone Martini, *Annunciation*. Florence, Uffizi.

was employed throughout the Italian peninsula and, at the end of his life, in France, and was one of the apostles of the Sienese style whose work was influential even beyond the Alps.

Simone's *Annunciation* (1333) (Fig. 2) embodies the essence of his art. Perhaps nowhere else has the Annunciation been conceived in such a splendid, ethereal, and simply beautiful way. The treatment of the figures and the measured, charged space between them demonstrates Simone's extreme sensitivity to the formal rhythms of void and solid. This feeling for shape, interval, and grouping was learned from Duccio, but in Simone's hands it is transformed.

The refined, sweet melancholy of the *Annunciation* immediately reminds one of Duccio's *Maestà*. The emotional tenor of Simone's paintings is similar to that in Duccio's work, but even more pronounced. The sadness and isolation of

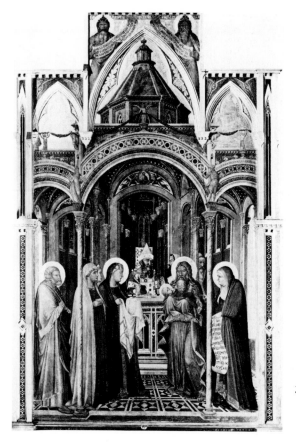

3. Ambrogio Lorenzetti, *Presentation of Christ in the Temple*. Florence, Uffizi.

the protagonists of Simone's religious drama change them from symbols into vivid, complex personalities. The dreamy wistfulness of his work prefigures much of the spirit of subsequent Sienese painting.

The painting of Ambrogio Lorenzetti (c.1300–1348), while also springing from Duccio, runs counter to the styles and refinement of much of Sienese art of the first half of the Trecento. Ambrogio, whose brother Pietro was almost as talented as he, was an exact contemporary of Simone. Ambrogio also received commissions outside his native city, especially in Florence, where he was an influential painter.[4] Ambrogio, however, was not interested in gracious pictures full of elegant, ethereal forms and figures; rather, his work is notable for its expressive simplicity. In his *Presentation of Christ in the Temple* (Fig. 3), as in all his other works, the palpability and realism are essentially at odds with the more otherworldly art of Duccio, Simone, and most of their followers. Beauty, grace, and coloristic brilliance were not at the center of Ambrogio's universe.

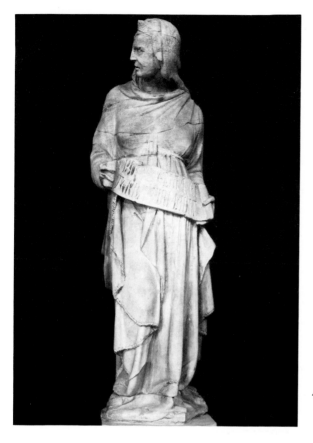

4. Giovanni Pisano, *Mary, Sister of Moses*(?). Siena, Museo dell'Opera del Duomo.

 Above all, it was the heart of the drama, the central emotional core, that fascinated Ambrogio. That drama revolves around monumental figures of considerable realism acting in environments very like those of the workshipper. Ambrogio's actors are decidedly different from those of Duccio and Simone; they are expressive, aggressive, and full of worldly hopes, dreams, and fears—they inhabit a different realm.

 Ambrogio was aided in the formation of this distilled drama by Giotto, whose revolutionary works from the teens and twenties are marvels of economy,[5] and in his search for expression by Giovanni Pisano, the distinguished sculptor of the Siena Cathedral.[6] In a series of life-sized statues (Fig. 4) carved for the façade during the 1290s, Giovanni developed a pictorial language of tremendous power; the straining, agitated prophets and saints convey an expressiveness previously unknown in Siena. The shock waves of Giovanni's art spread widely, touching both Giotto and Duccio, but they were most keenly felt by Ambrogio

and Pietro Lorenzetti. Both brothers learned from Giovanni's statues how to make the figure expressive, how to allow it to speak directly to the observer with considerable force.

That two styles as different as Simone's and Ambrogio's existed within the same small city shows the dynamic and versatile nature of Sienese visual culture. And, that both Simone and Ambrogio started out under the influence of Duccio, that inexhaustible mine of inspiration, motif, and style, demonstrates the flexible, wide-ranging potential of the Sienese school. Duccio died in the teens of the fourteenth century, Simone died in 1344, and both Pietro and Ambrogio were probably lost when the great plague of 1348 decimated Tuscany. The passing of these major artists is one of the many turning points in the history of Sienese painting and, in some ways, marks the beginning of the period covered by this book.

The painters working after these four great artists may be divided into two groups. One consists of men such as Luca di Tommè and Niccolò di Ser Sozzo, who carried on, although in a modified form, the stylistic principles of the older generation. In themselves they are extremely interesting, but their work is more concerned with the past—with the careful conservation and imitation, although adapted to new ideals, of the first half-century of Sienese art. Their visions and aims were those of Simone Martini, the Lorenzetti brothers, Lippo Memmi, and, of course, Duccio.

The second group of painters,[7] however, were intent on reshaping and re-directing the art they had inherited. Consequently, it is this group that we must follow as our story begins. While these artists never equalled their brilliant fore-runners of the first half of the Trecento, they were innovative and, above all, charming. Moreover, they trained many of the outstanding painters who worked in the first half of the fifteenth century. Although they shared many characteristics, they each possessed an individual, readily identifiable style.

Bartolo di Fredi (c.1330–1410) was one of the most fascinating and skillful of these painters.[8] He was much sought-after, and his long career was filled with commissions both at home and for the many cities dependent on Siena for their intellectual and artistic needs.

Among Bartolo's first works is a large *Madonna della Misericordia* (Fig. 5), a popular Trecento image depicting the Virgin sheltering members of the con-fraternity of the Misericordia. This altarpiece probably derives from a similar im-age by Lippo Memmi, the brother-in-law and close follower of Simone Martini. Although Simone's influence is everywhere evident, the panel reveals Bartolo's independent idiom in its strongly individualized, often contorted faces, and in its loving depiction of detail. Bartolo shares with many other Sienese artists of

5. Bartolo di Fredi, *Madonna della Misericordia*.
Pienza, Museo della Cattedrale.

the second half of the Trecento a love for strong patterns of color. There is a breathtaking rainbow of intense local hue in the crowd swarming about the Madonna's brilliant red cloak. Bartolo is not a subtle colorist, but like many of his contemporaries, he is always sensitive to color as an enlivening, decorative force.

Bartolo's most famous painting, and without doubt his masterpiece, is the large *Adoration of the Magi*, c.1400 (Fig. 6). Now dismembered—it probably lacks a predella and perhaps side wings—this expensive commission was meant to be placed in some important site. The fact that it and other large altarpieces were awarded to Bartolo suggests that he was highly respected during the last quarter of the Trecento and the first decade of the Quattrocento.

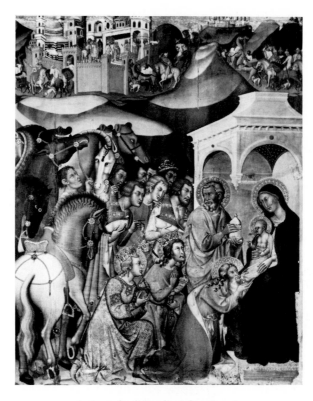

6. Bartolo di Fredi, *Adoration of
the Magi*. Siena, Pinacoteca.

The *Adoration of the Magi* is a good example of Sienese painting of the late
Trecento. In conception it is not the charged, ritual of adoration so often seen in
the paintings of Bartolo's Sienese ancestors; it lacks both the grace and the im-
mediacy of so much of the older art. As even the casual spectator can observe,
the picture is full of joy, movement, and fantasy; and in these characteristics it
closely echoes the paintings of Bartolo's contemporaries, many of whom seem to
have been influenced by his works.

Bartolo's painting is activated by bold, sweeping lines and abstract form: the
swinging, prismatic mountains filling the background; the great curves of the
horses' necks and huge rumps; the arches of the Madonna's little house; and
the jumble of the crowds that course through the compressed space. Bartolo's
love of detail adds to the activity; from the costumes of the kneeling Magi to the
architecture of the distant city (surely meant to be Siena, with its striped cathe-
dral and tall towers), clarity and specificity arrest the eye as it moves from one

passage of the painting to another. So thick is the detail in some places, that the observer can get lost in it and forget the painting's subject.

The altarpiece has some startling images: the sharply foreshortened horses are memorable creations, and each of the intense figures in the foreground, many with fine, wavy blond hair, is worthy of the closest attention. But the most felicitous parts of this charming and happy picture are the fantastic background, with its sweeping greenish hills; the toylike cities, with pink and blue walls; and the exotic cavalcade of the Magi winding through the valleys.

Bartolo's decorative use of form and detail is complemented in the *Adoration* by a wide range of saturated hues—pinks, blues, greys, reds, whites. These strong colors are spread across the surface of the altarpiece in wide, pronounced patterns similar to those in Bartolo's *Madonna della Misericordia*; and in its patternlike coloration the *Adoration* resembles an Indian or Turkish miniature. This feeling for the decorative potential of color is one of the traits shared by all Sienese painters; from Duccio on, these artists thought of color not only as an aid to the building of form but also as an independent decorative tool. During the last quarter of the Trecento, Bartolo and his contemporaries utilized color to create rhythms and chords different from any seen in Siena before. They were infatuated with color and used rainbowlike palettes to create bright-eyed, happy pictures.

The pulsating *Adoration* exercised considerable influence on several non-Sienese painters. Gentile da Fabriano, who worked in Siena around 1425, must have studied it with care, for he introduced the chaotic swirl of figures and some of the splendid horses into his own *Adoration*, painted in Florence during the 1420s.[9] The same horses must have also inspired one of Gentile's Florentine contemporaries, Paolo Uccello, whose own charging, rearing, strongly foreshortened steeds populate several of his battle and hunt pictures.[10]

Nowhere is the unreal nature of Bartolo's painting, which so fascinated Gentile and Uccello, better seen than in a series of Old Testament scenes completed around 1360. These frescoes are on the aisle wall of the Collegiata of San Gimignano, a hill town about thirty miles from Siena. Among the most interesting is the *Dream of Joseph* (Fig. 7), a story that allowed Bartolo to utilize his fertile imagination. Because the Old Testament was seldom illustrated during the fourteenth century, there was probably no prototype for this scene, and Bartolo may have had to compose it from scratch.

The fresco is divided by architecture and landscape into three narrow vertical sections. In the central one, Joseph sleeps in a large bed covered with a green and gold spread. Just outside the room, as though it were a landscape, is Joseph's dream of the sun and the moon and eleven stars bowing down to him while the

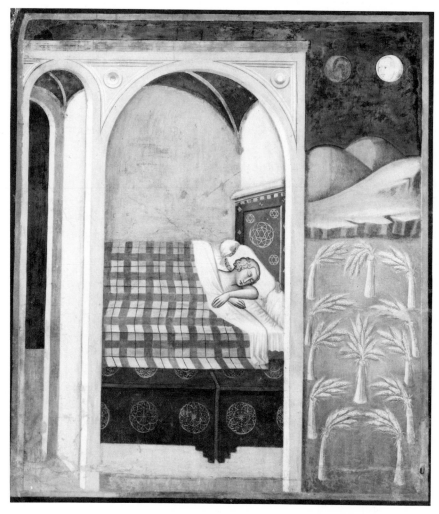

7. Bartolo di Fredi, *Dream of Joseph*. San Gimignano, Collegiata.

sheaves of his brothers gather around his sheaf—all prophetic of his coming glory. In the background of this dreamscape the barren lunar hills (like those around Siena) dominate the horizon, making the entire picture slightly eerie. To envelop the whole scene in a mist of unreality, Bartolo has made it decorative and flat. By keeping the forms near the front, by painting objects in a generalized, almost abstracted fashion, and by using wide fields of unbroken color, he has elevated the *Dream* into the realm of fantasy occupied by the *Adoration of the Magi* and many of his other works.

In both the *Adoration* and the *Dream of Joseph*, Bartolo, like every Sienese artist, has drawn heavily from the past. His figure style is indebted to Duccio, Simone Martini, the Lorenzetti brothers, and several of his near contemporaries, especially Barna da Siena, the author of a large fresco cycle directly across from Bartolo's Old Testament paintings.[11] The architectural divisions of the room and the compartmentalizing of space and landscape seem to derive from Pietro Lorenzetti and Simone; but the borrowing is creative, never slavish. Each motif emerges from Bartolo's brush transformed by his imagination and inventiveness. The more measured world of Simone is submerged in active, chaotic scenes. Ambrogio and Pietro Lorenzetti's monumentality and expressiveness have been tamed, made both more fantastic and less heroic.

Paolo di Giovanni Fei, a close contemporary, parallels Bartolo in his conceptions of religious drama and in the idiom in which these conceptions are shaped. He was perhaps trained by Bartolo himself. Paolo was active from around 1370 to just past the first decade of the Quattrocento.[12] Like Bartolo di Fredi, he was one of the artists who moved painting in Siena from the world of Simone and the Lorenzetti to the style of the new century.

The *Presentation of the Virgin*, c.1398 (Fig. 8), was probably made for the Siena Duomo. It clearly documents Paolo's relation to the influential style of Ambrogio Lorenzetti, whose *Presentation of Christ in the Temple* (Fig. 3; in all likelihood also from the Siena Duomo) served as Paolo's model. Ambrogio's painting, which may have had wings containing standing saints, is painted on a single unified panel subdivided into three compartments by painted columns. As usual, Ambrogio reinterpreted the old altarpiece type he was about to paint: The result is a newly integrated space in which the old triptych divisions are retained only by the articulation of the painted and carved architecture.

In turn, Paolo di Giovanni Fei rethought Ambrogio's solution and decided on a return to the old triptych type of three separate panels. However, he has kept Ambrogio's unity by extending the space of the composition behind the pilasters marking the junctures of the separate panels. Obviously, this painting is not the work of a slavish copyist but of an innovative, intelligent artist. This type of rethinking and modification of older styles was common among Paolo's contemporaries.

Perhaps the greatest difference between Paolo's *Presentation* and the work of any of the remarkable artists of the first half of the fourteenth century is the emotional climate of the narrative. Instead of the expressive, heroic painting of the Lorenzetti brothers or the elegant, mellifluous altarpieces of Duccio and Simone Martini, Paolo's works depict a charming, domestic, confused, often humorous world. A wealth of detail, pattern, and movement creates a visual hurly-burly leading the eye from one part of the picture to another in a series of little lurches.

8. Paolo di Giovanni Fei, *Presentation of the Virgin*.
Washington, National Gallery.

The figures stem from Simone and the Lorenzetti brothers, but they are more relaxed, less expressive. Types abound—serious old men, beautiful women, and plump, full-faced young virgins. These bodies are not interconnected by a powerful central drama but are more like the individual tesserae of a colorful, glittering mosaic.

Color itself assumes a highly decorative role. Pastels and other bright colors sparkle across the surfaces of Paolo's *Presentation* and dozens of other Sienese paintings of the late Trecento. In the first half of the century, color was utilized both as abstract decoration and for the construction of form; the shape and rhythm of solids were made tangible by hue, which served to knit the composition together. But in the painting of Paolo di Giovanni Fei and many of his contemporaries, color plays a more independent role. For example, in the

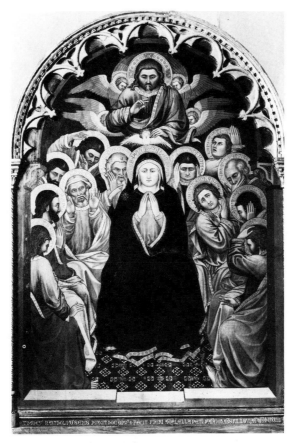

9. Taddeo di Bartolo, *Pentacost*. Perugia,
Galleria Nazionale dell'Umbria.

tapestry-like patterns of Bartolo di Fredi's *Adoration of the Magi* or in Paolo's brilliant *Presentation*, color creates its own rhythms and patterns.

Although he was not as fascinated with color as Paolo di Giovanni Fei or Bartolo di Fredi, Taddeo di Bartolo (c.1360–1426) maintained the varied, original palette of the Sienese painters working between c.1375 and 1430. Although he is still a vastly underrated figure, Taddeo was a busy artist and the most prophetic painter of his time. He was often called away from Siena to execute important commissions—a sure sign of contemporary esteem—and, like many other artists, he was also active in the Sienese government, in which he held a number of posts.[13]

Taddeo seems to have begun his career in the last years of the 1380s. He was strongly influenced by the Lorenzetti through Andrea Vanni (a Sienese painter once in partnership with Bartolo di Fredi) and by Bartolo himself. Taddeo's style evolved rapidly, as can be seen in the *Pentacost* (Fig. 9), a remarkable picture from 1403.

Even though the *Pentacost* is loosely based on Duccio's famous rendition of the subject on the back of the *Maestà*, Taddeo's picture is not only original but, in many ways, unique. There is a wholeness and monumentality about the work that is lacking in his Sienese contemporaries. The sources of this monumentality are not fully known, although some of it comes from the Lorenzetti brothers. Other important influences in this painting may be found in the work of several artists active in Florence around the beginning of the Quattrocento: Agnolo Gaddi, Spinello Aretino, and especially Antonio Veneziano had a part in the formation of Taddeo's idiom.[14] Taddeo also seems to have been swayed by Barnaba da Modena, a talented north Italian painter active in Tuscany.[15] Nevertheless, even the influence of any or all of these artists cannot account for the massive, sharply foreshortened figures who form a tight chain around the large Madonna near the center of the picture. Of course, each apostle acts—perhaps *reacts* is a better word—in an individualized way, but all this variety is held in tight check. The unity and centralization of the *Pentacost* are not found in the paintings of Taddeo's Sienese contemporaries. Here and in several other panels and frescoes Taddeo reveals a personal style slightly out of step with the more decorative, lyrical idioms of Bartolo di Fredi, Paolo di Giovanni Fei, and a number of other artists working in Siena during the second half of the Trecento.

Taddeo's independence can be seen again in his *Annunciation* (Fig. 10). When Taddeo received this commission, he must have thought at once of Simone Martini's *Annunciation* of 1333 (Fig. 2), in the Siena Duomo, a picture that had become one of the icons of the city's style by Taddeo's time. Taddeo pays his respects to Simone's famous image by copying the basic elements of the older master's composition, but he substantially modifies the form and spirit of the work. Simone's elegance is played down; instead, the central figures now almost touch; the subtle twisting of forms, the sinuosity of line, and the shapely void between the figures are suppressed. In Taddeo's work the accent is much more on the stability of the great bodies and on the hermetic space in which they act. Even the side figures of SS. Cosmas and Damian are more stolid; in fact, they function like large brackets framing the central drama.

Taddeo's palette in the *Annunciation* and in many other pictures differs from that of his contemporaries. Color tends to play a slightly less decorative role; large areas of hue, usually highly saturated and dense, appear with frequency. Often Taddeo uses color to define and build figures and landscape and to

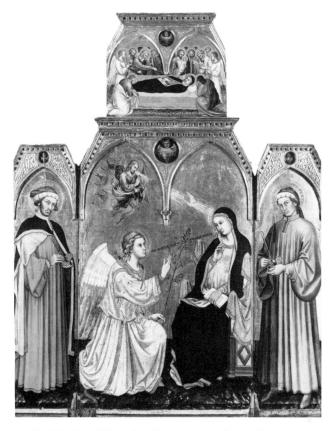

10. Taddeo di Bartolo, *Annunciation*. Siena, Pinacoteca.

integrate them into his compositions. He does not have the lighter, more over-
all decorative feeling for color that characterizes the palettes of many of his
contemporaries.

Taddeo's most striking and important paintings cover the walls of the chapel
of Siena's Palazzo Pubblico.[16] Chapels were often found in government buildings
during the Renaissance, but the one that houses Taddeo's frescoes is particularly
splendid and must have been very costly. Furnished with a handsome iron gate,
elaborately inlaid choir stalls, and a fresco cycle, it remains one of the most im-
portant Sienese ensembles of the fifteenth century. Since Taddeo was given this
expensive and prestigious commission he must have been held in the highest re-
gard by those responsible for governing the city.

The frescoes were painted around 1407. Several unskillful restoration cam-
paigns have badly damaged their surface and color. Nevertheless, enough of their

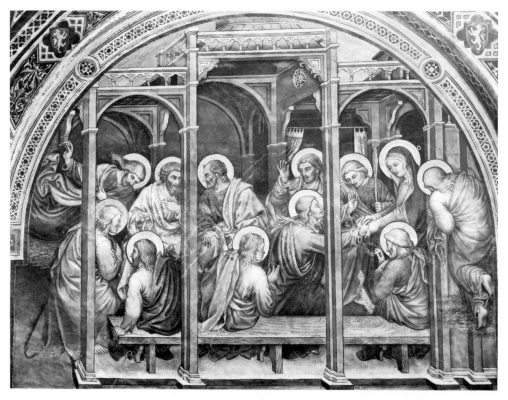

11. Taddeo di Bartolo, *Virgin Bidding the Apostles Farewell*. Siena, Palazzo Pubblico, Chapel.

design can be seen to establish them as landmarks in the painting of Renaissance Siena. Taddeo's frescoes are dedicated to the life of the Virgin, Siena's principal patron saint. After the battle of Montaperti in 1260, when the Sienese attributed their victory over the hated Florentines to her intervention, the city developed a particular veneration for Mary. Her image was seen everywhere, and the Duomo—Siena's major church—was dedicated to her Assumption. This widespread and fervent feeling was as strong in the sixteenth century as it had been several hundred years earlier.

In the *Virgin Bidding the Apostles Farewell* (Fig. 11), Taddeo demonstrates his considerable skill as a composer of complex narrative. Within a large building whose arches act like an armature around which the drama revolves, the Virgin greets the apostles, who have been brought by angels to bid her farewell. The turbulence of their arrival—at the left and right two are still airborne—relieves the static quality of the architectural frame and activates the front of the fresco.

The scale of the architecture and the figures and the balance between them are reminiscent of the works of a number of Taddeo's contemporaries; again, the names of Agnolo Gaddi and Spinello Aretino spring to mind. In the increased clarity of their compositions over that of their predecessors, both Gaddi and Spinello anticipated the style of Masaccio and his several followers. The heightened realism and unity of the panels and frescoes of these artists are matched in Taddeo's *Farewell*, with the massive actors drawn with daring foreshortening—note the flying apostle on the far right—and placed within a plausible space.

The painters of late Trecento Florence helped set the stage for the vivid narratives and figures of Masaccio, Nanni di Banco, and Donatello; their art was accepted and made part of the idiom of the next generation. But for Siena, Taddeo's work, especially the frescoes in the chapel of the Palazzo Pubblico, approached reality too closely. Like the last paintings by Ambrogio Lorenzetti, they tugged at the barriers between the realm of the sacred narratives and the spectator's own world; the holy figures were demystified by their nearness. Consequently, the highly original painting of Taddeo di Bertolo found little echo in later Sienese art.

Taddeo's independent tendencies are most evident in his *Assumption of the Virgin* fresco (Fig. 12) in the chapel of the Palazzo Pubblico. A vast and convincingly scaled landscape dominates the action; this rocky world sets the mood of the fresco. For landscape to perform such a key role in late Trecento Tuscan painting is rare, although in the frescoes of the Florentine Agnolo Gaddi large-scale landscapes appear with considerable frequency. It is also possible that Taddeo was swayed by the panoramic vistas of Altichiero, which he may have seen in northern Italy or known through copies,[17] or even by the large-scale landscapes by Ambrogio Lorenzetti in an adjoining room. But, unlike its possible sources, this *Assumption* landscape is almost Romantic in its evocation of foreboding vastness.

Many of his figure types derive from Duccio and the Lorenzetti brothers, but even here Taddeo demonstrates his originality. Always interested in coming to grips with the construction of the body and its placement in space, he spent much effort drawing each figure. The men looking into the sarcophagus and the figures in each of the fresco's corners are marvels of complicated and difficult foreshortening. This elaborate figural construction must be the polished result of many paper studies through which the forms evolved slowly. In the use of this technique Taddeo is unique. No other contemporary so fully developed the figure or paid so much attention to drawing. In fact, it was not until well into the Quattrocento that painters again became so interested in the complex arrangement of figures in space.[18]

Taddeo di Bartolo was a prophetic painter, although the direction of his

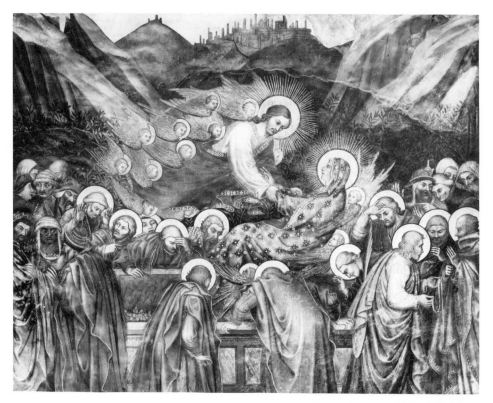

12. Taddeo di Bartolo, *Assumption of the Virgin*.
Siena, Palazzo Pubblico, Chapel.

style lay toward Florence rather than Siena. He was a gifted artist, capable of painting narratives charged with emotion. The sum of the parts of his works, especially those in the Palazzo Pubblico, assures them a secure, if unique, niche in the history of Sienese painting. Aside from the contorted figures, empty landscapes, and massive narratives, Taddeo's pictures have an air of hushed mystery and tension that is shared by many Sienese artists of the Renaissance. Far from the *retardataire*, minor artist that he is often considered, Taddeo was a thoughtful painter, often willing to rethink traditional ideas and strike out in new directions. In this respect he resembles his colleagues Bartolo di Fredi and Paolo di Giovanni Fei.

These three men were the most talented painters in Siena in the early decades of the fifteenth century. But there were other respectable artists of the period, perhaps not as original or as innovative, who often imitated the styles of their more-gifted contemporaries. One of these lesser masters is Andrea di Bar-

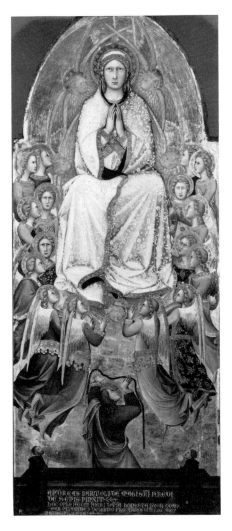

13. Andrea di Bartolo, *Assumption of the Virgin with Two Donors*. Richmond, Virginia Museum.

tolo (active 1389–1428), the son of Bartolo di Fredi.[19] Scores of paintings from his active brush still exist in Siena, in many small Tuscan towns, and in numerous museums throughout the world. The productivity of Andrea di Bartolo and many other late Trecento Sienese artists suggests that there was a considerable demand for painting in Siena and her provinces in the beginning of the Quattrocento.

Andrea's *Assumption of the Virgin with Two Donors* (Fig. 13) affords a good example of his style. What strikes one first about this painting is its color: the brilliant orange of the seraphim, who form a hot mandorla around the Virgin;

her icy white mantle shaded with blue; the pinks, blues, greens, and lilacs of the flying angels; and the strong red and blue of Doubting Thomas's robe, at the bottom of the picture. The effect of all this sparkling color before a glittering gold background is both sumptuous and unreal.

In front of the sarcophagus, the two tiny donor figures clasp their hands in fervent prayer. Like them, we are awed by Andrea's crowded vision of the *Assumption*: the stern, frontal Virgin regarding the worshipper without emotion; the ranks of svelte, fluttering, full-faced angels; the burning seraphim; and the anxious Thomas, who reaches for the Virgin's belt with hope and amazement, combine to fashion an image of power and fascination, a radiant vision filled with vibrating color. Andrea di Bartolo, as the figural and facial types reveal, is still very much under the influence of Simone Martini, the Lorenzetti brothers, and his father. It is interesting that Andrea, an artist of comparatively modest ability, could create this noteworthy painting. Such fine work by a minor master is testimony to the high level of skill in Siena at the beginning of the Quattrocento, a level that was maintained in great part by the influence of tradition and the respect for the past that was shared by all the artists of the period.

The masterpieces of Duccio, Simone, Pietro and Ambrogio Lorenzetti, and their immediate followers were not simply imitated. The artists working around the turn of the century substantially modified the early styles and interpretations of religious drama. Sienese painting was domesticized, made more anecdotal, less serious, and more detailed. Yet it remained an art of considerable charm and beauty, if not of the supreme quality it achieved in the first half of the fourteenth century. Moreover, in a city famous for its color, the painting of the period c.1375–1430 is remarkable for its decorative, dancing hue, which in itself is a major landmark in Sienese art.

New trails were being blazed by several important artists. Bartolo di Fredi and Taddeo di Bartolo envisioned forms and narratives that marked both of them as prophetic artists. They and their fellow painters made the late Trecento and early Quattrocento a lively and important period, which would be the fertile seedbed for the next generation of Sienese painters. These younger painters would work through the first half of the new century, shaping pictorial visions never seen before. These varied artists of the highest talent, originality, and imagination were to create a new Golden Age of Sienese art.

T W O

FOREIGN VISTAS

I N THE EARLY fifteenth century, several important Florentine artists executed commissions in Siena. Their art and the art of their co-citizens were to exert a strong influence on a small number of talented Sienese painters who turned a long-standing Sienese flirtation with Florentine art into something deeper and more serious. Three Sienese artists—Domenico di Bartolo, Vecchietta, and the sculptor Jacopo della Quercia, like Taddeo di Bartolo (see chapter 1), were decisively influenced by several successive waves of Florentine art of the late Trecento and early Quattrocento.

In 1408 Spinello Aretino, an Aretine artist painting in the Florentine style, completed a major fresco cycle in one of the most important rooms in the Palazzo Pubblico. The paintings embodied the crowded but structured narrative principles evolved by Spinello and his Florentine contemporaries. This idiom recalled that of the fabled Giotto, whose ordered and lucid paintings were much admired by Florentine artists at the end of the Trecento.[1]

Spinello's paintings and those of his Florentine contemporaries, in both Siena and Florence, impressed Taddeo di Bartolo and his contemporaries, just as works by Giotto had influenced Duccio and the Lorenzetti brothers. Of course, the influence was not just one way, for Giotto and other Florentines throughout the fourteenth and fifteenth century felt the powerful pull of Sienese painting.[2]

Another wave of Florentine influence came later in the Quattrocento, when the stylistic and contextual innovations of Masaccio, Donatello, and their small band of followers were admired and imitated by several Sienese artists.[3] Masaccio's realistic, heroic paintings, filled with a new naturalism, were in many ways antithetical to Sienese art and culture, which usually eschewed simple realism in any form. Nevertheless, as we shall see in chapter 3, some of the implements of representation forged by Masaccio and Donatello were adapted to a visionary art by Sassetta and Giovanni di Paolo, who realized at once that with such tools they could make the fantastic and unreal startlingly vivid.

However, a number of artists were deeply affected by Florentine art. They used it to create idioms that, while basically Sienese, were strongly indebted to the art of Masaccio and Donatello. In fact, the styles of Domenico di Bartolo and Vecchietta represent the peak of Florentine influence during the entire Quattrocento. The work of these two artists could never be confused with those of native Florentine painters, but their idioms reveal how eagerly they grafted Florentine inventions onto their Sienese heritage. The Sienese artists were further exposed to Florentine art during the late 1420s, when the font for the Siena Baptistry was commissioned.[4] Two important sculptors from Florence, Donatello and Lorenzo Ghiberti, were employed to make bronze reliefs of the legend of St. John the Baptist. Ghiberti's relief must have been admired by the people of Siena because it was both graceful and well made, two qualities most esteemed in the city. Moreover, its rather conservative, almost late Trecento, narrative must also have pleased the traditional Sienese taste.

Donatello's relief of the *Feast of Herod* (Fig. 14) was of a different order; it was something like a time-bomb whose dazzling stylistic and contextual repercussions would be felt in Siena for decades.[5] Set in a complicated, dizzying atmosphere, fashioned with all the latest Florentine techniques of representation, including the use of the one-point perspective system, the relief gives full vent to the horrors of the story it tells. A vacuum is created by the diners' flight from the grisly severed head of the Baptist, proferred, like a main course, on a salver. Twisting, turning, running, and stumbling, the figures create a human explosion that empties the center of the composition. The stage is set for this unique narrative by the purposely confused, complicated layers of background architecture and the many patterns of the obsessively worked bronze surface. In a powerfully condensed set of images, Donatello conveys the wild terror, revulsion, and chaos of the *Feast of Herod*. The tension of this highly original and daring relief, achieved through Donatello's considerable compositional and figural skills, left its mark on the Sienese artists. Giovanni di Paolo and Sassetta, for example, were most impressed by its chaotic, unreal world; while others, Domenico di Bartolo and Vecchietta, among them, were equally affected by Donatello's skillful crea-

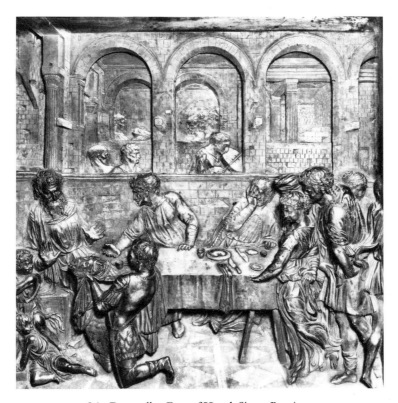

14. Donatello, *Feast of Herod*. Siena, Baptistry.

tion of space and architecture. To them, Donatello's work must have seemed a stunning use of the new representational tools of Florentine art.

Of course, it was not necessary for Florentine artists to work in Siena for their art to have an impact; Siena is only about fifty miles from Florence, and the road between the two towns must have been much used by Sienese painters and sculptors. One who seems to have traveled that road frequently was Domenico di Bartolo.[6] Although his career cannot be charted with certainty because of a lack of signed and dated paintings, it appears that he was born around 1400 in Asciano, a small town near Siena. Very early in his training, perhaps even at its inception, he was strongly influenced by Florentine painting, chiefly that of Masaccio, Masolino, and Filippino Lippi. Because the basic structure of his art is Sienese, even during the time he was actively absorbing the Florentine style, it appears that he was not trained in Florence but in Siena itself. Perhaps he made a number of early trips to Florence with his master or simply fell under the spell of the Florentines at an early age.

15. Domenico di Bartolo, *Madonna of Humility with Angels.* Siena, Pinacoteca.

Domenico's signed and dated *Madonna of Humility with Angels* of 1433 (Fig. 15) is one of the loveliest works of the early Sienese Quattrocento. Filled with a Florentine sense of form, if not spirit, and perhaps derived from a now lost picture by Masaccio, it is unlike any Sienese painting of the time. The composition revolves around the volumetric Madonna, who, trianglelike, is the physical and psychological fulcrum of the composition. Behind her are five irregularly placed angels, who form a sort of semicircle blocking further movement into space. As in the several surviving Madonna panels by Masaccio, the large figures dominate; their bodies create geometric shapes that give the picture weight, gravity, and peaceful stability—three characteristics seldom encountered in the much more agitated and fragmented Sienese painting of the early Quattrocento.

The pale pink of the angels' garments; the olive green, pink, and blue of the Madonna's robes; and the almost pistachio of the cloth on which the infant rests all display a sense of color and its chording peculiar to Sienese painting around 1400. This handling of the color and the treatment of the costumes and the faces suggest that Domenico had his earliest training in the shop of someone like

Paolo di Giovanni Fei or Taddeo di Bartolo. The latter is an especially likely candidate because of the Florentine influence apparent in much of his art; such a teacher would surely have encouraged Domenico to look at the latest Florentine developments.

Domenico di Bartolo viewed these Florentine events with a sympathetic and comprehending eye. More than any other Sienese painter, he understood the realistic, straightforward painting of Masaccio and his few followers and was able to utilize its principles without distorting them. With Masolino, Fra Angelico, and Filippo Lippi (whom he might have influenced, since this *Madonna of Humility* predates Filippo's first dated work by three years), Domenico di Bartolo formed one of the tiny group of acolytes willing to wrestle with Masaccio's empirical, heroic, and disturbingly unfashionable art. Consequently, Domenico's *Madonna of Humility* has contributed much more to Florentine than to Sienese art; its impact on the latter was minimal, and its formal and ideological tenets were not fully appreciated in Siena.

In 1437, four years after the *Madonna of Humility*, Domenico di Bartolo painted a *Madonna and Child* (Fig. 16). Here the two massive figures (unfortunately damaged) placed close to the viewer have the same awkward but compelling force one sees in paintings by Masaccio. Domenico di Bartolo consciously avoids the elegant canons of beauty so characteristic of his Sienese contemporaries in favor of a more direct, if less comely, image. The two very human protagonists are vital and unsophisticated; their bodies are carefully constructed and balanced. A profound emotional contrast between the curious, blessing child and his apprehensive mother fills the picture with foreboding, made all the keener by the rose hedge of flowers and thorns around the top of the composition.

While preparing this panel, Domenico di Bartolo, like Masaccio himself, may have looked back to the Madonna panels of Ambrogio Lorenzetti, in which the intertwined bodies of mother and child create a context both tender and fearful, a mood of protection and apprehension. In fact, the Madonna's spread right hand in Domenico's painting is reminiscent of hands in several of Ambrogio's paintings.

It is possible that both the *Madonna of Humility* and the *Madonna and Child* are modified copies of paintings by Masaccio or his circle, but Domenico's series of frescoes for the hospital of the Scala, done in the 1440s, could never be mistaken for works planned by a Florentine. For it is in these paintings that the Sienese elements in his work first begin to predominate, as Domenico falls increasingly under the spell of his native art.

The hospital of the Scala, situated across from the Duomo, was one of the wealthiest and most powerful institutions in Siena. It functioned not only as the chief hospital for the city and its surrounding territories but also as a charitable

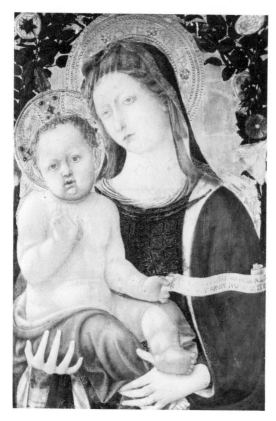

16. Domenico di Bartolo, *Madonna and Child*. Philadelphia, Museum of Art, Johnson Collection.

institution of considerable importance.[7] Already ancient by the fifteenth century, it was controlled by rotating committees of prominent citizens, including artists, who employed painters and sculptors to decorate its wards and church. From the influential facade frescoes (now destroyed), painted in the Trecento by Ambrogio and Pietro Lorenzetti, to the works by Beccafumi, done in the early sixteenth century, the hospital was the destination and repository of significant Sienese art.

Domenico di Bartolo's frescoes, along with those by several other Sienese artists, were painted around 1445 and decorated a large reception area of the hospital called the Pellegrinaio. Each fresco is devoted to some aspect of the institution's philanthropic work, and together they formed one of the largest fresco cycles of the Sienese Quattrocento. Each painting is a treasure trove of information about the Scala and its many charitable functions. The *Care of the Sick, Education and Betrothal of the Foundlings, Feeding and Clothing of the Poor*, and the other frescoes in the Pellegrinaio bring the Quattrocento to life.

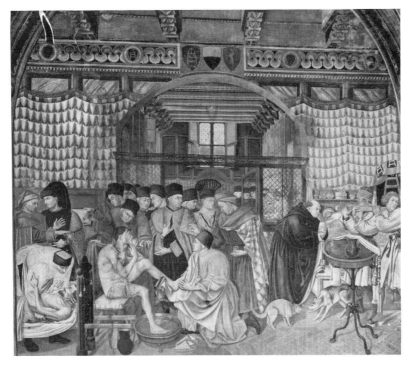

17. Domenico di Bartolo, *Care of the Sick*. Siena,
Hospital of Santa Maria della Scala, Pellegrinaio.

For example, *Care of the Sick* (Fig. 17) shows, with great accuracy, the interior of a hospital ward. The patients are looked after by doctors and lay superintendents of the Scala, who are carefully depicted doing their good deeds. The composition of the washing of the patient's feet in the center foreground is borrowed directly from the traditional image of Christ washing the feet of his disciples which is seen in scores of Renaissance paintings. Often new secular narratives, such as this one by Domenico di Bartolo, were simply adaptations of traditional religious stories that contained similar action. Moreover, the similarities between the two scenes of washing and the public display of humility the act implies would not have been lost on the leading citizens of Siena who were immortalized in Domenico's fresco.

Everywhere in the *Care of the Sick* Domenico di Bartolo has emphasized the splendor of the costume and the complexities of the decoration. Nowhere else in Siena is there such a profusion of objects and portraits (probably dictated by the

commission). The almost microscopic vision here and in the rest of his Scala frescoes was quite alien to some of the Florentines who most inspired Domenico di Bartolo.

The architectonic formation of Florentine narrative was the spur behind Domenico di Bartolo's minutely drawn *Education and Betrothal of the Foundlings* (Fig. 18). Under the arches of a large, elaborate building with much architectural detail, foundlings are being betrothed (the furnishing of their dowries was an important function of the Scala). Architecture orders the fresco, dividing the betrothal activities from the courtyard outside, where young foundlings are being cared for and educated. Both the architecture and the figures are placed within an accurate spatial construction, in which all the orthogonals meet at a single point on the horizon. Consequently, the space is ordered, measurable, and capable of mathematical expression, qualities seldom seen in Sienese painting of the first half of the Quattrocento. This interest in depicting a measured segment of the world must stem from Masaccio, Masolino, and Filippo Lippi, the pioneer realists of Florentine painting.

Yet, the overall effect of the picture denies its realistic construction. There is so much movement into and out of space by both figures and architecture and so much crisp anecdotal detail—floor tiles, decorated robes, oriental rugs, architectural moldings—that the scene takes on a strange encrusted feeling, far removed from the pared, stern narrative frescoes of Masaccio and his followers. This wealth of detail and interest in anecdote, which we have already seen in the works of Domenico di Bartolo's immediate forerunners Bartolo di Fredi and Paolo di Giovanni Fei, is part of the reemerging Sienese vision, which occurs in this and Domenico's other Scala frescoes.

Many of the nurses and their charges in the *Education and Betrothal of the Foundlings* are borrowed directly from Ambrogio Lorenzetti, an artist whose clarity must have been especially impressive to Domenico di Bartolo. Still, for all his admiration of his Sienese ancestors and his Florentine contemporaries, Domenico's Scala frescoes are unique, a peculiar blend of realism and fantasy, of immediacy and distance. Though they are filled with action and movement, they are strangely reticent and unapproachable.

Domenico di Bartolo had a most unusual and interesting career. He was strongly influenced by Masaccio and became a bold and intelligent student of that innovative Florentine. Domenico's first paintings belong in the forefront of a stylistic current that also carried Filippo Lippi, Domenico Veneziano, and, finally, Piero della Francesca.[8] His work was always strongly tempered by his Sienese precursors and contemporaries, but in its earliest stages at least, it is an anomaly in the art of Siena, where not even the most daring artists adopted so

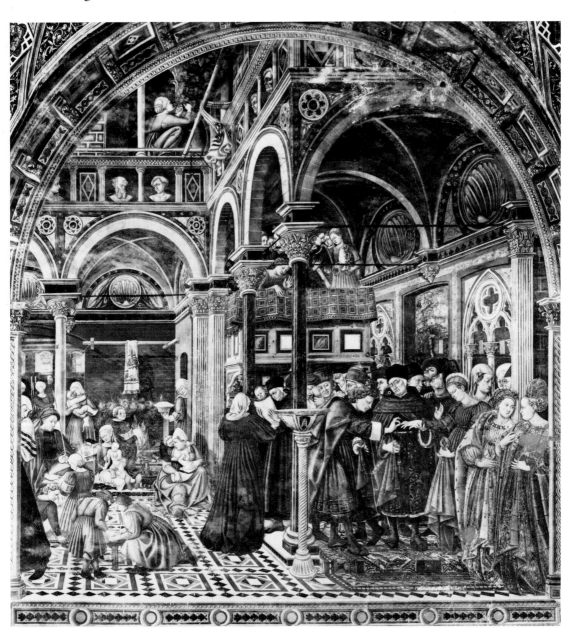

18. Domenico di Bartolo, *Education and Betrothal of the Foundlings*.
Siena, Hospital of Santa Maria della Scala, Pellegrinaio.

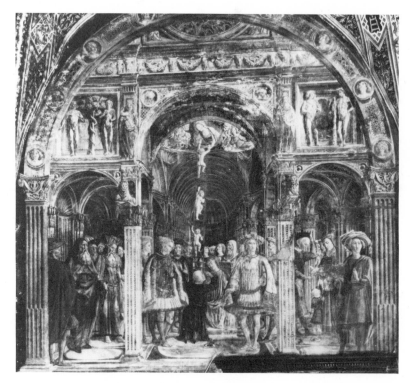

19. Vecchietta, *Vision of the Virgin*. Siena, Hospital of
Santa Maria della Scala, Pellegrinaio.

many Florentine conventions. Yet, by the time of the Scala frescoes these conventions had been integrated in a formal and contextual scheme that was Sienese from its striking color to its unreal spirit.

The power and richness of the Sienese tradition, which were compelling even to those fascinated with Florentine art, are apparent in another fresco in the Scala's Pellegrinaio, the *Vision of the Virgin* (Fig. 19) by Lorenzo di Pietro, called Vecchietta.[9] He was a close contemporary of Domenico di Bartolo, and both men were strongly swayed by their Florentine counterparts.

The *Vision of the Virgin*, painted in 1441, illustrates the vision of the mother of Sorore, the legendary founder of the Scala. The narrative centers on the ascent of the hospital's foundlings to heaven by means of a ladder (*scala* in Italian); as they reach Paradise, the Virgin welcomes them with outstretched arms. Sorore is seen twice: kneeling at the foot of the ladder and again at the right, with his hand to his head.

The attendant crowd—the many extraneous people included in this vision are a disturbing element—is ordered by the three arches of the church in much the same way that architecture is used to order the frescoes by Domenico di Bartolo. Both in its derivation from Brunelleschian principles and in its use as the armature for spatial and narrative organization, the architecture is strongly influenced by Florence. Florentine influence is also readily apparent in the figures in the crowd. Both in costume and in figural style, these elegant people are modeled on Florentine prototypes, probably those by Masolino, Domenico Veneziano, and Uccello—artists who must have impressed the young Vecchietta mightily. The Florentine interest in antiquity must have also spurred him to include the many Roman-inspired architectural ornaments and the two friezes depicting nude figures of Adam and Eve and Cain and Abel, which almost turn the facade of the church into a triumphal arch.

But the feeling that arises from Vecchietta's fresco is far from the calm, rational world of Florentine art of the early Quattrocento. Vecchietta, perhaps affected by Domenico di Bartolo's frescoes, has created a chaotic and disorienting scene. The interior of the church becomes a tunnel, as space rushes back into a nave that seems like something out of *Alice in Wonderland*. Further confusion is caused by the side aisles, whose spatial and architectural relation to the nave is unclear. What at first glance looks like rational Brunelleschian architecture turns out to be a setting for a supernatural occurrence: a vision of heaven. This use of complicated, irrational architecture, filled with nearly obsessive detail, owes much to Donatello, specifically to his bronze relief *Feast of Herod*, on the Baptistery font, a work that was to interest Sienese artists for the entire Quattrocento.

Vecchietta's relationship to Florentine art is fascinating and complex. Vecchietta was born in 1410 in the small town of Castiglione d'Orcia and appears to have received his early training in the shop of Sassetta, an artist also acutely aware of the latest Florentine developments. But unlike his master, Vecchietta may actually have worked in Florence, for his paintings in the remote Lombard town of Castiglione d'Olona seem to have been done in connection with a group of Florentines who were called to work there. In any case, from his earliest works, the Florentine influence permeates his painting.

Perhaps the high point of this influence is to be found in a polyptych now in the Uffizi, a painting of the Madonna and child with SS. Bartholomew, James, Eligius, Andrew, Lawrence and Dominic (Fig. 20). This altarpiece, signed and dated 1457, demonstrates how carefully Vecchietta had studied the work of his Florentine contemporaries Domenico Veneziano, Filippo Lippi, Andrea del Castagno, Fra Angelico, and Donatello. The harmony of the composition, with its serious and silent saints flanking the Madonna and child in a perfect balance,

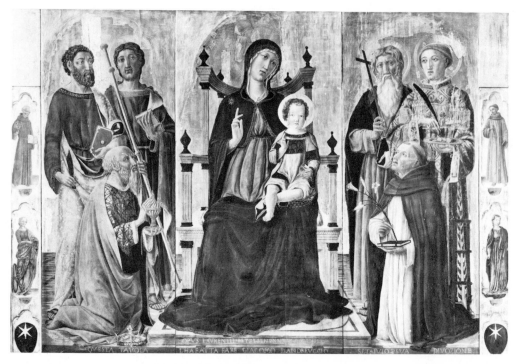

20. Vecchietta, Altarpiece. Florence, Uffizi.

is reminiscent of Fra Angelico, as is the convincing placement of the overlapping figures. A note of asymmetry is added by the Virgin, who seems just slightly off balance on her architectural throne, which itself carves out a large spatial niche. Both the throne and the Madonna, with her ample, rather coarse features recall Masaccio, an artist who must have continually amazed Vecchietta and his fellow Sienese.

But even at the height of his infatuation with the art of Florence, Vecchietta's pictorial language remains unique. Like all talented artists, Vecchietta takes much from others, yet he is able to transform his borrowings into something personal. In the Uffizi polyptych there is something decidedly un-Florentine about the fervent saints, who appear to be made out of crisp, folded metal. In fact, there is an overall brittleness about the painting, both in its form and in the feeling that arises from it, that is Vecchietta's own.

Much the same sort of spirit emanates from a large painting in Pienza (Fig. 21), which postdates the Uffizi polyptych by about five years. This polyptych of the *Madonna and Child Enthroned with SS. John the Baptist, Blaise, Nicholas, and Florian* is complete with an Annunciation lunette and three narrative predellas.

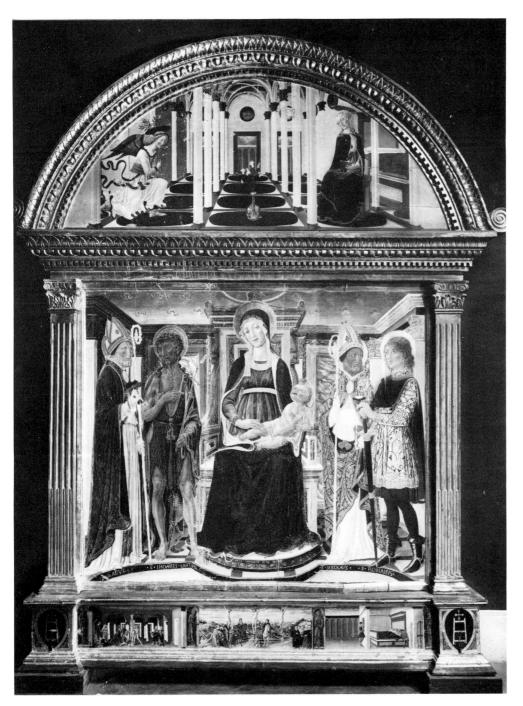

21. Vecchietta, Altarpiece. Pienza, Museo della Cattedrale.

Since it was commissioned for the small church at Spedaletto (in the Val d'Orcia near Pienza), which was consecrated by Pius II in 1462, the painting was probably done about the same time.

In the center portion of the altarpiece Florentine influence is still strong, and echoes of Domenico Veneziano remain. However, here the saints seem slightly more elongated and gaunt, their glances more burning, and their bodies even harder and sharper. The gracious Madonna and her twisting son (an exercise in the latest Florentine techniques of complicated foreshortening) form a stable and elegant focus for the saints' attention.

However, it is the lunette above this group that is the most interesting part of the painting. The holy drama of the Annunciation unfolds in a luminous hall filled with sparkling white columns. It has been suggested that this great room may owe something to the light-filled hall-church that Pius II built at Pienza, for which another painting by Vecchietta was commissioned.[10] But the painter has in no way tried to give a realistic view of this structure; rather, he has chosen to make it part of the story of the Annunciation. The asymmetry of the light—note how the right wall is bathed in light, while the left one is in deep shadow as the light pours through its doors—unbalances the tonality of the painting and creates a disturbance within the carefully constructed room. Also, the swift flight of columns (reminiscent of those in Vecchietta's *Scala del Paradiso*) careens back into space so rapidly that the center of the composition seems strangely empty. Moreover, the striking white cylinders of the columns and the circles of pavement, flattened to ovals by the foreshortening, create strong, colorful forms, that contradict the deep spatial construction of the building. The maroon and black patterns of the pavement seem to hover in space, detached from the floor they are supposed to cover.

Now, as one can see by the construction of the building, Vecchietta knew the rules of one-point perspective well. He had learned them through long study of contemporary Florentine works. But by the 1460s he was more interested in subverting the rules for realistic representation than in carrying them out to the letter. This tendency had been seen before in the *Scala del Paradiso*; it is a thread that runs not only through the painting of Vecchietta, where it becomes more and more prominent, but also through the work of many of the Sienese artists who were acquainted with contemporary Florentine painting.

Vecchietta was not one of the sublime Sienese colorists, although he often uses color in a daring way, the floor patterns of the Pienza *Annunciation* being a case in point. His sense of color and his choice of colors—his blues, pinks, yellows, and reds, for example—are derived from the Sienese tradition. Perhaps because he was also a sculptor, Vecchietta, like Michelangelo after him, often used color more as structure than for its abstract decorative possibilities.

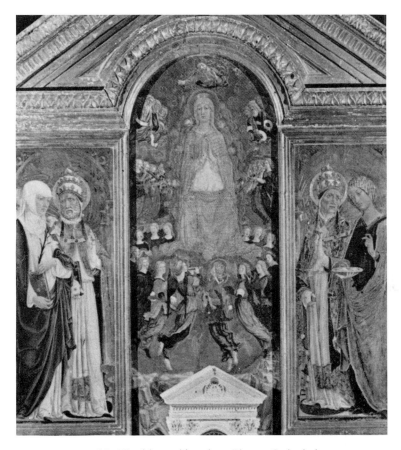

22. Vecchietta, Altarpiece. Pienza, Cathedral.

Vecchietta's hand is seen again in the Pienza Cathedral, in one of the finest paintings of his maturity—the altarpiece of the *Assumption* (Fig. 22). Erected in the 1460s by Pope Pius II, the Cathedral was the jewel of the rebuilding of Pienza. Corsignano, changed by Pius to Pienza in his own honor, was the pope's birthplace, and the Quattrocento structures of this remote Tuscan hill town still testify to his architectural ambition and sophisticated patronage.[11]

The pope—who was a Piccolomini and thus one of Siena's ruling elite—commissioned a series of altarpieces for the Cathedral by the important Sienese artists of the day. The very fact that this humanist pope, who would be expected to favor a Classically inspired style, ordered works from Quattrocento Sienese artists working within the traditions of their native city demonstrates the elasticity of so-called humanistic taste.

The altarpieces were placed in very up-to-date frames of Classical inspiration. In Vecchietta's picture the side figures are framed by simple, elegant moldings; a gilded arch swings above the ascending Virgin; and the whole altarpiece is topped by a heavily carved pediment.

The sumptuous frame is somewhat out of keeping with the wiry figures, which are very like those of Vecchietta's altarpiece in the museum directly across from the Cathedral. The protagonists of the *Assumption*, which was probably painted around 1462, seem even spinier and more nervous than their predecessors. The saints to either side of the *Assumption* still exhibit traces of Vecchietta's indebtedness to Domenico Veneziano and, above all, to Donatello, but they are of a spirit all Vecchietta's own. They are a curious mixture of agitation and isolation, and they communicate none of their secrets to the onlooker. Like so many personages by Vecchietta and by Domenico di Bartolo, they are distant, withdrawn into their holy meditations.

The Pienza *Assumption* is typical of the mature Vecchietta's use of color. White, blue, green, and much gold (this picture must have been very expensive) predominate in the wings, but the palette is sober in comparison with those of many of Vecchietta's Sienese contemporaries. In the *Assumption* panel itself there are brighter notes of red, violet, and blue, but the overall palette of the altarpiece, while skillful and pleasing, is not exciting. Here again, color is not an independent decorative force—except perhaps in the group of angels supporting the Virgin—but an aid to the construction of the figures, who appear almost to be made of thin sheets of creased tin.

For this *Assumption* Vecchietta has recalled a number of renditions of the theme from the past, including some resembling Andrea di Bartolo's (Fig. 13). Although he has drawn inspiration from these earlier works, Vecchietta has modified them substantially; for instance, he has added a deep landscape with trees and mountains stretching to a far horizon. Moreover, the angels dancing on air, as they carry the Virgin to heaven, are more volumetric and palpable, and demonstrative of Vecchietta's exposure to Florentine painting.

Around the frontal torso and head of the passive Virgin hover ranks of angels and saints, their bodies carving out a sort of divine niche for her. Some of these figures, especially the old men with white beards and the fluttering, swaying angels, would be copied by Vecchietta's heirs, most notably by Francesco di Giorgio, whose work will be discussed in chapter 4.

However, it is not Vecchietta's indebtedness or his influence that strike the onlooker, but rather the wonder and mystery of the *Assumption*. One feels little of the attempt at a rational, stable space that pervades the Uffizi polyptych (Fig. 20), the center of the Pienza *Madonna and Child with Saints* (Fig. 21), or even

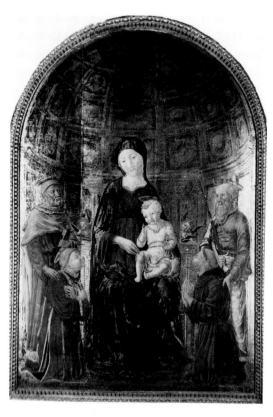

23. Vecchietta, Altarpiece.
Siena, Pinacoteca.

the side wings of the Pienza *Assumption* itself. Rather, Vecchietta has set the miracle of the Assumption in an equally miraculous atmosphere and landscape. Shimmering with gold, the heavenly host ascends from an arid, twisting landscape, where the doubting Thomas, dazzled with wonderment, stares heavenward. Gold, color, and form unite to create an image in the great tradition forged by the first Sienese painters a century and a half before. Free of the more empirical, more mundane spatial and formal concerns that so fascinated and frustrated him, Vecchietta has given full range to his fertile Sienese imagination and created what is perhaps his masterpiece.

In the 1470s Vecchietta began to plan his own burial place in the church of the Scala, to be decorated with painting and sculpture by his own hand. The altarpiece (Fig. 23) he designed and executed for this location still survives in the Siena Pinacoteca. In many ways it is a reassertion of his fascination with Florentine art. Set in a large apse (which reminds one of Piero della Francesca's Brera altarpiece commissioned for Urbino [12]) are the Virgin and child, two angels,

and SS. Peter, Paul, Lawrence, and Francis. The scale of the dome is monumental, and its coffered expanse anticipates some of the vast structures to be seen in the works of Fra Bartolomeo and Andrea del Sarto several decades later.[13]

It is interesting that the architecture is rendered not in paint but in the much less illusionistic medium of gold, a shimmering material that conflicts with the fictive spatial properties of the dome. Because of these unreal and flattening tendencies, gold remained the background for hundreds of Sienese paintings well into the Quattrocento. In Florence, conversely, the use of gold began to decline during the first years of the fifteenth century because the metal interfered with the increasing realism of figures, architecture, and landscape. The differing ideas on the use of gold held by artists from the two cities epitomize their varying views on the nature of painting.

In the center of Vecchietta's altarpiece sits the large, monumental Virgin holding the blessing child. In facial features, drapery style, and general bearing, these two figures—products of Vecchietta's most mature and pensive period— are closely related to the Pienza *Madonna and Child with Saints* and *Assumption*. The scale and seriousness of these figures mesh with the surrounding space and the Roman-inspired dome.

The same cannot be said of the attendant figures. The two angels peeking from behind the throne—perhaps inspired by similar characters in Masaccio's Pisa altarpiece[14]—are smaller in scale, but not disturbing. However, the four saints are not only out of scale but of a different body type from the Madonna and child. Spindly (note their puny hands), fussy in their detail, lacking the emotional charge of many of the artist's earlier figures, and timid in both glance and gesture, they seem curiously out of step with the large, dignified Madonna and noble apse.

Can this difference be explained by Vecchietta's waning powers? Possibly; but it is also plausible that the artist died before the work was completed (he seems to have been working on it in 1479, the year before his death). The attendants could have been painted and planned by members of his shop or by an outside artist called in to finish the job. To my mind that is the only way to account for such major differences between the architecture, the Madonna and child, and the saints. Nonetheless, the conception of the work is wonderful and certainly belongs to the mind of Vecchietta. It also reveals, once more, the pull of Florentine art on his remarkable imagination.

However, the true genius of Vecchietta resides not in his painting but in his sculpture. To trace the development of his work in stone, bronze, and wood goes beyond the limits of this book, yet no account of this sophisticated and complex artist would be complete without some discussion of his sculpture.

Vecchietta's most famous sculpture, like the large painting of the Assump-

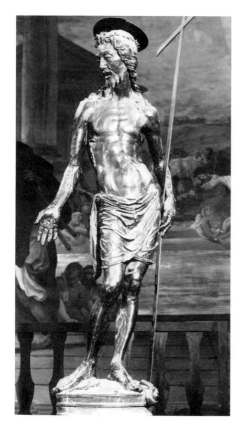

24. Vecchietta, *Resurrected Christ*. Siena, Santa Maria della Scala.

tion, was intended for his own tomb. Now in the Church of the Scala, this nearly life-sized bronze figure of the Resurrected Christ (Fig. 24) is one of the most striking and haunting images of Quattrocento Siena.[15] Instead of the triumphal reborn Christ almost always associated with the Resurrection, we see here a gaunt, enervated being. At once sensuous and repelling, this mannered figure with open mouth and bulging veins is indebted to the bronze sculpture of Donatello, who was working in Siena in the 1450s. Vecchietta carefully studied the bronze St. John that Donatello probably made for the Siena Cathedral and the two bronze pulpits for San Lorenzo in Florence. Their nervous energy, their intensely personal approach, and the revolutionary handling of the bronze must have fascinated and deeply impressed Vecchietta. Yet, this type of figure appears earlier in Vecchietta's own painting—in the two altarpieces in Pienza, for example—so Donatello's work in bronze must have appealed to something already formed in Vecchietta's fertile mind.

In any case, Vecchietta's *Christ* and Donatello's late works share a raw nerv-

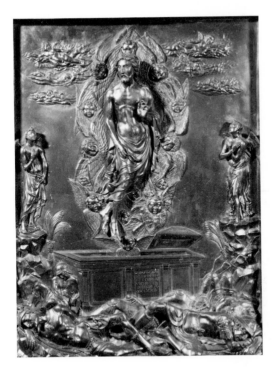

25. Vecchietta, *Resurrection of Christ*. New York, Frick Collection.

ousness and a pessimism that remove them from all other contemporary sculpture. The *Christ*, which was to be part of the tomb complex Vecchietta designed for himself, is full of pain, enigmatic, nervous, and devoid of hope. Much like the *Resurrected Christ* of Donatello's San Lorenzo pulpits, Vecchietta's depiction of the central figure of Christianity seems hardly capable of life, let alone the salvation of mankind.

A bronze *Resurrection of Christ* (Fig. 25) in the Frick Collection, probably also from Vecchietta's tomb complex, is also strongly influenced by Donatello. The jumble of soldiers, the faceting of the rock formations, and the bold, abstracted handling of the bronze reveal study of the San Lorenzo pulpits or some other late work by Donatello. But the gracious, levitating Christ and the suave attendant angels show a feeling for formal polished elegance (evident also in the Pienza *Assumption*) that was shunned by the much more direct and expressive Donatello. The large areas of smooth, polished bronze that back the figure have almost the same function as the gold backgrounds in Vecchietta's paintings. There is a disconcerting relationship between the volume of the foreground figures, which are worked in high relief, and the flat bronze areas, on which the

mandorla of cherubim surrounding Christ and the clouds of angels around his head have been applied. One is reminded of some of the spatial characteristics of Donatello's pulpits of the 1460s and of Ghiberti's second doors for the Baptistery of Florence, completed around 1450.[16]

In both his painting and his sculpture, Vecchietta, like Domenico di Bartolo, absorbed many of the latest Florentine developments. From his early Scala frescoes to the late altarpiece for his tomb, his principles of compositional organization were strongly indebted to his study of Florentine art. Taking much from Donatello, both he and Domenico di Bartolo used one-point perspective and convincing volumetric figural construction to make their images and narratives increasingly less realistic and earthbound. This pattern of borrowing and adaption is both common and traditional in Sienese art: it begins before Duccio and is found even in the last paintings of the school, but nowhere is the connection between Siena and Florence as strong and obvious as in the work of Domenico di Bartolo and Vecchietta, the two artists who heard the siren song of Florence more often and with greater intensity than did the other Sienese artists.

But, their later works clearly demonstrate that both artists remained strong adherents to the Sienese tradition. Their striking mixture of fantasy and fervor was shared by a small group of their contemporaries who were remarkable visionaries.

T H R E E

THE VISIONARIES

AND THEIR FOLLOWERS

T WO ARTISTS, Sassetta and Giovanni di Paolo, were to origi-
nate, develop, and carry into the unfolding Quattrocento
styles of remarkable power and vision. Their art contains a particularly Sienese
mixture of innovation and deep respect for and utilization of the past. They
transported their painting to a preternatural realm, where spectral saints wander
through golden mountains whose peaks touch radiant skies. The two men ex-
erted a limited but powerful sway on a number of other noteworthy painters,
but the latters' talents and powers of invention, while considerable, were not
equal to their teachers'.

Sassetta's altarpiece, painted between 1423 and 1426 for the wool guild of
Siena (the Arte della Lana), had a tremendous impact on Sienese painting for
the rest of the century. It was placed in the guild's chapel and dedicated to the
guild's feast day, Corpus Domini. Like Duccio's *Maestà* of a century before,
Sassetta's altarpiece expanded the possibilities of the city's style and served as a
milepost in its art.

Only the bare facts are known of Sassetta's life.[1] His real name was Stefano
di Giovanni. His father seems to have moved from Cortona to Siena, and the
artist himself was probably born in Siena around 1390. How he came to be
called Sassetta is unclear, but the suggestion that the name might refer to the

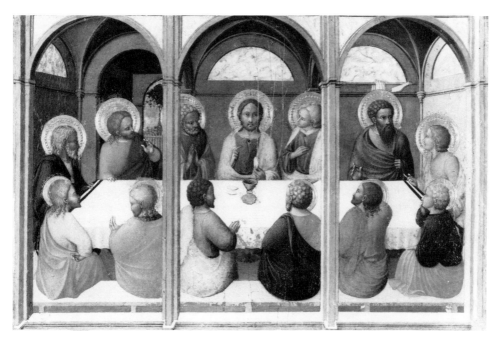

26. Sassetta, *Institution of the Eucharist*. Siena, Pinacoteca.

place of his birth, a town called Sassetta in the Maremma (an area southwest of Siena), is certainly wrong. Moreover, the sobriquet may not have appeared until the eighteenth century. Nevertheless, from the Arte della Lana altarpiece until about the middle of the century, several large and important works allow us to trace the outlines of Sassetta's career.

Originally, the Arte della Lana altarpiece consisted of a center *Exaltation of the Host* (Corpus Domini), picturing the Host worshipped by flying angels in a landscape. This painting was flanked by four panels of saints. Above the major panels were the *Coronation of the Virgin* and the angel and Virgin of the Annunciation. The predella below was in three parts, with scenes from the lives of SS. Thomas Aquinas and Anthony and the miracles of the Sacrament on either side of a *Last Supper*. By the early nineteenth century the chapel had been demolished, and Sassetta's large altarpiece had been dismantled, dispersed, and, in great part, lost. The remaining fragments testify to Sassetta's youthful brilliance.

Some of the most evocative parts are the predella panels now in the Siena Pinacoteca. The *Institution of the Eucharist* (Fig. 26) was the central one and was originally directly below the *Exaltation of the Host*. In the *Institution of the Eucharist* Christ is the pivotal figure, for he alone faces the worshipper as he holds the

eucharist wafer, the symbol of his mystical body. All the compositional elements work to reinforce this centrality: Christ is in the center of the picture, at the center of the three enframing arches, and the object of most of the apostles' gazes. Even his pink cloak stands out from the duller clothes of the others. Sassetta probably made this composition formal and static in order to repeat and reinforce the hierarchical scene of the *Exaltation of the Host* above.

Although the scene is heavily indebted to the *Last Supper* from Duccio's seminal *Maestà*, Sassetta has given the narrative a new coherence, rationality, and clarity. The placement of the figures, the construction of the architecture, and the clear, convincing relation between all parts of the picture reveal a mind wrestling with the problems of presenting a narrative realistically, yet the result is far from mundane.

Like his near contemporary, Domenico di Bartolo, Sassetta had fallen under the spell of the Florentines, especially Masolino and Masaccio. He was among the first to appreciate and understand the latter's austere and rigorous art. When the Arte della Lana altarpiece was begun, around 1423, Masaccio was only 22 and just beginning his short but eventful career; thus Sassetta was one of the earliest to be influenced by this new current in Florentine painting. This openness to Masaccio's style should not surprise us, for Sienese painters of every generation have been sensitive to the latest developments in art outside their own city walls. Duccio himself, the founder of the Sienese school, looked at the paintings of the revolutionary Giotto and incorporated various aspects of them into his own work. But, with the exception of Domenico di Bartolo in the early part of his career, no Sienese painter let an outside idiom overwhelm his style.

The delicacy, gemlike colors, and anecdotal detail of the *Institution of the Eucharist* all proclaim it as Sienese. Sassetta's unalloyed Sienese heritage is even more obvious in another predella panel from the Arte della Lana altarpiece, the *St. Anthony Beaten by Devils* (Fig. 27). Its panoramic landscape gives Sassetta's poetic vision full rein. What strikes one first about this picture is not the narrative action but the mood: The blue sky is streaked by low clouds lit by horizontal rays of the setting sun; the distant mountains with their stands of trees are silhouetted against the sky; and, closer to the onlooker, the chalk hills and valleys are bathed in the slanting, luminous, but diffused light of late afternoon, making the branches on the trees burn with golden light. Evocative, welcoming, yet spectral, Sassetta's remarkable world continues a tradition of Sienese landscape painting that stretches from Ambrogio Lorenzetti to the early sixteenth century.

Siena is situated high above a beckoning and lovely countryside; glimpses of the surrounding land can be seen from hundreds of windows and from the streets and piazzas below. It is no wonder that the city's artists were captivated by

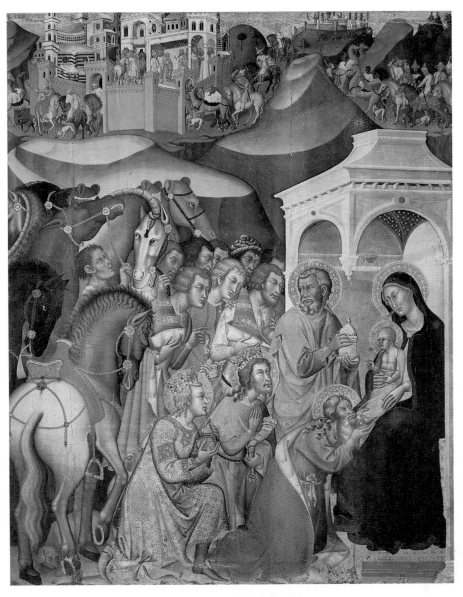

Bartolo di Fredi, *Adoration of the Magi*. Siena, Pinacoteca.

Color plates courtesy SCALA/Art Resource, NY.

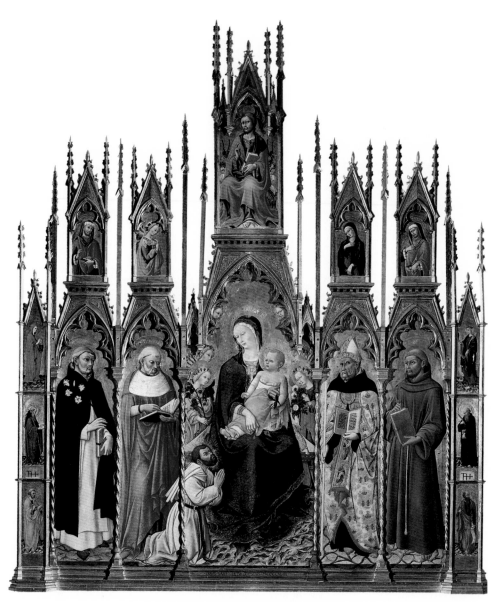

Sano di Pietro, Altarpiece. Siena, Pinacoteca.

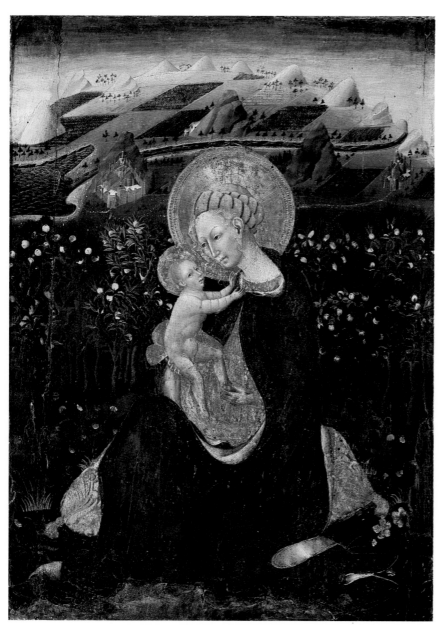

Giovanni di Paolo, *Madonna of Humility*. Siena, Pinacoteca.

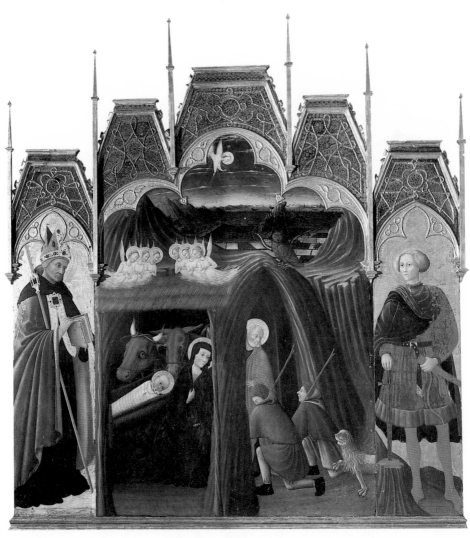

Pietro di Giovanni d'Ambrogio, *Adoration of the Shepherds*.
Asciano, Museo di Arte Sacra.

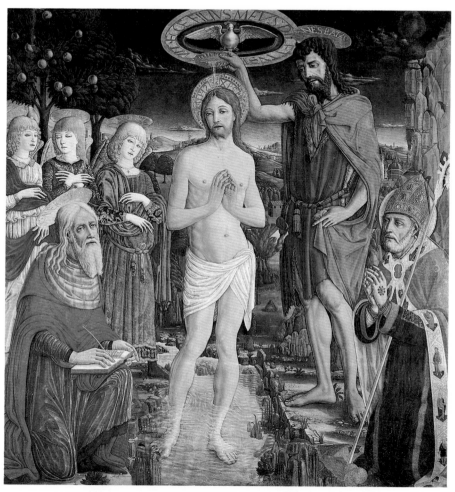

Guidoccio Cozzarelli, *Baptism of Christ with SS. Jerome and Augustine*.
Sinalunga, San Bernardino.

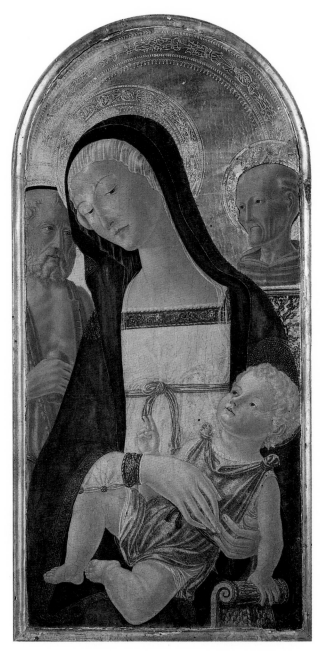

Neroccio de'Landi, *Madonna and Child with Saints*.
Siena, Pinacoteca.

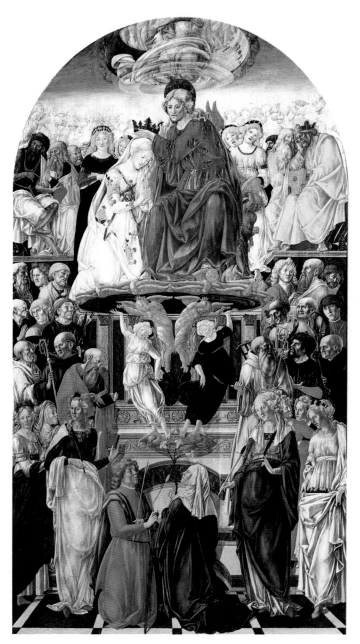

Francesco di Giorgio, *Coronation of the Virgin*. Siena, Pinacoteca.

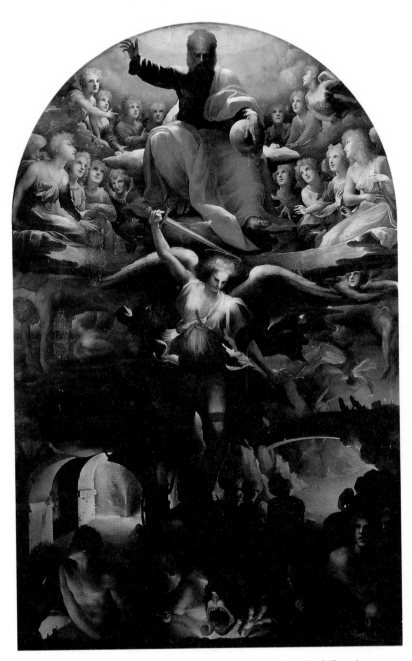

Beccafumi, *Fall of the Rebel Angels*. Siena, San Niccolò al Carmine.

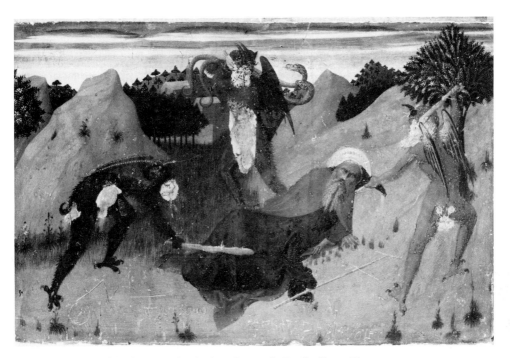

27. Sassetta, *St. Anthony Beaten by Devils*. Siena, Pinacoteca.

landscape. Sassetta's landscape, however, is not a simple repetition of what he saw; rather it is infused with supernatural power manifested by the light, by the land, and by the strange balletic scene of demonic violence. In the center of this enchanted world St. Anthony writhes, enduring the torment of the hideous devils: pulled, beaten, and lashed, the pathetic, wild-eyed saint stares out helplessly.

About six years after completing the Arte della Lana altarpiece, Sassetta began the next of his major extant works, the *Madonna of the Snows* (Fig. 28), dedicated to St. Mary of the Snows (Santa Maria delle Nevi). The predella of this altarpiece tells the story of the miraculous summer snowfall that delineated the foundation of the church of Santa Maria Maggiore in Rome. The Sienese had a special veneration for this event, and several altarpieces dedicated to Mary as the Virgin of the Snows were made for Sienese churches.[2]

Sassetta's altarpiece was intended for the altar of St. Mary of the Snows in the Siena Duomo and was, therefore, a commission of extraordinary prestige. The painting has large areas of gold and lapis and was probably one of the most expensive altarpieces painted in Siena during the entire fifteenth century. Although it has come down to us in a battered and abraded condition, with much paint missing, the altarpiece is still magnificent. Both its commissioner and its

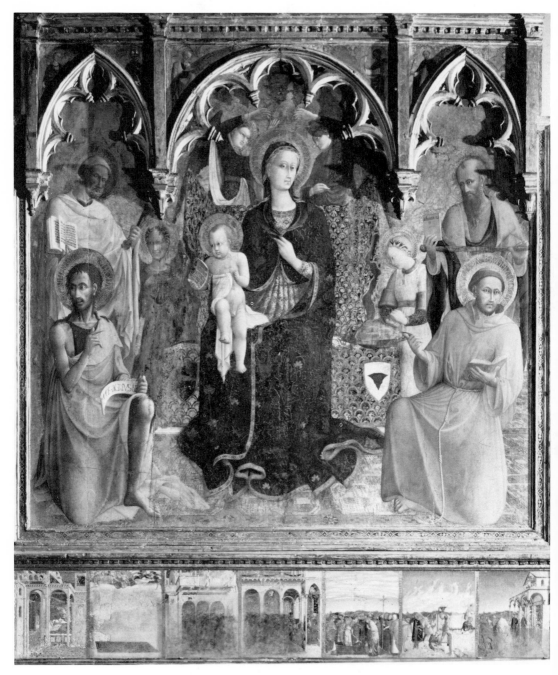

28. Sassetta, *Madonna of the Snows*. Florence, Palazzo Pitti, Contini Bonacossi Collection.

artist were aware that it would be in close proximity to Duccio's *Maestà* (Fig. 1), Simone Martini's *Annunciation* (Fig. 2), and several other altarpieces by renowned artists of Siena's glorious past.

Sassetta proved himself worthy of the challenge. His altarpiece not only continues the tradition established by Duccio but does so in a very innovative manner. It contains many new ideas about composition and space. The symmetry and balance are unprecedented in Sienese painting except for the work of the Lorenzettis. The large Madonna is the center of a balanced grouping of saints and angels, all set into space in a coherent, rational way. The harmony of the work, its architectonic quality, and the skillful foreshortening of the figures—note especially the angels holding the crown above the Madonna's head—reveal the influence, but not the domination, of Masaccio. Throughout the altarpiece Sassetta makes the language of Masaccio and his first followers, among whom he must be included, his own.

Sassetta has put the monumental, serious inventions of Masaccio, which inspired the angels and the massive child, into a pictorial context unlike anything by a Florentine painter. In a realm where grace and fantasy rule, the colors—pinks, yellows, reds, and blues—are vivacious; and there is a wealth of pattern and an abundance of gold. Even the figures, such as SS. John and Francis, are skillfully and volumetrically constructed and appear to float in this richly patterned world. The seriousness of Masaccio has been replaced by a lighter, more delicate spirit evident in many of the details, for example, the dainty angel kneading a snowball at the right of the throne.

Everywhere Sassetta's heritage reasserts itself: The wistful Madonna and the melancholy saints recall Simone's figures of a century before; patterns of design and color demonstrate knowledge of works such as Bartolo di Fredi's *Adoration of the Magi* (Fig. 6), finished several decades earlier; and the sumptuousness of the ensemble—frame, gold, color, and design—accord with the time-honored traditions of Sienese painting.

It is only in the predella that one sees a major break with the past, possibly because Sassetta felt freer to experiment in this less-conspicuous part of the altarpiece. The events of the miraculous founding of Santa Maria Maggiore are narrated in seven small panels, some of them badly damaged. Filled with figures, action, and architecture, they form a lively foil to the splendid panel above. But they are also remarkable for their overall composition, for they all seem to be part of a long, continuous narrative, especially the three rightmost paintings, which share a common mountainous horizon. Although the idea of a unified predella is first seen in the work of Pietro Lorenzetti,[3] to whom Sassetta's small paintings are heavily indebted, never before had the little panels been so effectively unified.

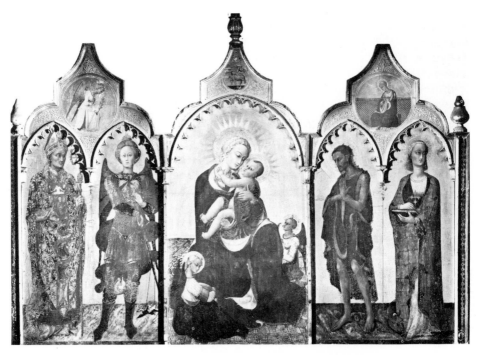

29. Sassetta, Altarpiece. Cortona, Museo Diocesano.

Nowhere are the up-to-date inventions of Sassetta's fertile mind and his love for the Sienese past better meshed than in a polyptych (Fig. 29) in the lovely hill town of Cortona, the artist's ancestral city. In the center are a Madonna, child, and angels; and pictured in side panels are SS. Nicholas, Michael, John the Baptist, and Margaret. Unfortunately, the painting lost much of its enlivening surface detail because of improper storage during the Second World War. Traditional types and forms are especially evident in the central panel, where the Madonna sits. Her body is nearly frontal, but moves into space on a subtle diagonal axis extending from her curved back to the foremost folds of her robe in the lower right corner. This axis is intersected by another formed by the foreshortened bodies of the two angels. Thus the figures move back and forth in space with the direction and rhythm of an X. Such strong movement is not traditionally found in the central panel of a polyptych, and its invention must be credited to Sassetta, who uses traditional motifs and forms to create new compositions and contents.

The influence of Simone Martini is felt in the swinging beauty of the Virgin's posture, in her looped robes, and in the delicate, comely faces. But it is the ethereal grace combined with tinges of melancholy that particularly recalls the

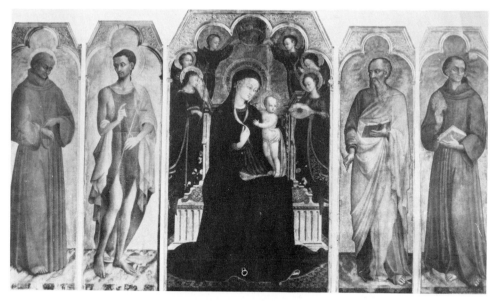

30. Sassetta, Reconstruction of front of Sansepolcro altarpiece: *Madonna and Child with Angels, St. John the Evangelist,* and *St. Anthony of Padua,* Paris, Louvre; *The Blessèd Ranieri* and *St. John the Baptist,* Florence, Berenson Collection.

older artist. Extraordinary refinement of color, line, and form only heightens the sadness of these elegantly shaped but wistful figures.

The crown of Sassetta's imagination is the large double-faced altarpiece for the high altar of San Francesco in the small, provincial town of Sansepolcro. The work is unusually well documented. It was contracted for in 1437 and set in place in 1444. Unfortunately, the altarpiece was dismembered and the pieces are now scattered.[4]

On its front, the Blessed Ranieri, John the Baptist, John the Evangelist, and St. Anthony of Padua flanked the enthroned Madonna, child, and angels (Fig. 30). The back of the polyptych was composed of a central image of St. Francis in Glory surrounded by scenes from his life and legend (Fig. 31). Ancillary panels further decorated the sides and top of the painting. Like the *Madonna of the Snows,* the Sansepolcro altarpiece was a large, elaborate, and important commission, indicative of the fame Sassetta had achieved outside of Siena by the late 1430s.

Florentine influence is still apparent in the Madonna and child panel, especially in the wonderfully foreshortened faces of the music-making angels; but there is less concern with the rational construction of either figure or space. Pat-

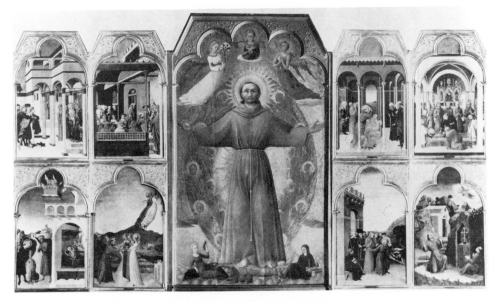

31. Sassetta, Reconstruction of back of Sansepolcro altarpiece: *Ecstasy of
St. Francis*, Florence, Berenson Collection; *Mystic Marriage of St. Francis
with Poverty*, Chantilly, Musée Condé; seven other scenes from the legend of
St. Francis, London, National Gallery.

tern, line, color, and detail are as important as the spatial arrangement of the
figures. The same tendency is seen in the flanking saints, whose willowy, weight-
less bodies make swaying patterns against the gold ground. The overall minute-
ness and fineness of this work, its taunt line, and its comely form all signal
Sassetta's concern for the glories of Duccio, Simone Martini, and his vital Si-
enese heritage. Sassetta has not forgotten the lessons of Florence, but they now
seem less important as his attention turns more to rendering celestial figures in
an aura of sanctity and grace. Sassetta, like many Sienese artists, increasingly
moved from the measurable to the unfathomable and supernatural.

Nowhere is this aspect clearer than in the surpassing *St. Francis in Ecstasy*
(Fig. 32), in which the transported saint hovers in a mist of reddish gold sera-
phim.[5] Blessed by three virtues and standing on three vices, he is suspended over
a rippling green sea stretching back to a dark horizon of hills and inlets. This
blaze of transcendental color and form is a glorious vision of religious ecstasy.
Bellini's *St. Francis* and Bernini's *Vision of St. Teresa* are two of the rare images that
inhabit the same world of inspired imagination. So radiant is this central panel
that the onlooker feels part of some ethereal, shimmering realm. As an aid to
devotion and meditation, part of its original function, the incandescent *St. Francis*

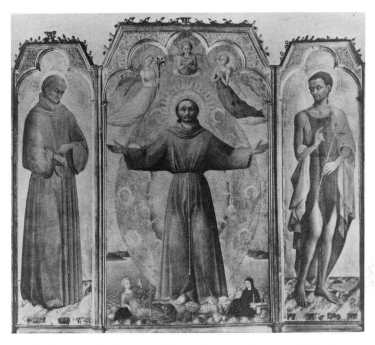

32. Sassetta, *St. Francis in Ecstasy*. Florence, Berenson Collection.

in Ecstasy is nearly unmatched in the entire history of art. At once iconic and realistic, remote yet near, the saint touches us profoundly. This primordial and vibrant talisman is one of the miracles of the Sansepolcro altarpiece and of Sassetta's art.

Several of the small scenes narrating the Franciscan legend are also master-pieces. The most famous, and deservedly so, is the *Mystic Marriage of St. Francis with Poverty* (Fig. 33).[6] Sassetta's considerable power of imagination is released in this vision; he has searched for and found wonderful equivalents for the tender, mystical nature of his subject. The sharply foreshortened, deserted landscape and the looming range of dark grey mountains—with an occasional distant peak still catching the sun—dotted with tiny cities create a still, expectant setting for the miraculous action occurring in the foreground. The three apparitions, each acting not only as the personification of a virtue but also as an abstract field of color filling the center foreground, are as comely, ethereal, and reticent as their virtuous natures.

In an unforgettable gesture of timidity and humbleness, Francis reaches for-ward to slip the ring on the hand of Poverty. Above, the virtues ascend toward heaven, but not before Poverty looks back to gaze tenderly on her new bride-

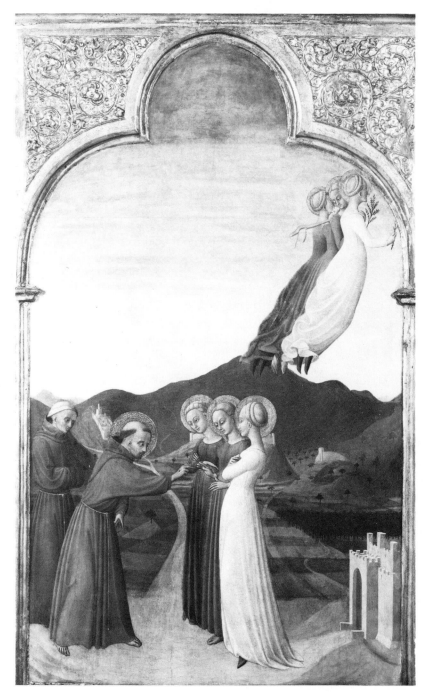

33. Sassetta, *Mystic Marriage of St. Francis with Poverty*.
Chantilly, Musée Condé.

groom once more. This touching and important look is utterly in keeping with Sassetta's human and sensitive portrayal of this scene, a portrayal completely free of deadening dogma and exactly in tune with the buoyant spirit of Francis himself.

Sassetta has found visual analogues not only for the spirit of the marriage of St. Francis to Poverty but for Franciscanism in general: the fertile plains with their rich patchwork fields, the forests, the tiny hill towns softly bathed in the light of the sinking sun, and the luminous sky, which turns from white behind the hills to blue above. The soft, unreal light itself infuses every part of the picture with holiness, quietude, and peace.

The strange juxtapositions of scale between figures and architecture or between figures and landscape cannot be seen as mere mistakes on Sassetta's part. Rather these rapid shifts in scale emphasize the unreality of what is occurring; like almost everything else here, and like the great *St. Francis in Ecstasy*, they transport us to another, purer world.

This world is glimpsed again in the *Stigmatization of St. Francis* (Fig. 34) from the Sansepolcro altarpiece. Here the craggy prismatic rocks, the small chapel, and the tops of the trees are illuminated by the same divine light seen in the *Mystic Marriage of St. Francis to Poverty*. Warm and flickering, it seems to come from the vision of the crucified Christ above. This holy light, which is Sassetta's metaphor for the spirit of Francis and his beliefs, is the same illumination we have seen in other panels from the same altarpiece. Comforting and pantheistic, it is one of Sassetta's finest inventions.

The solemnity of the *Stigmatization*—the crown of the saint's life and the proof of his holiness—is reinforced by Sassetta's judicial use of warm, sober, earth colors. The predominant browns, greys, golds, and greens help form a crystalline land; figures, architecture, and earth are set against a bright blue sky lightly streaked with wispy clouds. Throughout the picture one sees, feels, and almost breathes a subtle film of light and color. The atmosphere of this picture and of the other outdoor scenes on the Sansepolcro altarpiece seems to have deeply impressed the young Piero della Francesca, a native of the city. Sassetta's use of color, its chording, and his fascination with tone and light must have been endlessly compelling to Piero, whose main interests lay along the same lines.[7]

Centuries later it is hard for us to imagine what the now-scattered altarpiece from Sansepolcro looked like when it was whole and fresh on the main altar of San Francesco. Yet, from the dispersed, damaged pieces there still arises such powerful vision and imagination that there is no doubt that this work was a masterpiece. The ecstatic visions of passionate, swaying figures engaged in actions of great purpose and dignity, all enveloped in wondrous light, must have moved the

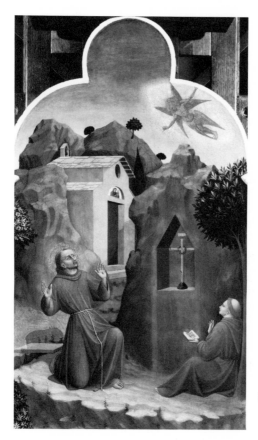

34. Sassetta, *Stigmatization of St. Francis*. London, National Gallery.

worshippers as they faced the powerful altarpiece. Like so much of Sassetta's work, the Sansepolcro altarpiece is otherworldly yet full of earthy beauties, mystical yet approachable.

Another fascinating aspect of Sassetta's painting is the strong imprint of his personality on the interpretation and realization of image and story. That is something impossible to imitate, and in this sense Sassetta is unique in Sienese art. Nevertheless, several artists of considerable talent did paint within the orbit of his remarkable style. Even though their works were not crafted with his consummate skill, they are exciting examples of the fantastic vision Sassetta's art inspired.

The artist who perhaps understood Sassetta's aims best was responsible for a series of small panels of the life of St. Anthony. The eight scenes, now scattered, probably surrounded a large standing or seated image of the saint, most likely frontal and iconic. The scenes from his legend must have offered protec-

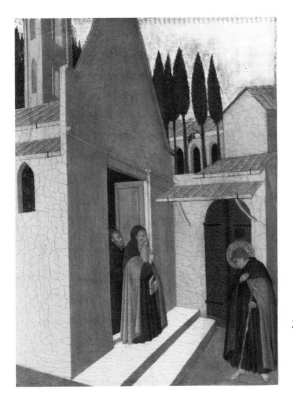

35. Sassetta follower, *St. Anthony Leaving the Monastery and Wandering in the Desert*. Washington, National Gallery.

tion against St. Anthony's Fire, a dreaded, painful, and sometimes fatal bacterial disease named after him.

Each of the eight panels chronicles a particular moment of the saint's life: a turning point, a miracle, or some other important event. His decision to leave the monastery and wander in the desert is the subject of one of the loveliest of the series (Fig. 35). This painting is notable for the depiction of architecture: The smooth, unbroken green planes of the facade and flank of the church and the reddish orange tile roofs create an animated series of diagonals, verticals, and horizontals and form an exciting abstract grid. The sensitivity to subtle composition, seen in the interweaving of the church, steps, roofs, doorways, and looming campanile, is something the artist certainly learned from Sassetta. Yet in all eight pictures there is something unsettling; the spectator feels a little off balance, as though the scene were slowly shifting. That quality is not characteristic of Sassetta, even in his most visionary moments. The basic method of pictorial construction—the creation of space, the placement of architecture and other objects, and the relation between those objects—in the St. Anthony scenes differs from Sassetta's.

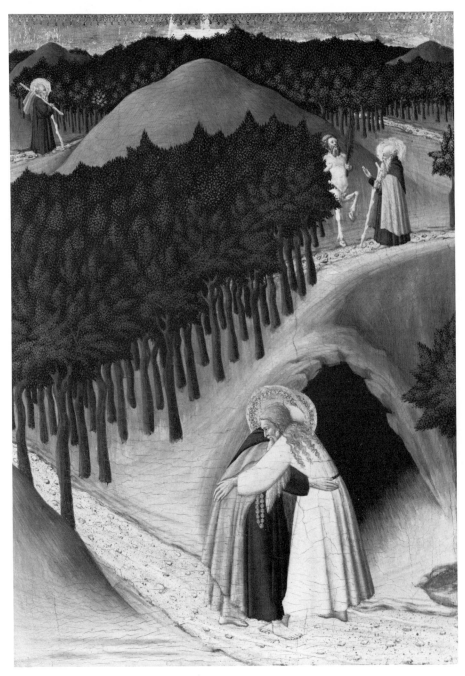

36. Sassetta follower, *Meeting of SS. Anthony and Paul.*
New Haven, Yale University Art Gallery.

The *St. Anthony Leaving the Monastery* has a cool beauty of subdued but balanced color, harmonious interlocking composition, and intense figural gesture. These characteristics are present in other St. Anthony scenes, but are especially evident in the charming *Meeting of SS. Anthony and Paul* (Fig. 36). Here space recedes both into the picture and up its surface, as the artist utilizes both the older convention of placing the things that are farthest back at the top of the picture and the newer concept of making things recede toward the background. Again, the combination creates a curious but not unpleasing feeling of shifting and imbalance, which, in this case, happily sets the stage for a miraculous story.

Anthony's journey to meet the ancient hermit St. Paul is told graphically by both the multiple figures of the voyager, dressed in pink and black, and the twisting path that runs from upper left to lower right. Like everything else in this picture, the path is a mixture of the real and the symbolic, the literal and the figurative.

The native Sienese love of landscape surfaces also in this picture. The landscape is derived ultimately from the Lorenzetti, but passed through Sassetta's world (although it lacks his mysterious light). Of course, it is not a portrait of a place but the topography of fantasy, a setting in which centaurs prance and hermit saints embrace.

In this painting and in all the others from the St. Anthony series, the artist shows a great sensitivity to color and originality in its use. He works in the tradition of a long line of Sienese colorists, from Duccio through Sassetta, but it is to the latter that he is most immediately indebted. The contrasts between the green and brown of the trees and the grey pink undulating earth are subtle, lyrical, and captivating. The fields formed by the pinks, blacks, and creams of the saint's robes in the foreground, like the smooth green and white plains of the *St. Anthony Leaving the Monastery*, are exciting abstractions of both color and form.

Yet, these pictures are much more than the sum of their compositional devices, for they have a strange, bewitching atmosphere. Perhaps the most entrancing of the entire series is the *St. Anthony and the Porringer* (Fig. 37). Originally, near the center foreground, stood a porringer, possibly painted in silver. This object, now completely removed, was really a devil who had transformed himself to tempt the saint; but upon seeing the porringer Anthony raised his hands and the object disappeared in a puff of smoke.

Set in a desolate wind-swept land of folded hills and arid soil, the saint appears alone, isolated, the only living thing except for a few animals and birds. The thorny, gnarled trees themselves seem as devoid of life as the very stones. A shifting pattern of color—the green foreground; the pinkish grey plane on which the smooth, pink church stands; and the distant, dark grey mountains lapped by a green sea—transforms the scene into a surpassing quilt. Arching

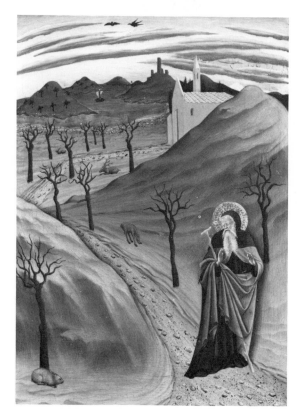

37. Sassetta follower, *St. Anthony and the Porringer*. New York, Metropolitan Museum of Art, Lehman Collection.

above the earth and dominating it, is a dazzling sky. From the smoldering pink horizon, it grows progressively lighter and more luminescent until it is streaked by swift clouds of grey blue and purple, reflecting the rays of the rising sun. From just these several inches of paint one senses the vast curvature of the earth and the limitless sky. Full of movement and drama, the glowing sky is the ethereal counterpart of the barren, devil-inhabited wilderness, with its ominous black trees, its unyielding hills, and its lonely human occupant: the gaunt, ascetic desert saint wrestling with demonic forces.

The attribution of the panels of the legend of St. Anthony has been the subject of much controversy. Various experts have given them to Sassetta, to Sano di Pietro, and to an artist called the Master of the Osservanza,[8] after his triptych of 1436 in the Church of the Osservanza just outside Siena. This large work is close in style to the St. Anthony panels. It ultimately derives from

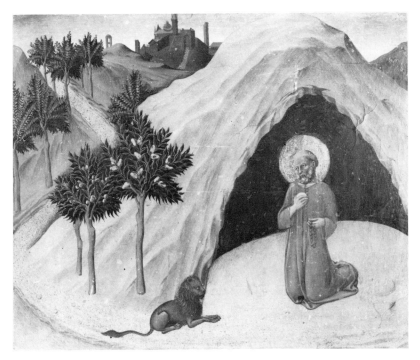

38. Osservanza Master, *St. Jerome in the Desert*. Siena, Pinacoteca.

Sassetta, for the delicate Madonna, the hefty child, and the two stern saints are variants on his style. The wide, subdued range of clear color and the love of pattern and elegant line, although characteristic of almost the entire Sienese school, are also taken directly from Sassetta.

Yet the Master of the Osservanza triptych is a recognizable personality. He is not as refined or polished as Sassetta, nor does he have Sassetta's remarkable light and atmosphere, but he is nevertheless a painter of considerable talent. Basically conservative and cautious, he is less impressed than Sassetta, especially the young Sassetta, by the new Florentine style of Masaccio and Masolino. His debt to the past is always evident, and like Sassetta himself, he owes much to Simone Martini, that guiding light of many Sienese artists.

One of the closest connections between the Master of Osservanza and the artist responsible for the St. Anthony scenes occurs in the *St. Jerome in the Desert* (Fig. 38), one of the predella panels from the Osservanza triptych. It is now in the Siena Pinacoteca and has recently been cleaned. At first glance, it is very like the St. Anthony panels. The treatments of the landscape, the trees, and the figure of the kneeling saint are similar. But, there is a rationality about the construction

of the landscape and the light that is unlike the illogical world of the St. Anthony scenes. Full of delicate and varied color, the *St. Jerome in the Desert* seems strongly influenced by the little paintings of the legend of St. Anthony. However, it lacks the fundamental mystery of those extraordinary panels; its imagery is somehow tamer, more graspable.

The love of clear, limpid color in the *St. Jerome in the Desert*—in which large areas of unmodulated hue form striking color fields punctuated by stronger accents, such as the bright pink of the saint's hat or the green trees with their yellow fruit—reappears in what is perhaps the Osservanza Master's finest work, the *Birth of the Virgin* (Fig. 39), in Asciano. This remarkable altarpiece is based directly on the painting of the same subject by Pietro Lorenzetti in Siena. The fact that a work painted more than a century earlier could be such a strong source of inspiration for this talented and inventive painter shows how alive the past was to Sienese Renaissance artists.

Of course, the Osservanza Master has made certain fundamental modifications, for his approach to the story is different. For instance, St. Anne's bed has been shifted to the right and replaced by the attendant women and a door through which one sees the next room. Also new are the large upper panels of the Virgin, child, and angels and the scenes of the Virgin's death and burial.

Pattern, line, color, and gold combine to make the Asciano *Birth of the Virgin* a brilliant altarpiece. Pietro Lorenzetti's somber treatment of the scene has been enlivened by the introduction of scores of decorative details and pattern. The story has been made more particular and homey, like the painting of the same subject by Paolo di Giovanni Fei in the Siena Pinacoteca, which also seems to have strongly influenced the Osservanza Master. (Here is a good example of an artist of late Trecento influencing an important artist of the next generation.)

There are also a number of interesting paradoxes in the Asciano painting. For instance, the floor and the side walls recede toward the horizon in an orderly fashion, giving the impression of a convincing movement back into space. However, this feeling is partially negated by the conscious introduction of many space-denying patterns and by the tipping of the wall just outside the leftmost door. This tension between a rational, mathematical construction of space and a more empirical, more impressionistic vision characterizes much of Sienese painting of the fifteenth century.

A wonderful example of this conflict is in the *Virgin Bidding the Apostles Farewell* (Fig. 40), one of the predella panels from the Asciano *Birth of the Virgin*. Near the center of the picture the walls of the Virgin's house move into space in an alarming rush. Like the fluttering apostles who fly in at the left, the very house seems to float. Inside, where the ancient Virgin says good-bye to her

39. Osservanza Master, *Birth of the Virgin*. Asciano, Museo di Arte Sacra.

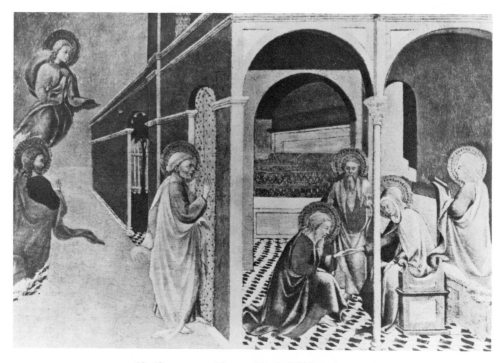

40. Osservanza Master, *Virgin Bidding the Apostles Farewell*. Florence, Berenson Collection.

faithful friends, the scene is spatially calmer, although the floor tiles are set in a disturbing pattern, which makes the floor seem to shift slightly. The Master of Osservanza has purposefully distorted the construction of one-point perspective by making the floor pattern slightly irregular.

The rush of space, the instability of the central structure and its foundation, and the strong asymmetric contrast between the void on the left and the architecturally divided and subdivided space on the right are all part of the artist's consciously constructed narrative. The combination of the real and the fantastic reinforces the miraculous nature of the tender and touching scene.

Without doubt, the Master of the Osservanza was a painter of considerable talent. Although his work stems from Sassetta and is also heavily indebted to the late Trecento and to the great masters of the early Quattrocento, he forged his own style. It has been suggested that the Master of the Osservanza is none other than Sano di Pietro, a well-known, prolific artist active in Siena until the 1480s.[9] There are two reasons for this suggestion: first, the stylistic and interpretative characteristics of the paintings by the Osservanza Master and Sano are strikingly

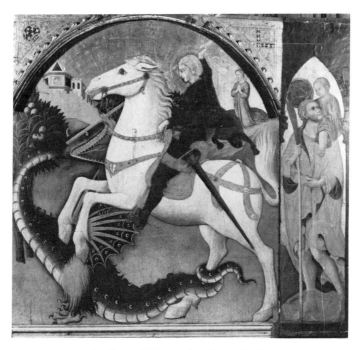

41. Sano di Pietro, *St. George Slaying the Dragon*. Siena, San Cristoforo.

similar; second, the earliest certain work by Sano di Pietro (a large polyptych in the Siena Pinacoteca) dates only from 1444. Sano was born in 1406 and enrolled in the painters' guild in 1428. Consequently, he was in his late thirties when he signed and dated this first known work. In the Quattrocento young artists usually started their careers in their early 20s (Sano's matriculation would square with that); seldom, if ever, do an artist's first works date from his late 30s.[10] All this means that it is very likely that Sano had executed a considerable body of work before he painted his earliest known dated picture. But can that body of work be the paintings identified with the Osservanza Master? Or, to put it another way, was the young Sano responsible for the 1436 polyptych from which the Osservanza Master takes his name? This question is extremely difficult to answer because all Sano's certain works are dated 1444 or later and come from a mature period in the artist's life, when his style was already fixed.

When we turn to Sano's more certain work we are on firmer ground. The style of his first undisputed painting, the 1444 Pinacoteca polyptych, is closely reflected in a fragmentary altarpiece of *St. George Slaying the Dragon* (Fig. 41). This boldly dramatic work betrays some of Sano's most important artistic debts.

His love of abstract pattern is apparent in the shapes made by the highly stylized bodies of the rearing charger and the scaly, twisting dragon. The large arabesques of these two principals derive ultimately from Bartolo di Fredi or another of the influential early Quattrocento painters. The fantasy of the work—the toylike horse and the rather tame dragon with tiny, ineffectual wings and puppetlike mouth—is another characteristic of Sano's painting, one he shares not only with Bartolo di Fredi but also with Sassetta.

A fairytale air permeates this painting. The bold knight on his fearless steed, the frightened princess praying for her salvation, the evil dragon, the fantastic trees heavy with fruit, and, in the distance, a walled town whose towers catch the sun are all part of Sano's particularly romantic fantasy. Action is frozen in a lovely, timeless, pristine world; all this is achieved, however, by a highly sophisticated manipulation of form and color.

The touchstone for Sano's style is the large polyptych (Fig. 42) of 1444 in the Siena Pinacoteca. Signed and dated by the artist, it is the largest and finest of his surviving works. Exquisitely wrought and confident, it is certainly the painting of a mature artist, and it stands as proof that he had done much previous work. Almost perfectly preserved (it seems only to be missing the predella), Sano's painting shows what such polyptychs originally looked like. It is composed of many compartments, arched, fretted, and pinnacled; it is large in its size, complexity, and splendor. Both the frame and the painted surfaces are covered with considerable amounts of gold, a sure sign that this commission was expensive and prestigious.

The central field of the polyptych is occupied by the Virgin, child, and saints. St. Jerome appears at the Madonna's right hand, the position of greatest honor on a polyptych (originally the painting was in the Siena convent of the Gesuati di San Girolamo). Below the Virgin kneels the Beato Giovanni Colombini. The title beato, or blessèd, signifies that Giovanni was considered a sort of demisaint, although he was never canonized.[11] There were numerous beati in the turbulent history of Sienese spirituality, and many, like Giovanni Colombini, withdrew from the world into a life of mystical contemplation and asceticism.

Above the fervent Giovanni Colombini rises the Madonna, clad in an almost perfectly preserved robe of light blue. With elastic hands she holds a stiff Christ child, whose bright pink garment forms a striking contrast with her own blue clothes. Similar bright fields of color are seen in the reds, blues, and yellows worn by the angels, who hold red and white roses behind the Virgin's throne. Sano is not as subtle a colorist as Sassetta; his palette is bright and clear, more like that of the St. Anthony scenes attributed to the Osservanza Master.

Throughout his works, and especially in the 1444 polyptych, Sano delights

42. Sano di Pietro, Altarpiece. Siena, Pinacoteca.

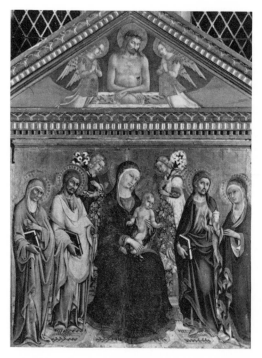

43. Sano di Pietro, Altarpiece.
Pienza, Cathedral.

in rendering a multiplicity of objects: the variegated marbles on which the saints stand, the embroidered cloaks and hems, the flowers, the angel wings, and the books create a wealth of visual detail and color. An encrusted, jewellike quality is his hallmark. The sheer size and the variety of color, pattern, and detail of the 1444 polyptych are overwhelming. The altarpiece seems to glitter and glow not with the coldness of a diamond but with the warmth and depth of a lustrous ruby or emerald.

Sano's altarpiece (Fig. 43) for the Cathedral at Pienza, done about fifteen years later, was probably commissioned by Enea Silvio Piccolomini, the famous humanist pope Pius II.[12] The altarpiece is very modern; its up-to-date frame has fluted pilasters, Classically inspired capitals, and a pediment. That may have been Pius's idea rather than the choice of the rather conservative Sano. All the altarpieces in the Cathedral have similar frames, which are very much in keeping with the style of the church, designed by the Florentine architect Bernardo Rossellino. The pope may have felt that the type of elaborate, fussy frame around Sano's 1444 polyptych and similar works would have been out of place in the severe, unadorned setting of the new church of Pienza.

This attitude may also help to explain a composition that is unusually severe

for Sano. The relative simplicity of the main field, with its four saints placed in a *V* around the Virgin, the measured interval, and the studied calmness of gesture make for an extremely stable, quiet depiction of the Virgin, child, and saints. This mood, and the comprehensible space that helps give rise to it, may have resulted from the influence of several Florentine artists. Perhaps Sano, who was around 55 when the Pienza altarpiece was painted, looked at Fra Filippo Lippi, Fra Angelico,[13] or several other Florentines painting in about the same style. Or, it is possible that he turned to his Sienese contemporary Vecchietta, who was working in a Florentine-influenced idiom. Sano might have been led to experiment with this style by his commission; similar altarpieces in the cathedral suggest that it may have stipulated a picture consisting of a Virgin and child flanked by four saints, all in a single field. Such a composition, like the frame types of all the altarpieces, might have been considered appropriate for the dignified new cathedral.

Yet, even in this most sober of his paintings, Sano's style remains staunchly Sienese. The skillful and original use of color continues. Mauve, subtle greens and browns, cool greys, and warm reds abound. The contrasting colors of the robes isolate the figures and call attention to them as entities; each large color chord moves the viewer's eye across the surface of the painting in a series of abrupt jumps.

Moreover, the richness of the 1444 polyptych and most of Sano's other paintings is maintained in the Pienza altarpiece. The oriental rug on which the figures stand, the gold-encrusted embroidered cloth over the throne, the heavy woolen garments, and the roses held by the attending angels all give the variety and sumptuousness that are characteristic of Sano. All his autograph paintings display a delight in and a love of the stuff of the physical world.

As his popularity grew, Sano became one of the busiest artists in Tuscany. The list of his surviving works is itself impressive; but with the increase in work came a corresponding increase in the intervention of Sano's helpers. Because there was so much to do and so many patrons waiting, Sano turned over a considerable amount of the actual painting and, sometimes even the designing, to members of his workshop. During the last decades of his career, consequently, the quality of both conception and execution declined. Some works seem to be connected with the artist only by virtue of being produced in his shop; while others, especially the scores of small panels of the Madonna and the Christ child with saints and angels, appear to have been almost mass produced.

Nevertheless, several later works still demonstrate the facility of Sano's sparkling art, notably, the large altarpiece (Fig. 44) in the Collegiata of the small town of San Quirico d'Orcia in the Sienese territory. Also surrounded by an up-

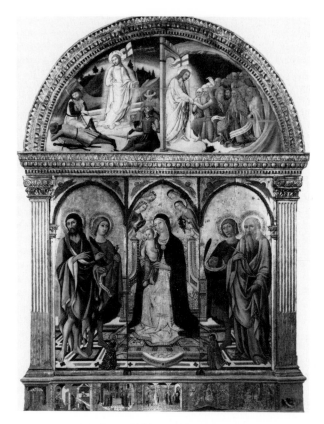

44. Sano di Pietro, Altarpiece. San
Quirico d'Orcia, Collegiata.

to-date frame complete with pilasters and a carved lunette, this depiction of the
Madonna and child with angels and saints includes SS. Quirico and Fortunato,
both of whom were objects of local devotion.[14] Although the main field of the
painting is still made up of three panels, each with its own arched top, Sano has
spatially unified the picture by a continuous patterned floor. However, he care-
fully avoids a completely coherent space by not allowing the orthogonals of the
pattern to recede into space toward a single vanishing point on the horizon; he
thus achieves a more irregular, less logical, support for the figures.

The Virgin and saints are placed between a predella and a large painted
lunette. The pretty and charming predella still contains many echoes of Sano's
art; but the major interest of the altarpiece lies in the *Resurrection* and *Christ in
Limbo* scenes in the lunette. Sano, again recalling Sassetta and, perhaps, the
small St. Anthony scenes, has created a spectral *Resurrection*. Just as the sun's first

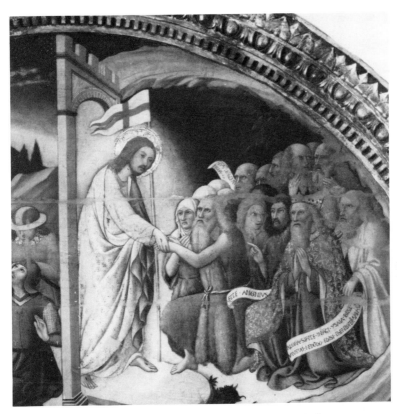

45. Sano di Pietro, *Resurrection* and *Christ in Limbo*
(detail of Fig. 44). San Quirico d'Orcia, Collegiata.

rays start turning the clouds the softest shade of pink, a weightless Christ glides out of a sarcophagus placed before the still-black hills. Ethereal and shining in his white and pink robes, he hovers silently over the earthbound soldiers dressed in strong colors of red, grey, yellow, and purple. The bright foreground forms a striking contrast with the black hills and silhouetted cypresses.

The *Christ in Limbo* (Fig. 45) is equally impressive. The same radiant Christ, enveloped in a luminous mandorla, reaches out to touch the kneeling supplicants. The supernatural illumination energizes these lunette scenes and makes them eerie. With their large size, the brightness of their carefully chorded color, and their remarkable illumination, these narratives make an impressive crown for the altarpiece.

As this altarpiece demonstrates, Sano was capable, even late in his career, of producing works of considerable interest. Conservative, a traditionalist in the

best Sienese sense, he has often been accused of being a *retardataire* artist. But this charge is untrue and anachronistic. The Sienese of the fifteenth century did not think in terms of *avant garde* or old-fashioned; each artist was part of the powerful and respected tradition of Sienese art, which traced its foundations to Duccio and the early Trecento. The very fact that Sano received so many commissions from such diverse patrons, both in Siena and outside the city's walls, testifies to his popularity with those who paid for art. Such commissions would not have been awarded to someone who was out of step with his time. Moreover, as the autograph works themselves show, Sano was endowed with considerable talent for a specific type of religious imagery. He also showed a marked, but again limited, development from the idiom of Sassetta to a more personal style, not untouched by some of the contemporary developments in Florence.

Above all, Sano is one of the happiest, most untroubled artists to have painted in Siena in the Quattrocento. While his work occasionally shows an interest in the mystical and supernatural, his major concern is the depiction of comely figures swathed in robes of bright color in an opulent world. Objects—flowers, marble, floor tiles, embroidered robes, angels' wings, and a hundred other tangible things—fascinate him. Deep piety is usually not reflected in his figures or landscape (with the exception of the St. Anthony pictures, if indeed they are Sano's, and the San Quirico lunette) but in the innate wonder of glistening gold threads on a rich cloak or in a soft rose petal of almost incandescent white. It is with our heart rather than with our mind that we love Sano.

Giovanni di Paolo, a contemporary of Sano's, is an artist of an entirely different character. Both cerebral and emotional, he ranks with Sassetta among artists of the first half of the fifteenth century in Siena.[15] Giovanni's earliest surviving painting, and without doubt one of his first, is the now-fragmentary Pecci altarpiece executed in 1426 for the Church of San Domenico in Siena. His talents were recognized early, for this expensive and prestigious commission was awarded to Giovanni when he was only about 25.

Fortunately, the central panel (Fig. 46) of the Pecci altarpiece has survived, and a recent cleaning reveals the brilliance of Giovanni di Paolo's youthful style.[16] What first impresses one about this picture is the careful and sumptuous working of the surfaces. The Madonna's embroidered dress, the angels' wings of peacock feathers, the fantastic rug covered with plant motifs, and the wonderful punched halos, with their elaborate inscriptions, all make for a precious picture, like a detailed cameo or an elaborately set jewel. Like Gentile da Fabriano's Uffizi *Adoration of the Magi* of three years earlier, the Pecci Madonna was meant to glorify the holy figures and to proclaim the wealth and good taste of the individual who paid for it.

The Madonna and the angels display a remarkable delicacy of execution and

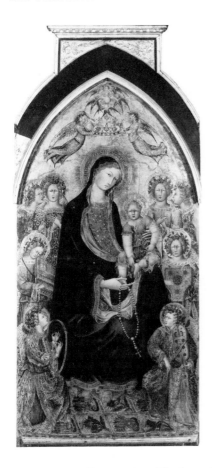

46. Giovanni di Paolo, Central
Panel of Pecci Altarpiece.
Castelnuovo Berardegna,
Santi Giusto e Clemente.

a sweetness of expression. The branches and flowers entwined in the angels' radiant blond hair are worked with a skill seldom seen in Quattrocento painting. The attenuated, tense figures and the hands of the music-making angels are also exquisite. Much of this delicacy and refinement owes its origin to Paolo di Giovanni Fei, whose sophisticated and refulgent panels were admired by Giovanni di Paolo. The latter may have made a trip to Florence shortly before beginning the Pecci altarpiece, for the massive, broad-shouldered child, who sits in a complex position, appears to be indebted to some lost composition by Masaccio or one of his early followers.[17] It is interesting that although Giovanni di Paolo was clearly impressed by the volume and spatial dominance of Masaccio's art, he chose to utilize these qualities only in the child. Such selective use of the Florentine idiom is one of the hallmarks of his extremely personal art.

The individuality of Giovanni's thoughts on religious narrative is evident in the predella panels of the Pecci altarpiece, which are now divided between the

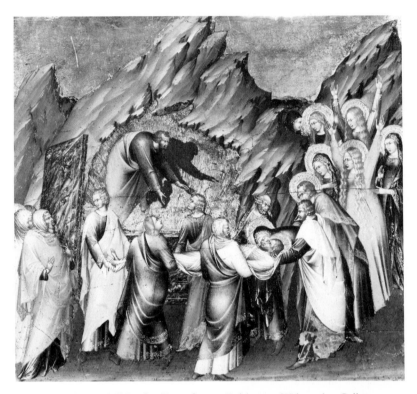

47. Giovanni di Paolo, *Entombment*. Baltimore, Walters Art Gallery.

Staatliche Lindenau-Museum in Altenberg and the Walters Art Gallery in Baltimore. Perhaps the most innovative and exciting is the Baltimore *Entombment* (Fig. 47). Before a wild, sharp background of undulating mountains, a tense and agitated drama unfolds. We respond emotionally to the ragged, twisting mountains and the scattered figures grouped irregularly across and up and down the picture's surface. A basic instability is caused partially by the space and partially by the objects in it.

The figures are elegant and lithe, almost fashionable. Many of them are descendants from the style of Duccio and Simone Martini, although those holding Christ seem to be borrowed from the *Carrying of the Baptist* by Andrea Pisano, on the Florentine Baptistery, done about a century before. Yet with their arms flung out in grief and their faces dumb with horror and sorrow, they recall works by the Lorenzetti or, more particularly, a series of Passion panels done by an expressive follower of Simone Martini. Such a high emotional level occurs in all Giovanni di Paolo's subsequent works.

The night's darkness adds to the uniqueness and mystery of the *Entombment*.

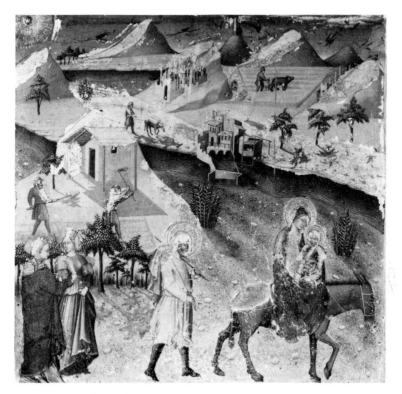

48. Giovanni di Paolo, *Flight into Egypt*. Siena, Pinacoteca.

The picture is illuminated by an indeterminate light source coming from the left and by a radiance that seems to emanate from the tomb itself. This light is so strong that it spotlights the bent figure with outstretched hands and creates one of the first cast-shadows in the history of Italian art. This remarkable naturalistic depiction occurs in a picture infused with a supernatural spirit.[18] The mysterious light from the sarcophagus is really the subject of the picture, for it portrays the sanctity and divinity of Christ's tomb. Those who heard Mass at the altar in San Domenico would have understood. The altar itself was considered the tomb of Christ, and at the moment of the miracle of transubstantiation, he himself appeared among the communicants. The supernatural light was not only a sign of the divinity of the tomb but also a harbinger of Christ's eventual resurrection and ascension—a note of optimism in a troubled and turbulent scene.

The *Flight into Egypt* (Fig. 48), in the Siena Pinacoteca, was probably a section of an altarpiece, now partially destroyed, in the Church of San Francesco in Siena. This painting demonstrates the increasing brilliance of Giovanni di Paolo's narrative style. While certainly borrowing from older paintings, such as

Ambrogio Lorenzetti's *Good Government*, in the Siena Palazzo Pubblico, and other landscapes by Ambrogio and his brother Pietro, Giovanni di Paolo has made his *Flight* into an extremely personal image. The scene is set in a wide and deep panoramic landscape filled with mountains, rivers, and trees and populated by towns and farms. The atmosphere is one of peace and plenty, with a raised golden sun, much like that made by children, shining on the land. Yet, there is something unsettling about the mountains, which seem to be erupting from the earth; something hallucinatory about the sudden sharp shifts in scale; and something disturbing in the intensity of the ubiquitous brilliance. Like many of Giovanni's landscapes, the scene is just slightly out of kilter, a fascinating mixture of minutely observed mundane detail set in a world strangely different from our own.

By 1440 Giovanni developed a style that was even more personal. From around this date until the end of his career, his work exhibits a more dramatic, more eccentric—perhaps *neurotic* would be a better word—and more mystical character, which distinguishes him from all other Sienese painters. These strains are easily seen in a large *Crucifixion* (Fig. 49), signed and dated 1440, which once formed the center of an altarpiece. The work is a painful meditation on loss and grief, with the physical and emotional sorrow of the Marys and St. John the Evangelist graphic and piercing. Not since the tortured figures of Pietro Lorenzetti had Siena seen such expressive beings. The massive Christ, completely devoid of life, hangs limply on the cross, his muscular frame contorted with pain, his veined skin (reminiscent of Vecchietta's bronze Redeemer) a deathly green. It is not the promise of Resurrection and eventual salvation that is expressed here but the torment of crucifixion and the total absence of life.

Mary Magdalen kneels, embracing the dead legs, still unable to comprehend Christ's fate. Her body, her outstretched arms, her craning neck, and her expectant face are simply but brilliantly realized, her whole form a gesture of hope and longing. Mary's abstract angular shape is similar to John's, his anguish expressed by his arms flung above his head. His fingers are almost grotesque, his eyes glazed, and his hair snakelike. The Virgin's grief is not so public but it is just as vivid. Sunk within herself, Mary meditates on the meaning of the horror that has just occurred. Although she is less angular, reminiscent of a Virgin by Duccio or Simone, she is just as expressive as the other two mourners.

Color too is used by Giovanni to convey the message of sorrow. The blocks of nearly monolithic color—John's brown tunic and pink robes, Mary Magdalen's red dress, and the Virgin's simple red and blue clothes—set up fields of unrelated color that emphasize the jagged, unsymmetrical articulation of the figures and the emphatic, awkward nature of their gestures. The power of their expression recalls crude Mexican wood sculpture.

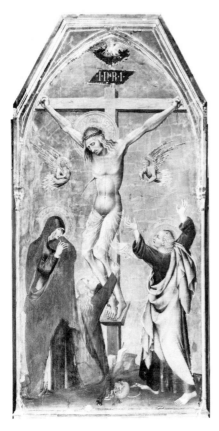

49. Giovanni di Paolo, *Cruci-fixion*. Siena, Pinacoteca.

Probably not more than a half decade after this *Crucifixion* Giovanni painted a famous work, the *Expulsion from Paradise* (Fig. 50), which was probably part of a predella. In this daringly asymmetric composition the awesome figure of God, enveloped in a cloud of blue seraphim, casts his golden radiance over the whirling cosmos, which he both animates and directs. Before him, the angel drives Adam and Eve out of a Paradise strewn with golden fruit and from whose flowering forest floor the four rivers of Paradise spring.

The whole scene is transported to the highest, most fertile realms of fantasy. Our eyes are immediately attracted and then hypnotically held by the sphere of the cosmos that contains the barren plains and mountains of earth, the un-wished-for destination of Adam and Eve. Composed of rings of blue, mauve, white, and red, the great disk has a life of its own. It is as alive as the bearded deity, from whose presence arises a mist of irridescent golden light. Like a vivid

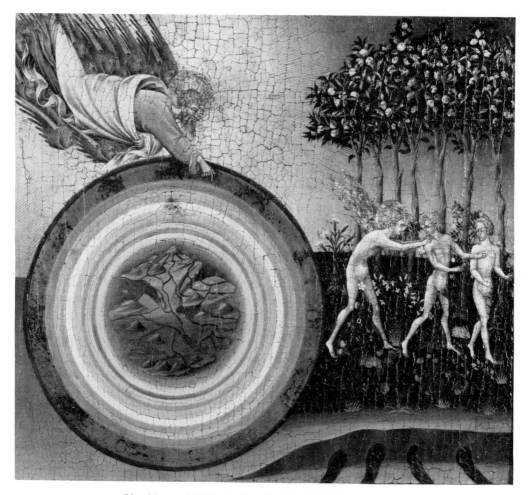

50. Giovanni di Paolo, *Expulsion from Paradise*. New York,
Metropolitan Museum of Art, Lehman Collection.

dream, the pulsating cosmos and the radiant God remain firmly fixed in our
memories.

To the right of the cosmic apparition, the frail, dainty Adam and Eve step
lightly across the flowering meadow. The blooming trees behind them create
twisting silhouettes against the sky. The Paradise these mortals leave is charming
and lush indeed. Lovely variegated flowers, rabbits, and an incandescent blue sky
proclaim a peace and plenty very different from the rocky, arid earth set in the
center of the enormous disk. But there is no real drama in this section of the

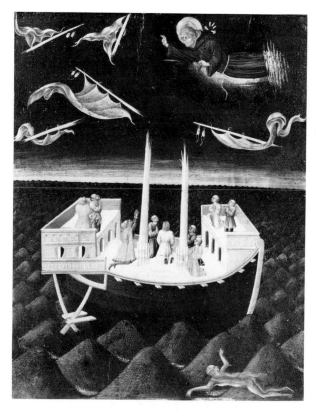

51. Giovanni di Paolo, *St. Nicholas of Tolentino Saving a Ship*. Philadelphia, Museum of Art, Johnson Collection.

panel. Poised, conscious of their bodies, graceful and attractive, the svelte Adam and Eve seem more concerned about their appearance than about their expulsion from Paradise.

Although the *Expulsion* is extremely imaginative and filled with novel and beautiful forms and colors, the painting is somehow disturbing. Perhaps it is the marked asymmetry or the supernatural effects of light or the figures, who seem to be performing some ritual. Whatever its cause, the sum of this picture is extremely personal and shows us the interior world of Giovanni di Paolo himself.

This world is seen again in another predella panel from the same period, the *St. Nicholas of Tolentino Saving a Ship* (Fig. 51). The arrangement of this panel sets the stage for the miracle it portrays. The fragmented masts with their wildly blowing sails, the green sea filled with towering waves, the swinging lines of the

ship, the saint, and the mermaid all contribute to the frenzy and disorientation appropriate to the subject. What we see here is not a mundane transcription of the events of a shipwreck but the horror and sense of helplessness it inspires. Consequently, the impact is more immediate and vivid than an accurate depiction would be.

Moreover, Giovanni knew that by their very nature miracles could not be presented in a rational and orderly setting. For this reason he and many other Sienese artists disregarded much of what they saw in the more rational and realistic art of Florence. The fantasy and mysticism of traditional Sienese painting and of the city of Siena itself were paths from which they did not often stray.

Even in the midst of the miracle, Giovanni di Paolo's painting is compelling: The movement of the waves; the shattered ship riding on them; the dawning sky, which fills the picture with suffused, gentle light; and the brilliantly colored figures delight the eye. The entire picture seems to dance before us like some miraculous maritime vision. In the vastness of the sea, both beautiful and menacing, salvation comes to the fervent passengers in the shape of a saint propelled by divine force, his body enveloped in mystic light, his feet still in the clouds.

In his maturity, Giovanni di Paolo rethinks and rearranges every subject he is commissioned to paint. A good example, now in the Siena Pinacoteca, is the large *Presentation of Christ* (Fig. 52), ordered by the Pizzicaiuoli (the Sienese guild of spice and color merchants) and set up in their chapel in the Church of Santa Maria della Scala around 1450.[19] Ambrogio Lorenzetti's panel, then just across the street in the Duomo, was a famous prototype for this subject. Both altarpieces were probably equipped with wings inhabited by full-length standing saints. From Ambrogio, Giovanni borrowed, with modifications, the general arrangement, the architecture, and the disposition of the figures.

Ambrogio Lorenzetti's influence on Giovanni di Paolo was not smothering, for the Quattrocento artist has used the older man's work as a springboard for his own interpretation of the sacred event. It is as though Giovanni di Paolo has seen the action through a distorting glass. For example, he has radically foreshortened the side wall of the temple, sending the viewer's eye rushing back into the building's space. The panel has an extremely high level of visual activity and an almost obsessive use of detail. This concern with detail, an inheritance from the late Trecento, distracts our eye from the action and pulls it in several directions.

Giovanni di Paolo has not only abandoned the calmer, more monumental world of Ambrogio's *Presentation* but also introduced a new race of protagonists. The stately, grave participants of the older picture have been replaced by a breed of spidery, agitated figures. With searching eyes and groping hands, these phantoms glide across the picture's surface performing, like Adam and Eve in the *Expulsion*, some ritual act known only to their creator. The neurotic intensity

52. Giovanni di Paolo, *Presentation
of Christ*. Siena, Pinacoteca.

of these figures makes this picture arresting. Seldom in the history of Italian art
had religious narrative been so stamped by such an introspective and strange
personality.

Throughout his entire painting career Giovanni di Paolo was a talented col-
orist. His palette was not of the highly refined, decorative type of Duccio or
Simone Martini; rather, he used color to help form the emotional core of his
pictures. In the *Presentation*, the red and white of the floor tiles diminish into
space at unequal rates, creating a broken, unstable surface on which the holy fig-
ures stand. The alternation of white, grey, and rust on the building fragments it
into an uneven range of hue and intensity. The instability of the picture is further
increased by the color chording of the central group of figures, which moves
back into space in the form of a jagged *V*. Isolated areas of gold, black, blue,
pink, and grey—to name just a few of the colors—break up the group and inten-
sify the isolation that is already evident in the closed silhouettes and perplexed

faces. In fact, color makes the spatial recession from the foreground to the priest behind the altar move in a series of jumps. Like almost everything else in the picture, color leaves the viewer uncertain and uncomfortable. The entire picture is like some giant kaleidoscope through which we glimpse a fractured world only tenuously connected to our own. One wonders what the worshippers who prayed before this striking altarpiece thought as they contemplated its strange images.

Another side of Giovanni di Paolo's artistic personality is glimpsed in the *Madonna of Humility* (Fig. 53), one of the artist's most distinguished works. Its mysterious sweetness and delicacy demonstrate the range and versatility of his style, and his abiding interest in landscape is evident here. The curvature of the vast background plane makes it seem to extend to the ends of the earth. This microcosm of the world, covered with a checkerboard pattern of cultivated fields showing the civilizing hand of man, is characteristic of all earlier Sienese painted landscape. The conical mountains rising from these fields are rather like the waves of the *St. Nicholas of Tolentino Saving a Ship*. These weird outcroppings add a further note of unreality to the cultivated fields, miniature trees, and tiny towns.

Separated from the background by a garden alive with golden fruit and multicolored flowers, sits the fragile Virgin, her head encased in a refulgent golden halo. This frail figure holding her coy, nude son is like a vision in an earthly paradise. There is an endearing springtime tenderness about this work. Soft light suffusing the background with a kind of preternatural luminosity, the intimacy of the mother and child, and the charming garden work together to make an ethereal and lovable picture. But it is much more than a description of two holy figures in a lovely atmosphere, for it contains some disconcerting yet fascinating aspects of the painter's imagination. The gnarled mountains rising in the background, the sly child, and the intensity of detail interject disturbing notes. Captivating and warm, but, at the same time, vaguely worrisome and disorienting, the *Madonna of Humility* is indicative of the complexity and profundity of Giovanni di Paolo's imagination, even in a theme that was well established in the Sienese repertory of types. In spite of that, or perhaps because of it, the work is compelling.

The same complexity of thought and reconsideration of subject are evident in a later work by Giovanni di Paolo, the fragmentary altarpiece, now in the Siena Pinacoteca, from the Abbey of San Galgano, south of the city.[20] This important center of monasticism had strong ties to Siena and was decorated by Sienese artists. The commission for Giovanni di Paolo's polyptych cannot be dated exactly but seems to have come around 1470, about a decade before the artist's death. The center panel of the altarpiece is missing, and it has been suggested

53. Giovanni di Paolo, *Madonna of Humility*. Siena, Pinacoteca.

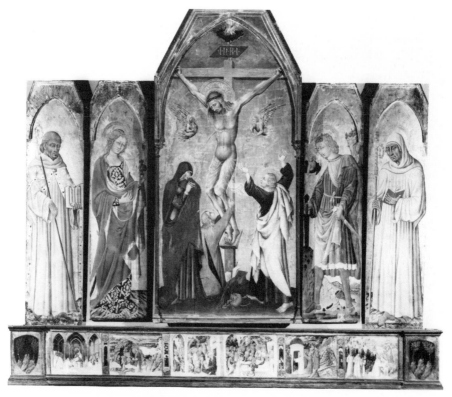

54. Giovanni di Paolo, San Galgano Altarpiece. Siena, Pinacoteca.

that it was the *Assumption of the Virgin* in Asciano, a small town not far from Siena.

The San Galgano polyptych has side wings (Fig. 54) of standing saints that reveal something new in the art of Giovanni di Paolo. The figures display a purposeful awkwardness that is achieved through the angular manipulation of the body and by an exaggeration of its various parts, for instance, the uncomfortable stance and strangely articulated pose of St. Bernard, at the far right. His face is of a rudeness only hinted at in earlier works; his hands, with their grotesque arthritic fingers, are shocking indeed. The roughness and crudeness in this and other late works cannot be ascribed to a failing of Giovanni di Paolo's artistic powers; rather, they represent a new, heightened, and powerful religious vision.

This vision is best seen in the predella panels of the San Galgano altarpiece. These six paintings—two in the center devoted to scenes from the Madonna's legend and four narrating events concerning three of the saints above—strike a new and chilling note, for here Giovanni di Paolo expresses his most personal

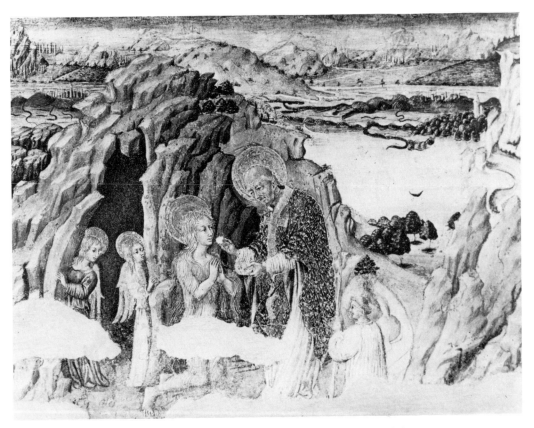

55. Giovanni di Paolo, *Last Communion of Mary Magdalen*
(detail of fig. 54). Siena, Pinacoteca.

meditation on religious drama. In an eerie world, icy colors of pale blue and
white invoke some arctic dreamscape, and the pale, nervous figures seem devoid
of life.

In the *Last Communion of Mary Magdalen* (Fig. 55), in a landscape of pri-
meval beauty, the gaunt, hirsute saint receives the wafer from an ancient St. Mas-
simino. The two ecstatic saints stand on a precipice overlooking ranges of folded
mountains resembling those found in the work of Guido da Siena and other
early Sienese painters. Giovanni di Paolo might even have looked at such old pic-
tures to study the strong, abstract power of their landscapes and figures.

Below the heights on which the saints stand is a glassy lake with a solitary
boat. From the lake, rivers like giant black serpents snake into the grey plain
beyond. The distance is dotted with the icy grey towers and lofty mountains.
Cold and barren, the landscape resembles the moon. How different this is from

the charming early landscape of the Siena Pinacoteca *Flight into Egypt* or the sprightly panorama behind the *Madonna of Humility* in the same gallery. Like Donatello's reliefs from the San Lorenzo pulpits of a decade or so earlier, the predella scenes, which are perhaps influenced by the sculptor's work, reveal a frightening and hypnotic side of the artist's mind.[21]

When Giovanni di Paolo painted the predella scenes for the San Galgano altarpiece he was around 70 years old. One is tempted to see in his work a Late Style, that phase of a great artist's activity in which his art leaves tradition and convention for images and narratives conveying the deepest, most personal, and most condensed meditations, often of a pessimistic nature. Sometimes daring, usually unstylish, and made with little concern for reigning ideas of beauty and grace, late works are often an artist's most enigmatic, attractive, and powerful creations. We have only to think of the late works by Donatello (the pulpits are among them) or those by Titian, Rembrandt, or Turner to see the truth of this statement. The predella panels from the San Galgano altarpiece and several other late works by Giovanni di Paolo seem to belong to this sphere of late artistic creativity. They are part of some private world infused with magic and sanctity, comprehensible but just outside our reach. Like a mirror in an amusement park, they distort reality in a slightly menacing way.

Another example of his endlessly fascinating later style is Giovanni di Paolo's *Assumption* (Fig. 56). This work was originally in Staggia Senese, a small town near Siena. It was signed by the artist and dated 1475, making it one of his last works. The polyptych has four saints flanking the *Assumption* and is equipped with a predella depicting the donors, three saints, and, in the center, a panoramic scene of the emaciated Christ as Man of Sorrows flanked by Mary and St. John the Evangelist, the whole set against a mountainous background. Over this unusual predella stand the same type of distorted, almost grotesque saints seen in the San Galgano altarpiece: faces with large glazed eyes and twisted lips set on bodies both compressed and contorted. Some of the figures, John the Baptist, for instance, are painful to behold; the gaunt, stunted body of the desert saint is covered by a network of popping veins, like those of Vecchietta's nearly contemporary *Resurrected Christ* (Fig. 24).

The exact center of the middle panel is occupied by a sphinxlike Madonna hovering above the angels. Her oval face with its twisting features regards the worshipper without the slightest trace of emotion; like the Holy Sacrament, used in the Mass once performed before the altarpiece, she is an object of supernatural power and mystery. Her rigid body seems paper thin beneath a white robe covered with space-denying gold embroidery.

Giovanni di Paolo was long fascinated by musical instruments. His earliest

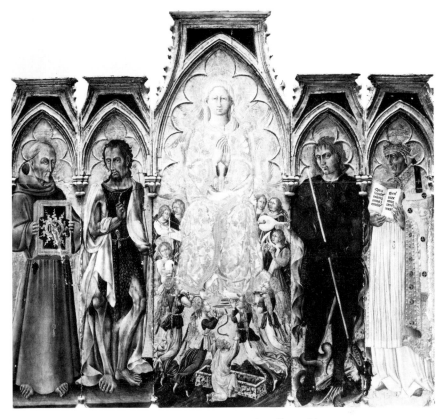

56. Giovanni di Paolo, *Assumption*. Siena, Pinacoteca.

painting, the Pecci *Madonna*, contained wonderful representations of them. In the *Assumption* he has assembled a little angelic symphony, with recorders, a hurdy gurdy, bagpipes, a portable organ, a lute, and a harp furnishing a musical accompaniment for the event. From above, subtler heavenly sounds are provided by the beating wings of golden seraphim.

Below, outside of the circle of fluttering angels, a fervent St. Thomas grasps for the Madonna's belt, his angular arms and outstretched, expressive hands reminiscent of John's from the 1440 Pinacoteca *Crucifixion*. Set in a barren landscape above which the angels dance in the air, St. Thomas strikes the single note of human passion and anxiety in this iconic central panel.

The artist has lavished an unusual amount of attention on the color of this central panel; alternating patches of pink, blue, and white set up an abstract, decorative rhythm that reinforces the hierarchical and symmetrical nature of the

great Madonna. The freshness and vivacity of these colors make Giovanni a worthy heir of the remarkable Sienese colorists, although he is often more concerned with using color to build and separate form than for its more decorative qualities.

Giovanni di Paolo is a very complex and interesting figure. Arising from the styles of the late Trecento, those of Taddeo di Bartolo and Paolo di Giovanni Fei in particular, he soon emerged as one of the most original painters Siena had ever seen. In contact with the Florentine style and impressed with the darker works of Donatello, he developed his art along increasingly expressive lines. Beautiful and charming, but at the same time suppressed, wild, and often menacing, his idiom became more and more personal and fantastic. From the golden elegance of the Pecci *Madonna* to the arctic world of the San Galgano predella panels, Giovanni di Paolo's artistic journey became more introverted and complex, but his painting always carried the strong, undefinable stamp of his personality. Seldom did such haunting images issue from a Renaissance painter's brush.

A number of lesser figures trailed in the wake of the Sienese visionaries. Perhaps the best of them was Pietro di Giovanni d'Ambrogio, an artist sometimes capable of rising to considerable heights.[22] He was influenced by Sassetta, who was a close contemporary, and by Giovanni di Paolo. His masterpiece is the *Adoration of the Shepherds* (Fig. 57), in the Museo di Arte Sacra in Asciano, the same treasure house that displays the Osservanza Master's *Birth of the Virgin* and a number of other supreme Sienese paintings. Pietro di Giovanni's altarpiece is of a traditional Sienese type: a central scene surrounded by two or more standing saints, here St. Augustine (?) and St. Galganus, a local saint much venerated by the Sienese. Also traditional is the elaborate profile of the frame and the cusping of the arches.

The central panel portrays a night landscape—a daring and rare setting for holy drama. From the dawning sky, streaked with clouds and punctured by distant mountain ranges, to the swirling brown cave with its thatched roof, the atmosphere is heavy with expectation and mystery. The emotional charge of this landscape is obviously inspired by the extremely expressive landscapes of Giovanni di Paolo and the love of earlier Sienese painters for the depiction of the natural world. However, when these depictions passed through the filters of the artists' minds, they often emerged as fantastic visions. Nevertheless, no previous Sienese painting, not even the work of Giovanni di Paolo, is quite like the spirit and form of the fantastic night setting of the Asciano picture. Such high-quality painting makes us regret that so few works of Pietro di Giovanni d'Ambrogio survive.

Sassetta's influence is clearly seen in the figure types. The two saints and the occupants of the central panel have the same delicate, sharp facial features found

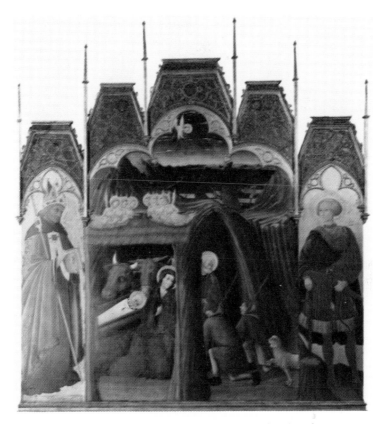

57. Pietro di Giovanni d'Ambrogio, *Adoration of
the Shepherds*. Asciano, Museo di Arte Sacra.

in many of Sassetta's works, but they carry a hint of unconscious caricature,
something that often occurs when an artist of lesser talent is inspired by the style
of a master whose work he does not fully understand.

The freedom of painting and invention of the Asciano *Adoration* can be
credited only to Pietro di Giovanni d'Ambrogio. The flock of angels hover over
the thatched roof of the shed in a bank of flame, which, along with the whitish
blue horizon, illuminates the scene. There is something naive about the rigidly
wrapped infant, who resembles a doll, and the sloe-eyed animals, who gaze mel-
ancholically out at the worshipper. Humorous notes are also introduced: the
rough shepherds, who kneel awkwardly, and their little dog, who looks like a
miniature domesticated lion.

Pietro di Giovanni d'Ambrogio, like Sassetta, is a capable colorist. Perhaps
influenced by the mature Sano, Sassetta, and Gentile da Fabriano, who worked

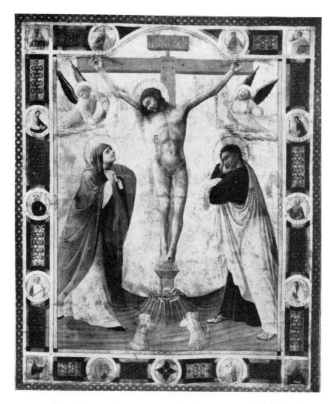

58. Pietro di Giovanni d'Ambrogio, *Crucifixion*.
Paris, Musée Jacquemart-André.

in Siena during the 1420s, he fashions a rich and varied palette using subtle colors of considerable saturation. Especially noteworthy are St. Augustine's green mantle lined in red and St. Galganus's reddish tunic and bright red hose. These figures serve as brackets of color enclosing the much more muted *Adoration*.

Pietro di Giovanni d'Ambrogio's other noteworthy work is a banner dated 1444, of the *Crucifixion* (Fig. 58), now in the Musée Jacquemart-André in Paris. Painted on both sides, this picture was carried in procession by the members of the flagellant confraternity who kneel at the foot of the cross. Such works were painted in great numbers throughout the Italian peninsula during the Renaissance and even up to very recent times; it is still possible to see them carried through the winding streets of provincial towns during important feast days. Strongly influenced by traditional types and demanding easily readable images, these banners are often powerfully iconic.

In the *Crucifixion*, Pietro di Giovanni d'Ambrogio creates an image of remarkable drama while fulfilling all the iconographic and stylistic traditions and requirements of a banner. Symmetry, one of the organizing principles of the banner, is the hallmark of his composition. The rigid border, with its half-length saints in roundels, serves as a perfect frame for the Crucifixion, which is severely divided into mirrorlike halves on either side of the fragile body of Christ. Mary appears to move out toward us, while John moves backward, his gesture of horror and grief mirroring Mary's. The contorted bodies of two flying angels complete the upper parts of each half. The compartmentalizing of the work strengthens the drama of the Crucifixion by making the figures and their placement seem immutable. Like the paintings of Piero della Francesca, who was Pietro di Giovanni d'Ambrogio's near contemporary, the banner has geometric power and majesty.

Much of the force of the remarkably foreshortened body gestures could have been achieved by prolonged study of the works of Ambrogio and Pietro Lorenzetti, who, more than any other Sienese artists, mastered the technique of making the entire body expressive of strong emotion. Again, in the figures and faces of the banner one sees a debt to Sassetta's types, especially in the slender Christ. However, the economy of the drapery and the piercing portrayal of anguish once again demonstrate Pietro di Giovanni d'Ambrogio's novel interpretive gifts.

The art of Sassetta, the Osservanza Master, Sano di Pietro, Giovanni di Paolo, and their followers is one of the peaks in the long history of Sienese painting. Traditional, ever eager to mine the treasures of Siena's past, these artists were also highly individualistic and inventive. All were conscious of the art of Florence, with its high specificity and concern for the construction of a fathomable reality, but none of them embraced it. Certainly, they utilized some of its tools of representation and its motifs, but fundamentally they were repelled by its mundane treatment of religious drama.

Perhaps the greatest achievement of these painters was their visionary sense. They endowed the holy stories with unique fantasy and grace. They so distorted and made fantastic the elements in their environment—landscape, for instance—that they brought viewers into a world that was new, mythical, and just beyond their physical and intellectual grasp. This world is full of miracles and apparitions, of weird mountains and golden skies, a world at once compelling, attractive, and slightly threatening. The glittering altarpieces of this period gave the Sienese full vent for their naturally mystical interpretation of religious imagery.

F O U R

THE LAST QUARTER

OF THE QUATTROCENTO

T HE LAST QUARTER of the fifteenth century saw the rise of a
new generation of Sienese artists. The most talented and in-
ventive of them, Matteo di Giovanni, Neroccio de'Landi, and Francesco di
Giorgio, were influenced but not overwhelmed by their visionary predecessors,
by Florentine art, and by the rich Sienese visual tradition, which they mined and
utilized throughout their careers. Like every other generation of Sienese artists,
the painters of the late Quattrocento fabricated a style that was both traditional
and very much their own invention. In many ways, theirs was the last generation
to remain within the ancient boundaries established by Duccio and his followers.

Matteo di Giovanni,[1] one of the major artists dominating the latter part of
the fifteenth century in Siena, seems to have been born around 1435 in San-
sepolcro, a small town near Arezzo, now famous as the birthplace of Piero della
Francesca. Matteo probably received his earliest training in his home town. One
of his earliest works, an altarpiece (Fig. 59) in the Museo dell'Opera del Duomo
in Siena, contains echoes of Piero della Francesca's style. The four angels to ei-
ther side of the throne bear a strong resemblance to the ephemeral ivory-skinned
creatures in Piero's London *Baptism*. That Matteo knew Piero's painting is certain,
for he himself painted the side saints (still in Sansepolcro) that once flanked it.

Several other influences are apparent in the stylistic makeup of Matteo di

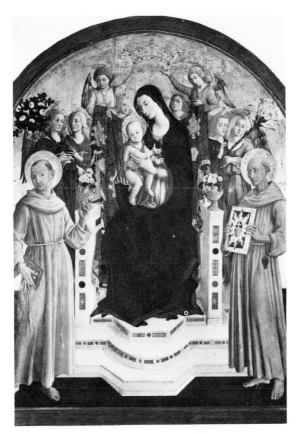

59. Matteo di Giovanni, Altarpiece.
Siena, Museo dell'Opera del Duomo.

Giovanni's altarpiece, but none are strong enough to suggest the identity of the artist's first master. The tall, striking Madonna clearly reveals the sway that Giovanni di Paolo, and perhaps Sano, exerted on the young artist, while the handsome angels behind the throne seem to stem from Domenico di Bartolo. The standing SS. Anthony of Padua and Bernardino, a near contemporary of Matteo's, seem to be indebted to yet another painter, Vecchietta. But, all these influences have been heavily modified by the synthesizing mind of the artist; the altarpiece betrays Matteo's stylistic debts but is not overwhelmed by them.

Even in this altarpiece of 1460, a very early work, Matteo di Giovanni shows himself a skillful composer. The carefully drawn grid of figures and objects is masterfully relieved by a sensitive adjustment of posture and gesture. Both flowing and stable, the composition reveals Matteo's interest in a type of

well-knit architectonic composing that is anticipated in Siena only by Sassetta and Vecchietta, for instance, Sassetta's *Madonna of the Snows* (Fig. 28) or Vecchietta's Uffizi altarpiece (Fig. 20). The various spatial planes, the overlapping of figures and objects, and the delicate balancing of form show that from his earliest work, Matteo di Giovanni was aware of the latest Florentine developments. In fact, he and his fellow painters, again working on the examples of Sassetta and Vecchietta, were to move the Sienese altarpiece type from the traditional compartmentalized polyptych to a single field in which space and action were unified.

Another early work by Matteo, probably painted around the time of the altarpiece in the Museo dell'Opera del Duomo, is the *Madonna with Child and Angels* (Fig. 60), now in the National Gallery of Art, in Washington. This small panel is a happy image, filled with the same smooth-skinned, graceful types and radiating a sweetness soon to disappear from Matteo's work.

The picture has some strikingly innovative aspects. A novel, if slightly disturbing, feature is the daring asymmetrical placement of the two central figures. Pushed nearly to the left border, the large child, being chucked under the chin by the Virgin, throws the picture off balance, disturbing the symmetrical and rhythmic pattern set up by the four standing angels at the back. The leftward movement is further amplified by the large dark area formed by the robe over the Virgin's knees and by the cherubim. The latter are usually seen surrounding holy figures, but here they appear only around the left side of the diagonally placed Virgin, their strange bodiless shapes adding a further note of discordant asymmetry to the composition. The lowest cherub's head is upside-down and disturbingly cropped by the frame, which also truncates the Madonna's knees. This cogitated picture, with its cunning composition and peculiar angle of vision, reminds one of a Japanese woodcut or an Impressionist painting in which the perspective is skewed.

There is also something unsettling about the way Matteo's figures are packed into the picture's limited space. They seem constricted, hemmed in to the left and right by the frame and set uncomfortably close together. The airlessness and slightly claustrophobic quality of this painting finds its echo in works by Matteo's talented contemporary Neroccio, an artist discussed later in this chapter. However, there are passages of grace and beauty in this picture as well. The Madonna, with heavy lids and wide eyes set in a face of great smoothness and refinement, reminds one of Simone Martini's remarkable Virgins painted more than 150 years before. The Madonna and the angels all have long fingers and elegant hands, held in impossible positions of ultrarefinement. The wistfulness and melancholy so characteristic of many of Matteo's later works make their first appearance in this daring painting.

The spatial and psychological complexities of the Washington *Madonna*

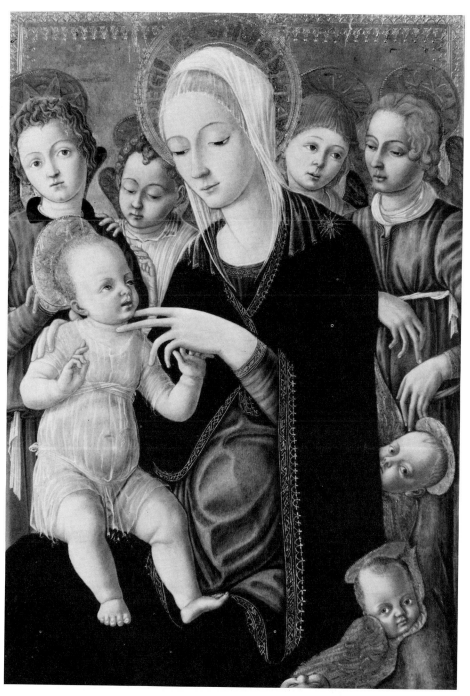

60. Matteo di Giovanni, *Madonna with Child and Angels*.
Washington, National Gallery.

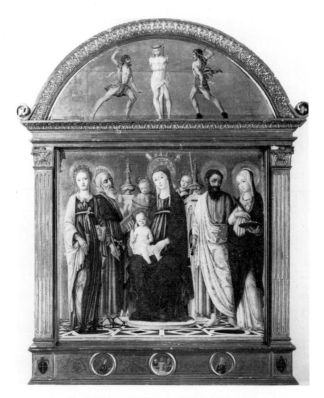

61. Matteo di Giovanni, *Madonna and
Child with Saints*. Pienza, Cathedral.

demonstrate that even as a young man Matteo was already a sophisticated painter.
His skill must have been recognized quite early, for around 1465 he was commis-
sioned to paint one of the several altarpieces for the new Cathedral at Pienza
built by the Sienese Pope Pius II.[2] As we have seen, some of Siena's most impor-
tant artists—Vecchietta, Sano di Pietro, and Giovanni di Paolo—received these
prestigious commissions. It is interesting to note that Pius, the great humanist
pope, commissioned not Florentine but Sienese artists, painters who are now
labeled "Gothic" or some other equally derogatory or imprecise term.

Like Sano's and Vecchietta's altarpieces, the Pienza painting by Matteo, the
Madonna and Child with Saints (Fig. 61), is of a simple shape bounded by fluted
pilasters and crowned by a large semicircular lunette. Matteo had undoubtedly
been to Florence shortly before creating the altarpiece and was impressed by the
work of his contemporaries there. Echoes of the art of Andrea del Castagno[3] are
evident in the facial types, and of Antonio Pollaiuolo[4] in the muscular lunette

figures. Matteo has moved away from the slightly less successful, piled-up treat-
ment of the Opera del Duomo altarpiece to a more-accomplished, more-rational
treatment of the figure and the space into which it is set. Like Sano's composi-
tion for his own altarpiece in the cathedral at Pienza (Fig. 43), Matteo's is a ra-
tional, believable image. The commissioner, Pius II, probably had some say in
the general arrangement of the figures and the shape of the panel.

Matteo's love of strong characterization is evident in the Pienza altarpiece.
The comely and gracious female saints (Catherine of Alexandria and Lucy, the
latter probably derived from Duccio) make a strong contrast to the expressive
bearded John the Evangelist and Matthew. The new foreshortening for dramatic
effect allows the figures to communicate more effectively with the worshipper.

Yet, the highest point of this new dramatic intensity is found in the lunette,
Flagellation. Here Matteo has reduced the story to its essentials: In a brutal bal-
let, the two flagellators lunge forward, their whips whirling over their heads; be-
tween them stands a bound and passive Christ. The delicate adjustment of the
figures, to one another and all three to the size and shape of the lunette, reveals
Matteo's skill as a composer. The savagery that will be found increasingly in the
artist's work appears here also. But it is the angry muscular tormentors, their
helpless victim, and the placement of the figures against a shining void of gold
that makes this scene so compelling.

The same neurotic energy often reappears in the work of the last three dec-
ades of Matteo's career. The *Assumption of the Virgin*, (Fig. 62), from the 1470s,
illustrates the developing psychic tension in his painting. Probably originally
flanked by standing saints, this work is part of a long line of Assumption altar-
pieces dating back to the Trecento. Its composition recalls many earlier altar-
pieces, including that by Andrea di Bartolo (Fig. 13). But Matteo's makes its
own contribution by the fullness of its imagery and by its sprightly protagonists.

As in Matteo's earlier paintings, there is an emphasis on the figure as form, a
love of the shapes of drapery, and a flattening of image into a series of planes.
These elements are very much in the Sienese tradition; from the Duecento on,
artists in Siena concentrated on the decorative and formal aspects of the figure
and enlivened the surfaces of their altarpieces with vivid, abstract shapes.[5] In
Matteo's *Assumption* this tradition survives in the bands of colorful flattened fig-
ures who hover very near the plane of the picture.

The deep background, with its meandering rivers and winter hills set against
the horizon, remind one of the artist's early admiration for Piero della Francesca's
panoramic views. This landscape is very different from the much weirder images
found in the work of Giovanni di Paolo or Sassetta. Certainly, Matteo's (and
Piero's) landscapes are more grounded in reality, on the careful observation of

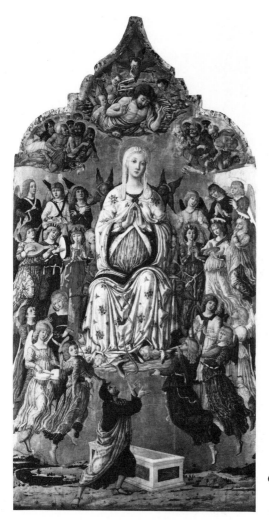

62. Matteo di Giovanni,
Assumption of the Virgin.
London, National Gallery.

topographical features; but it is a reality that has been distilled and rearranged, so that when it issues from their brushes it is nearly as fantastic as the dreamscapes of Giovanni di Paolo and Sassetta.

Each of the participants—from the fervent Thomas, whose delicate hands grope for the Virgin's belt, to the ranks of hovering, ecstatic angels around the comely, sad-eyed Virgin—emits a subtle emotional vibration that is the hallmark of Matteo's later style. The expressiveness and sharpness of feeling in his work ties him to the Quattrocento visionaries and from them back to Duccio and Simone Martini.

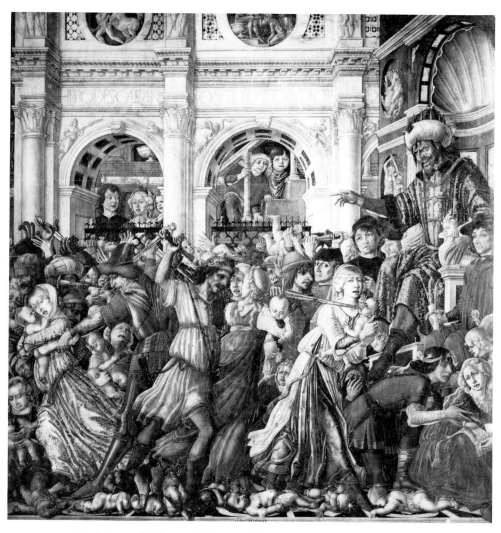

63. Matteo di Giovanni, *Massacre of the Innocents*. Siena, Sant'Agostino.

Matteo's extraordinary pictorial energy is perhaps best seen in a picture done less than a decade after the London *Assumption:* the *Massacre of the Innocents* (Fig. 63), an altarpiece of 1482 in Sant'Agostino, Siena. In this storm of cruelty, Matteo's fascination with the brutal and violent is evident. Waves of undulating figures form a solid human frieze in the foreground, portraying contrasting emotions: the bestial murderers who fall upon the children with glee are opposed by the horrified mothers vainly trying to save their children. In the mass of

twisting and heaving bodies, Matteo dwells on dreadful acts: faces are punctured, bodies are run through with swords, and children are snatched from the arms of their wailing mothers. The entire scene is narrated with chilling, brilliant detail. There seems to be no salvation for anyone, as the whirling figures dart into and out of the picture's space.

Above the crowd, the smirking Herod urges his soldiers on, while behind two arches, spectators gape at the bloodletting. Now these elements—the frieze of activated figures, the evil ruler sitting to one side of the composition, and the arches behind—probably derived from that seminal bronze relief so important for Sienese painting of the Renaissance, Donatello's *Feast of Herod* (Fig. 14). But they have been so rearranged and so rethought that they bear almost no resemblance to it. It is not Donatello's motifs that are the key for Matteo; rather, it is the great sculptor's uncanny portrayal of dizzying horror that has so attracted the painter.

Yet, in another *Massacre of the Innocents* (Fig. 64), done in 1491 for Santa Maria dei Servi, in Siena, the unchecked swirling confusion and horror have been suppressed. Matteo has organized his drama into a more compact, graspable, if less exciting, whole. The composition is now much more architectonic; the sultan sits in the center and is flanked not only by two advisors but by the symmetrical order of the palace architecture as well. The writhing frieze of soldiers, children, and women below is also more ordered.

In the Servi *Massacre* we see some Florentine elements, not the earlier idioms that attracted Matteo before, but the more architectonic style, which emerged in Florence toward the end of the Quattrocento. Clearly, the Servi *Massacre* is influenced by Ghirlandaio[6] and perhaps by Filippino Lippi,[7] both of whom must have impressed Matteo with their brilliant anecdotal detail and their ability to narrate complex stories with clarity and ease. Matteo must also have studied the paintings of Piero di Cosimo[8] and other Florentines working just before the more rhetorical and monumental art of Leonardo, Raphael, and Michelangelo began to dominate the city.

For all Matteo's infatuation with Florentine art of the 1490s apparent in the Servi *Massacre*, the painting still exhibits the uneasy, almost claustrophobic, quality found in his previous works, even in the earliest of them. The compressed human frieze close to the spectator contains the same savage soldiers and the ethereal, Botticelli-influenced mothers seen in the version in Sant'Agostino. The fascination with cruelty surfaces again in the faces of Herod and many of the soldiers.

One of Matteo's last known pictures is a large and badly damaged *Assumption of the Virgin* (Fig. 65), in Sansepolcro, which was painted in 1487, around the time of the Servi *Massacre*. The fascinating mix of his late style appears here

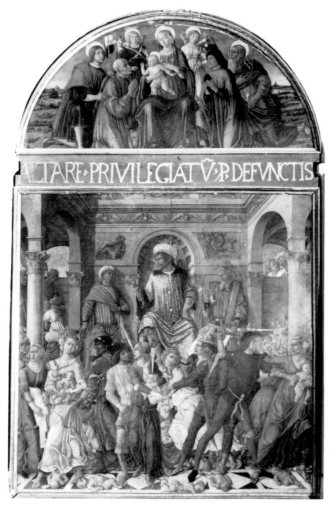

64. Matteo di Giovanni, *Massacre of the Innocents*. Siena, Santa Maria dei Servi.

again. The deep panoramic landscape is illuminated by a morning sun, whose rays touch the mountains on the distant horizon. The Virgin moves heavenward, flanked by fluttering angels and awaited by Christ and ranks of saints. Robed in white and enclosed in a fiery mandorla of seraphim, the Virgin is the focus of the upper part of the altarpiece. With its flattened, vibrant figures, this section recalls not only Matteo's earlier version in London but scores of Assumptions dating back to the early Trecento. The feeling for beautiful shape, rhythm, color, and

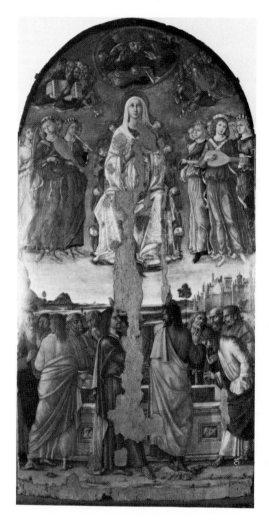

65. Matteo di Giovanni,
 Assumption of the Virgin.
 Sansepolcro, Santa Maria
 dei Servi.

interval, that precious Sienese heritage, is apparent. In the upper part of the
painting, the patterns are constructed by the white, blue, orange, violet, red, and
green colors of the figures' refined shapes. Matteo was not one of the great
Sienese colorists. On the whole, his use of color was discreet but not exciting.
However, in this late work he demonstrates that extreme sensitivity to color in-
herent in almost every Sienese painter.

Yet, the glory of the actual *Assumption* does not quite harmonize with the
lower part, in which the apostles stand in wonder around the Virgin's empty

sarcophagus. Here, space is expanded and made real while the figures have become more volumetric and palpable. Now, this dichotomy between the realms of the real and the supernatural appears in many Assumptions, but seldom is it so apparent or sharp. The landscape, with its wide river-strewn plain and distant mountains, is of a different and less fantastic order than that in the London *Assumption*, painted some fifteen years earlier, or, for that matter, from the wild and mystical world of Vecchietta's *Assumption* in Pienza (Fig. 22), completed in the 1460s. In the Sansepolcro picture Matteo presents a sweeping view of tall, thin trees and sunlit towns, a landscape reminiscent of those he probably saw in the paintings of the Umbrians—Perugino and Pintoricchio—who were working around the same time.

Perugino probably also furnished inspiration for the standing apostles, but like Matteo's other borrowings, they have been transformed by the artist's fecund mind. Although they belong to a more heroic and tragic race than Matteo's earlier protagonists, the apostles still exhibit much of the tenseness and some of the same controlled menace of the earlier figures.

These disturbing beings appear again in another late work by Matteo, the large altarpiece of the Madonna and child with angels and four saints in the Siena Pinocoteca (Fig. 66). The skillfully drawn figures of the kneeling Cosmos and Damian seem to be in arrested movement. To the right, the posing St. Galganus elegantly rests one hand on his hip and with the other holds the knobbed sword protruding from between his legs. The full-blown Madonna is a stunning creation of the mature Matteo's volumetric late work. To either side of her are weird and frightening images of cherubim, whose coy, staring faces seem like disembodied heads of children.

At first glance, the altarpiece seems symmetrically arranged in the rigidly architectonic mold of Matteo's paintings of the 1480s and 1490s, but further observation reveals some strange anomalies. The Virgin is not quite in the center of the picture. The space to the right is so limited that St. Galganus's arm is cropped by the frame. Moreover, Cosmos and Damian do not balance each other. The older saint kneels in front of the marble step, his foot almost touching the leading edge of the altarpiece, while his companion is placed farther back, squarely on the step itself. Thus, diagonal rhythm—from the kneeling saint at the left, through the Madonna, and back to St. Galganus—is countered by a similar but opposite movement from the kneeling saint at the right to the standing St. Sebastian at the far left. Undoubtedly, Matteo's inspiration for this composition of standing and kneeling saints arranged on the marble architecture of the Madonna's elaborate throne can be traced back to Florence, perhaps to the work of Filippino Lippi or Antonio Pollaiolo. But the stricter symmetry and

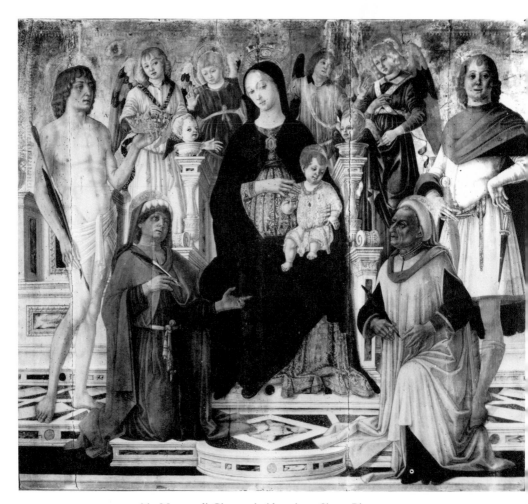

66. Matteo di Giovanni, Altarpiece. Siena, Pinacoteca.

more rational organization of the Florentine model has been replaced by a much more unbalanced and unsettling structure, one that accords perfectly with the figures, who seem disturbed and isolated in their airless environment.

As the Sansepolcro *Assumption* and the Siena Pinacoteca altarpiece demonstrate, Matteo's art had evolved significantly. His first paintings, which were still under the influence of Vecchietta, Sassetta, Sano di Pietro, and Piero della Francesca, demonstrated his unique artistic personality. He then moved toward a broader, more expressive, and—during his last years—more architectonic style that is best seen in the Servi *Massacre* and Pinacoteca altarpiece.

67. Guidoccio Cozzarelli, *Baptism of Christ with SS. Jerome and Augustine*. Sinalunga, San Bernardino.

Matteo was capable of great flights of lyric beauty. But he was also a painter of powerful drama and savagery. Although he was a skillful colorist with a varied palette, especially his pinks, reds, and creams—the range and subtlety of color in the last works are noteworthy—he often preferred to use color in the service of form rather than give it a more independent decorative function.

Matteo's style was closely imitated by Guidoccio Cozzarelli (1450–1516). As an assistant and follower of Matteo, he was the author of numerous Madonna panels, a handful of them of a quality quite near Matteo's own work.[9] Cozzarelli was also the producer of many small panels and altarpieces that are not much more than pallid and tired imitations of Matteo's more innovative, fiercer painting.

Cozzarelli's finest painting, the *Baptism of Christ with SS. Jerome and Augustine* (Fig. 67), was directly inspired by Matteo and is perhaps a copy of a lost work by that master. The fervent saints with their slightly sad faces are reminis-

68. Neroccio de'Landi, *Annunciation*. New Haven, Yale University Art Gallery.

cent of a number of Matteo's works, especially his polyptych with two kneeling
saints in the Cathedral of Pienza. The figure of John the Baptist also recalls the
angular, gaunt saints that so frequently populate Matteo's pictures.

This *Baptism* departs from Matteo di Giovanni in its treatment of landscape.
It is panoramic and deep, and filled with hills, clouds, and blooming orange
trees, possibly reflecting the influence of one of the Umbrian or North Italian
artists who worked in Siena during the second half of the Quattrocento.[10] The
peaceful, attractive background, however, is one of the rare instances of Cozza-
relli's independence from Matteo. Aside from a few inspired works, such as the
Sinalunga *Baptism* and several fine Madonna panels, much of Cozzarelli's paint-
ing remained a pale echo of Matteo, and, on occasion, it sunk to the level of
caricature.

The path followed by Matteo's art is paralleled roughly by his notable con-
temporary Neroccio de'Landi, who was born in 1447.[11] Like many of his fellow
artists in Siena, Neroccio was a pupil of Vecchietta, and his early work is much
indebted to that great teacher.

Vecchietta's influence is still apparent in a lunette of the *Annunciation* (Fig.
68), done around 1475, when Neroccio was in his twenties. Like Vecchietta's
splendid *Annunciation* lunette in Pienza (Fig. 21), this painting was originally
placed over an altarpiece, but the main panel is now lost. Vecchietta's rushing
angel and reticent Virgin must have been in Neroccio's mind, but his indepen-
dence is manifested by the entirely different form and spirit of his lunette. Ne-
roccio has suppressed the architectural framework of Vecchietta's swiftly reced-
ing columns, which send the viewer's eye hurtling down a tunnel of space; and
he replaced the large, floating ovals of the pavement with a grid floor pattern that
makes space recede more evenly and convincingly. Neroccio's fundamental spatial
rhythms are consequently more peaceful and less disquieting than Vecchietta's.

Neroccio's elegant *Annunciation* figures are also subtler and more lyrical than his teacher's. These types, which appear throughout Neroccio's career, are certainly influenced by his immediate forerunners, above all by Vecchietta and Sassetta; but they are also indebted to Neroccio's study of the more-distant Sienese past, specifically Simone Martini's svelte figures. Like his fellow artists, Neroccio studied Simone's magistral *Annunciation* (Fig. 2), of 1333, at the time in the Siena Cathedral, but now in the Uffizi, in Florence. Of course, the art of the early Trecento was always a touchstone for Sienese artists of the Renaissance, but in Neroccio's holy figures the link to the past is surprisingly close and immediate. His radiant, willowy beings with curly golden hair, however, have a delicacy and grace nearly unmatched in the long history of Sienese painting; their buoyancy and charm leave the spectator spellbound.

Neroccio's pictures are notable for the subtle meshing of their various parts. In the Yale *Annunciation* the interplay between the floor pattern, the figurative frieze of the distant wall, the architectural elements, and the soft, yielding figures in arrested motion creates a peaceful and inviting whole. The delicate, lilting spirit of the lunette is amplified by the landscape, seen through an arched opening in the wall. Here a placid, tree-lined river meanders to the sea beneath a blue sky filled with white clouds.

The same refined atmosphere of Neroccio's *Annunciation* appears in his portrait (still in its original frame) of an unidentified young woman (Fig. 69) in the National Gallery, Washington. It is the earliest and one of the finest of a handful of Sienese portraits. There were many Florentine Quattrocento portraits but portraits were rare in Siena.[12] In other areas of the Italian peninsula, donor portraits often appear in large altarpieces, but for some unknown reason, even such portraiture is uncommon in Siena.

Neroccio's haunting portrait is by no means realistic. Abstracted, dreamy, and oblivious of the spectator, the smooth-skinned woman looks to the viewer's left. Even the cascades of wavy blond hair that fall to her shoulders and her splendid dress and translucent pearls do not offset the strange melancholy of this picture. Neroccio has carefully guarded his sitter by showing us her idealized face and expensive clothes but nothing of the inner workings of her mind. In fact, she is so idealized and distant that one wonders whether she is a real person or some heroine of the ancient world, like Helen, famed for her beauty. Such representations of ancient heroes and heroines were well known in Renaissance Siena.

One thing is certain: many of Neroccio's sources for this haunting portrait are Florentine. The landscape suggests the influence of Leonardo da Vinci, although the background is more placid and less mysterious than those in Leonardo's early paintings.[13] The positioning of the sitter may also owe something to

69. Neroccio de'Landi, *Portrait of a Woman*. Washington, National Gallery.

70. Neroccio de'Landi, *Madonna and Child with Saints*. Siena, Pinacoteca.

Botticelli's famous *Portrait of a Man Holding a Medal*, painted around 1475; but other Florentines may also have influenced Neroccio, who, for this work at least, probably had no Sienese prototypes. Yet, the psychological and social associations of Florentine portraiture play only a secondary role in Neroccio's picture. The woman, her costly jewels, the tranquil landscape, and the blue sky are almost as important as the sitter herself. The lilting, captivating spirit, which both emanates from and centers around the young woman, is the real subject of the picture. Neroccio's powers as a refined and skillful painter of grace and beauty are at a peak here.

Neroccio painted a series of small panels of the Madonna, child, and several saints, all done in half-length. These skillful paintings demonstrate the way he constantly modified and varied a traditional subject. One of these panels, the *Madonna and Child with Saints* (Fig. 70), in the Siena Pinacoteca, is a contemporary of the National Gallery portrait and the Yale *Annunciation*. It is done in the sweeping attenuated manner of Neroccio's early works. SS. Jerome and Bernardino are behind and to the sides of the large central Madonna, who holds the child across her lap. This formula is generally repeated on most of the panels belonging to the series; it was also adopted by Matteo di Giovanni, Francesco di Giorgio, and several other Sienese painters of the late Quattrocento.

The Madonna is as lovely and distant as the sitter in the National Gallery portrait. The picture reveals, once again, the artist's considerable debt to Simone Martini, but the elegant shapes and silky articulation of the figures are Neroccio's own. His canon of heavenly beauty is seen in the arched eyebrows, eyes, long nose, shapely mouth, slender neck, and, above all, the poised and mannered hands, which also owe their inspiration to Simone Martini.

The old saints, the comely Madonna, and her fair, bright-haired child seem uncomfortably crowded. It is as though there is not enough room for them to exist; the frame seems to compress them, giving the work a claustrophobic quality that is at odds with the lilting forms of the Madonna and her lively child, or with the pinks, blues, and extensive gold of this lustrous painting.

Another picture in the same series, but from a later period (perhaps the 1490s), demonstrates both Neroccio's maturation and his consistency. The *Madonna and Child with Saints* (John the Baptist and Mary Magdalen) (Fig. 71), now in the Indianapolis Museum of Art, is one of the high points of Neroccio's art. It is richer in color than the Pinacoteca panel—with large areas of deep red, green, and brown—and less attenuated, actually fuller and more robust. This fullness is seen especially in the face of the Madonna, which is brilliantly modeled with subtle, minute gradations of light and dark, and in the baby's pneumatic body and head. This distorted, spherical head makes a strange contrast with the nearby face of the comely young Virgin.

71. Neroccio de'Landi, *Madonna and Child with Saints*. Indianapolis, Museum of Art.

Again, the child, the Virgin, and the two saints seem uncomfortably wedged into the picture's space; yet, their proximity to one another is negated by the lack of psychological contact between them. Each seems lost in his or her own thoughts, unaware of the others inhabiting the same constricted space. This disturbing sense of isolation is characteristic of most of the paintings in this half-length series. Many of them are composed with the figures set against the near edge of the picture, in direct contact with the spectator. This proximity and the strange isolation of the pictures may have been influenced by Neroccio's observation of, or perhaps work on, bier heads—decorated panels, often with close-up images of the Virgin, child and saints.[14] Sometimes the best Sienese artists were commissioned to do them. Their often eerie style is recalled in many of the half-length panels by Neroccio.

The fineness and brilliance of the Indianapolis painting are created by a subtle use of shape, volume, line, and modeling. Bathed in a diffuse but bright light, the rapt figures emanate a slightly unsettling feeling.

Yet, Neroccio's painting, like Matteo's, for all its inspiration from outside sources and from Siena's own past, is highly individualistic and personal. This independence is well illustrated in another late painting (Fig. 72), dated 1492, now in the Siena Pinacoteca. This altarpiece of the Madonna and child with six saints demonstrates Neroccio's exquisite sense of color. With subtle but varied shades of gold, rose, grey, blue, pink, red, and green, the artist leads the spectator's eyes across the surface of the panel in a measured series of beats and rests. The brightness of the colors and their arresting combinations (rose and gold, green and red, blue and pink—to name a few) make this picture a glowing and captivating work.

The six saints in this ambitious picture are typical of the mature Neroccio: elegant, mannered in pose and gesture, and swathed—except of course for St. Sebastian, whose bare torso gleams like his white loincloth and soft golden hair—in robes so sharply creased and rigid that they appear to be made of tin.

Once again, Neroccio has consciously made the figures fit rather uncomfortably in the picture's space. They seem awkwardly wedged in, as though there were not enough room for them to stand without twisting and turning. A semicircular recession ends in the figures of SS. John the Baptist and Sigismund. They are partially covered by a throne sporting the same type of living heads seen in Matteo's altarpiece, also in the Pinacoteca. The two outside saints, Peter and Paul, also are abruptly cropped by the frame, creating further spatial disturbance. Equally unsettling are the saints' faces, which are varied in structure and age but are all equally worried-looking and isolated. These majestic beings are evocative of those removed, hierarchical images of the Sienese Duecento,

72. Neroccio de'Landi, Altarpiece. Siena, Pinacoteca.

which Neroccio must have studied with admiration. Yet, as do all the saints in Neroccio's altarpiece, they bear the stamp of the artist's personal style and interpretation.

In their overall articulation and in the construction of their robes, Neroccio's saints recall many of his standing wooden figures.[15] Neroccio and Francesco di Giorgio, like their teacher, Vecchietta, were well-known wood-carvers; perhaps their experience with sculpture affected their approach to painting.

The Madonna, who occupies the center of the picture, is a remarkable creation. Her expansive gesture, her posture, and the broad base of her robe make her stable and volumetric, unlike the constricted figures behind her. A goodly expanse of space separates her and her son from the tightly packed saints. The Virgin herself is a worthy descendant of the comely Madonnas painted by Neroccio in the earliest part of his career. Still reminiscent of Simone Martini's sad-eyed women, she regards the spectator with a melancholy detachment, while her lively son clamors for attention. The grace and delicacy of these two figures are typical of Neroccio, although their carriage and glance recall Botticelli, a painter Neroccio must have admired.

Neroccio's large altarpiece (Fig. 73) in the National Gallery, in Washington, furnishes another good example of his mature power. Dating from around 1495, just a few years after the Pinacoteca polyptych, this work contains many of the

73. Neroccio de'Landi, Altarpiece. Washington, National Gallery.

same elements, although both the space and the number of figures have been considerably reduced. Neroccio's Sienese heritage and his love of the art of his city's past are most obvious in this picture. It is alive with delicate, elongated shapes that move across the picture's surface, not back into space. Composed

with a superb feeling for rhythm and interval, it is equal to the most-refined altarpieces by Duccio and Simone Martini. The figures are separated by gold, fashioned into elegant abstract shapes, and their construction, carriage, and gesture are accomplished with refinement and skill. Although Neroccio was totally immersed in Sienese tradition, he was thoroughly aware of and borrowed from the latest developments in Florentine painting.

Francesco di Giorgio, along with Neroccio and Matteo di Giovanni, made up the remarkable trio of Sienese painters working in the last half of the Quattrocento.[16] He was born in 1439 and probably studied with Vecchietta, although there is no documentary proof of that. He was certainly in close contact with Vecchietta's pupil Neroccio de'Landi, for the two artists shared a workshop for several years at the beginning of their careers. Like Neroccio and Vecchietta, Francesco di Giorgio was a painter as well as a sculptor. He was known throughout the Italian peninsula as a military engineer and was an important designer of fortifications. His talents as an architect for both sacred and secular buildings were also much in demand; and his surviving works, especially the remarkable Church of Santa Maria del Calcinaio in Cortona, are very distinguished examples of Renaissance architecture. Francesco spent much time away from his native Siena, in the service of the dukes of Urbino, the kings of Naples, and patrons in many other cities.

Many Sienese artists were multitalented: they could paint, carve, and build with unusual facility. But Francesco di Giorgio was the Leonardo da Vinci of Siena. He spent so much time building and designing, carving, casting (he was an accomplished medalist), and drawing (a number of his drawings and a treatise on architecture survive), that painting seems to have been a relatively minor part of his artistic production. Nonetheless, he was a serious and inventive painter who forged his own personal style. While he was indebted to the Sienese past, he also created images and narratives of considerable importance.

One of Francesco's earliest surviving pictures, the *Annunciation* (Fig. 74) of around 1470, demonstrates his youthful brilliance, although the surface is badly abraded. All light blues, pinks, whites, and reds, the fulgent palette of this work coincides perfectly with its drama. The foreground is occupied by the Virgin and the Angel of the Annunciation. The two lithe, mannered figures who seem to hover, rather than stand or sit, are reminiscent of the graceful, floating beings of Neroccio's Yale *Annunciation*. The close interdependence of Neroccio and Francesco during the early years of their careers can be seen in the delicate faces and fine golden hair. Francesco di Giorgio's interest in the problems of drawing is apparent in both the position of the Virgin and her intricately folded robes.

The sacred drama of the Annunciation unfolds in a loggia attached to what

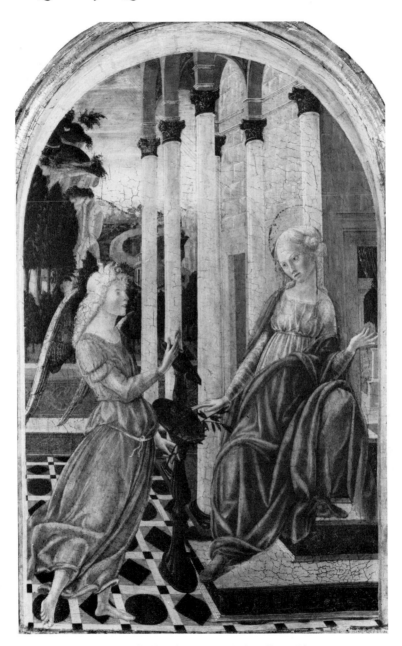

74. Francesco di Giorgio, *Annunciation*. Siena, Pinacoteca.

appears to be a palace. With its slender pink columns, red arches, and red pavement, the loggia is not meant to be a mere imitation of reality. The columns, of a proportion and deposition unlike any real architecture, and the tipped-up floor, with its space-defying pattern and weirdly placed lectern, belong to the world of fantasy and irrationality that was the heritage of Sienese painting of the Renaissance. As a skilled engineer and master draftsman, Francesco di Giorgio was quite capable of drawing correct perspective, but such a system did not interest him here. He and his contemporaries and teachers (Vecchietta and his Pienza *Annunciation* spring to mind) felt that the correctness and mathematical certainty of contemporary Florentine painting were too mundane; and, because they brought the spectator so close to the holy dramas and figures, perhaps too sacrilegious. For these artists correct one-point perspective would have been too static and predictable, devoid of the spatial and psychological tension so beloved by the Sienese.

Because of the sharp foreshortening of the floor and the construction of the loggia, the light, agile figures seem to float in the foreground. This space ends in a fantastic piled-up landscape, with hill towns picked out in red and a wide placid river. The scene may reflect Francesco di Giorgio's study of paintings by Piero della Francesca, perhaps in Urbino, where both men worked. But the twisting hills, with overhanging trees and sharp spatial jumps, mark the landscape as Francesco di Giorgio's own. In fact, its jumble of pink, red, and green fits perfectly with the unreality of the whole picture. From the gentle balletic movements of the figures to the overgrown, almost primeval, hills, this *Annunciation* is, at one and the same time, highly original yet very Sienese.

One of the most remarkable Sienese paintings of all time is Francesco di Giorgio's *Coronation of the Virgin* (Fig. 75), a grandiose altarpiece (337 × 200 cm). It appears to have been commissioned in 1472 for the chapel of SS. Sebastian and Catherine of Siena in the abbey of Monte Oliveto Maggiore, the great Benedictine monastery near Siena.

At first glance one is swept up by the sheer size, complexity, and luminous living color of this work—including a whole range of stunning reds, pinks, roses, whites, blues, and yellows. The range of color is matched by a remarkable composition. The center is occupied not by the *Coronation* itself, but by two graceful angels and two twisting seraphim, all supporting a saucer of clouds holding the Virgin and Christ. What one sees at first glance is not the central act of the holy drama but the original and bizarre mechanism of its support.[17] Further examination reveals, however, that the angels are supported by a cloud of seraphim below their feet, which, in turn, rests on a slender stalk of lilies held by St. Catherine. Unlike Florentine versions of the Coronation, this painting lacks a

75. Francesco di Giorgio, *Coronation of the Virgin*. Siena, Pinacoteca.

basic structural reality and logic—something found on earth, but not, the Sienese thought, necessarily in heaven.

Groups of holy onlookers mill around the empty space surrounding the angels and seraphim—really a great hole punched into an otherwise crowded painting. Among them are some of the most comely and the most grotesque of Francesco's holy beings. There are tall, elegant saints, such as Dorothy, at the lower right, and the women filling the lower left corner. But to either side of the cloud-carrying angels, there are deformed characters with heads like melons, distorted features, grimacing mouths, and leering eyes. The reason for these weird beings, all in the guise of saints, is unknown; but it is safe to say that except for the works of the late Giovanni di Paolo (which may have influenced Francesco here, although more by spirit than by form), there is nothing like them in the long history of Sienese painting. Some of them are horrifying, some simply bizarre, others funny—and obviously meant to be so.

Christ and the Virgin are the largest figures in the picture. They are the objects of the fervent gaze of the chapel's name-saints—Sebastian (here clothed, an unusual occurrence) and Catherine. The complex posture of Christ, with widely spread legs and twisting torso, recalls the Virgin from the Pinacoteca *Annunciation*. Francesco di Giorgio, like so many other Renaissance artists, was endlessly fascinated with the problems of drawing: how to put a figure in space, how to foreshorten an arm, how to make drapery move over a knee. The meek Virgin kneels to receive the crown; by both the gesture of her body and the expression of her face, she is a model of passivity. She also recalls a figure in the *Annunciation*, not the Virgin, but the much less complicated angel. The majesty of both Christ and the Virgin is very much in keeping with the solemnity and grandeur of the event.

There are at least three angles of view in this painting: down on the kneeling figures; straight-on for the middle row of saints and angels; and up for Christ, the Virgin, and the seated spectators behind them. These viewpoints give the painting a shifting, fluid quality and keep the many figures and shapes in flux.

Hovering above the entire luminous, multicolored vision is God the Father, surrounded by a whirlwind of astrological symbols. This majestic figure anticipates Michelangelo's famous images of God the Father in the Sistine Chapel painted years later.

In its grandeur and invention, this highly idiosyncratic *Coronation* is a high point in the fertile art of Francesco di Giorgio. It is also quintessentially Sienese in its grace, unreality, color, bizarreness, and deeply personal interpretation.

The triumphs of the Sienese imagination are not limited to great altarpieces, but are present in the many types of painting produced by Sienese Re-

76. Francesco di Giorgio, Fragment of a *cassone* front.
New York, Metropolitan Museum of Art.

naissance artists. A fine example in another form is a fragment of a *cassone* (chest) front by Francesco di Giorgio (Fig. 76), showing his version of a Classical theme. It was probably painted in the 1470s, although that is not certain, for the dating of such panels is notoriously difficult, if not impossible. A figure, most likely the Goddess of Love, is carried on a fantastic cart drawn by griffins. The picture is a blaze of gold (the cart) and silver (the lovely maidens' dresses). Even in its fragmentary form the painting lends the ancient theme a lilting splendor and draws the onlooker into an enchanted world of symbol and fable. The dawn sky, the craggy sunlit hills, the sweet golden-haired women, the delicate Goddess of Chaste Love sitting regally on her mobile throne, and the haughty griffins occupy a bewitching world of the Sienese imagination. In *cassone* panels painters were free to invest the ancient stories with the full range of supernatural mystery and charm that had to be more restrained in their altarpieces.

Although they were fascinated with the world of antiquity, the Sienese artists never conceptualized the ancient stories in a dry, archeological way; instead, they invented and fantasized, creating their own chivalric and elegant world of

the past. Eschewing crude imitation of Roman art, they reinvented the great age of myths and triumphs in an elegant Sienese style. There are many Sienese *cassoni* from the Quattrocento—some of them little known or studied—which are as lyrical and original as the one by Francesco.[18] The impact of the Classical past on Sienese art and letters is still not fully measured, but it was considerable; the Florentines were not the only ones reviving the past and incorporating it in their lives.

As we have seen, the Sienese humanists seem to have been more catholic in their taste than many of their Florentine contemporaries. How else would it have been possible for someone so steeped in the Classics as Pius II to commission such conservative artists as Giovanni di Paolo or Sano di Pietro? And, in the work of Francesco di Giorgio himself, we find such personal and insular pictures as the *Annunciation* and *Coronation* existing side by side with very stylish, up-to-date churches and medals. This duality is best seen in the combination of Giovanni di Paolo's weird, Duccio-inspired Pienza altarpiece and the stylish, antique-style frame surrounding it.

In 1978–79, prompted by early descriptions of paintings by Francesco di Giorgio in the Bichi Chapel in Sant'Agostino, Siena, investigators uncovered several frescoes of great interest hidden under coats of plaster.[19] Among them are two large paintings, the *Birth of the Virgin* (Fig. 77) and the *Adoration*, which constitute the sole surviving fresco cycle from the end of the Quattrocento by a Sienese artist in Siena; moreover, they are Francesco di Giorgio's only well-preserved works in the medium. Because the now-dispersed altarpiece (Fig. 82) for the Bichi chapel was done by Signorelli, who also executed several figurative roundels on the walls just above Francesco di Giorgio's painting, it is possible that this commission was originally given to Signorelli, an artist from Cortona.[20] Nevertheless, it was Francesco di Giorgio not Signorelli who executed the recently found paintings, which have provided insight into Francesco di Giorgio's late work as well as into the state of Sienese painting in the last years of the fifteenth century.

Painted around 1490, both frescoes exhibit a remarkable spatial breadth and depth not anticipated in previous Sienese painting. Of course, Francesco di Giorgio did not abandon the past—that is impossible for a Sienese artist—but he modified it greatly and used it to help change the direction of his art. For instance, the basic composition for the *Birth of the Virgin* can be traced to an altarpiece by Pietro Lorenzetti painted for the Siena Duomo, a composition that was repeated and modified by many later painters. But when Francesco di Giorgio utilized it, he chose to expand both its scale and its scope, to make it ampler and more monumental. This amplification is not limited to the size and architecture

77. Francesco di Giorgio, *Birth of the Virgin*. Siena, Sant'Agostino, Bichi Chapel.

of these two frescoes but is also found in the figures, which no longer hover, but are solid, volumetric, and firmly planted on the ground.

This new direction stems, first and foremost, from the artist's own inquisitive, empirical mind, which produced the strikingly original Pinacoteca *Annunciation* and *Coronation*. But Francesco di Giorgio also utilized some of the new developments in painting taking place around him; and that is interesting in light of his preoccupation with engineering and architecture during this late phase of his career. His outside inspiration in painting seems to have come from several distinct sources. In the work of Signorelli, who was both his associate and friend, Francesco di Giorgio glimpsed a world populated by large, sturdy figures whose construction provided the solution to certain complex problems of placement, foreshortening, and anatomy—figures that were not only representations of holy or mythological beings but also demonstrations of the painter's skill.[21] This concern with the empirical, problem-solving aspects of art—a concern that grew stronger in the early years of the sixteenth century—appealed to Francesco di Giorgio, who, in all the various arts he practiced, was an experimental artist. Also, in Signorelli's paintings of the 1490s, he would have found a profound interest in deep, panoramic landscape, convincingly scaled to the

weighty figures occupying it. A similar interest is also seen in Matteo di Giovanni's magistral Sansepolcro *Assumption*, painted just about the time Francesco di Giorgio was at work on the San Domenico frescoes.

In the paintings of foreign artists—including Perugino and Pintoricchio, whose work he had seen in Umbria and in the many other locations where his work took him—Francesco must have noticed an increasing interest in regularity and orderliness.[22] A new monumental, architectonic style was developing and would be carried to fruition by the next generation of painters, which included Raphael, Michelangelo, and Andrea del Sarto.[23] Signorelli and, to a certain extent, Francesco di Giorgio, on the walls of the Bichi Chapel, are forerunners of this new pictorial language. It is testimony to the imagination and flexibility of Francesco di Giorgio that he could paint works as fundamentally diverse in form, spirit, and meaning as the whirlwind *Coronation* and the calm, monumental *Birth of the Virgin*. The Sienese tradition still maintained its elasticity and inventiveness, even on the eve of its dissolution in the late fifteenth century. Francesco di Giorgio was a daring and resourceful artist, quite different from the delicate and conservative Neroccio, whose pink and blond apparitions look not to the future but to the past.

Trailing in the wake of the three great artists of late Quattrocento Siena—Matteo di Giovanni, Neroccio de'Landi, and Francesco di Giorgio—were a number of lesser painters. While their works are sometimes arresting and always charming, they do not have the spiritual or the formal power of those three remarkable figures.

Perhaps the finest of these artists was Benvenuto di Giovanni[24] (1436 [in Siena]–1518). He is documented working with his teacher Vecchietta on the frescoes for the Siena Baptistery in 1453. But, in his earliest known work, an *Annunciation*, of 1466 with SS. Michael and Catherine and a donor (Fig. 78), in the small church of San Girolamo outside Volterra, his personal style and independence are already apparent.

The elegant, balletlike ritual of the Annunciation unfolds before a background of shimmering gold. Placed on a platform of variegated marble, the thin, fragile actors seem to exist in a world devoid of air; so crisp and hard are the details of robe, face, and hair that there appears to be no intervening atmosphere between them and the viewer. Frozen and iconic, this early picture by Benvenuto is both a beautiful and a remarkable image. Very little of Vecchietta's more monumental Florentine idiom is seen in Benvenuto's Volterra *Annunciation*. In fact, its main source of inspiration appears to have been Simone Martini's 1333 *Annunciation* (Fig. 2) in the Siena Duomo. This famous panel was, of course, the spur for the Yale *Annunciation* by Neroccio, Benvenuto's contemporary and probably fellow student in Vecchietta's shop.

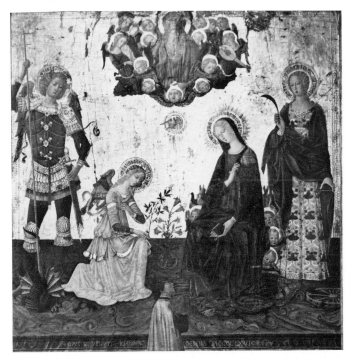

78. Benvenuto di Giovanni, *Annunciation*. Volterra, San Girolamo.

Neroccio's and Benvenuto's paintings depict the same type of radiant, blond, elongated figures. But Benvenuto, whose altarpiece in Volterra probably predates Neroccio's *Annunciation*, is not interested in the spatial and landscape complexities that fascinated Neroccio. Benvenuto ignored them (and the complicated setting of Vecchietta's own Pienza *Annunciation*, finished just a few years earlier) in favor of a flat gold background of the type popular in the early Trecento. Even the saints standing to either side of the *Annunciation* are probably derived from the two saints flanking the central panel of Simone's *Annunciation*. Although Benvenuto's work is inspired by the Sienese past, it is not simply an imitation. It reinvents rather than repeats Simone's famous composition, and it does so in a style that is Benvenuto's own.

The crystalline atmosphere of the Volterra *Annunciation*, which reappears throughout Benvenuto's long and productive career, is seen again in another *Annunciation* (Fig. 79), now in the Museo d'Arte Sacra della Val d'Arbia in Buonconvento. In this large altarpiece, probably painted in the last decade of the Quattrocento, one can see how much Benvenuto's horizons have expanded since the 1466 Volterra *Annunciation*. He and his fellow painters in Siena have moved

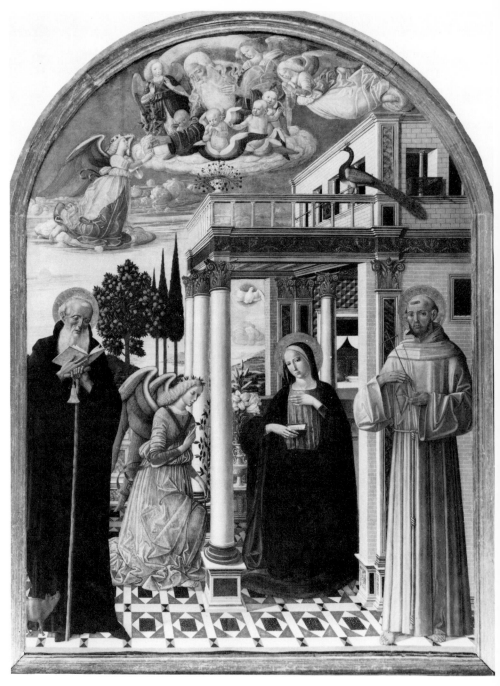

79. Benvenuto di Giovanni, *Annunciation*. Buonconvento, Museo d'Arte Sacra
della Val d'Arbia.

from the world of Vecchietta, Giovanni di Paolo, and Sano di Pietro toward the visions of the late Matteo di Giovanni and Francesco di Giorgio.

This second *Annunciation* is bright, with strong, highly variegated color—warm lemon yellows, deep reds, and cool, limpid blues. The entire surface is fragmented by fields of joyous color so appropriate to the subject. Not subtle or strange, like so many of his contemporaries' palettes, Benvenuto's color is unselfconsciously meant to appeal to the viewer's delight in strident, almost gaudy, hues in happy combination. The formation of this brilliant palette may owe something to Girolamo da Cremona and Liberale da Verona, two painters and miniaturists of considerable talent active in Siena during the second half of the Quattrocento.

The figures populating Benvenuto's later panels are more substantial than their counterparts in the Volterra *Annunciation* and not so influenced by Simone and the early Trecento. Benvenuto has turned toward a broader interpretation of the figure. However, these figures have what may be termed only lateral amplitude; in characteristic Sienese fashion, their wide but thin bodies extend across the picture's surface as pattern but not into its depth.

Like Matteo di Giovanni and Francesco di Giorgio, Benvenuto has transformed the background of his work into a panoramic, detail-filled world of mountains, placid lakes, and scudding clouds. Populated with blooming orange trees and slender cypresses, this sunny land is peaceful and inviting, the perfect complement to the joyous color of the altarpiece. In its simple festivity, Benvenuto's Buonconvento *Annunciation* is one of the happiest of all late Quattrocento Sienese paintings.

Benvenuto's other important late work is the *Ascension* (Fig. 80) in the Siena Pinacoteca. Divided into two spheres—a lower temporal landscape with figures and an upper heavenly realm—this work is notable both for its grandiose size (397 × 245 cm) and its profusion of images. Each of the dozens of figures, while still broadly conceived, is covered with voluminous drapery so crisply and intricately folded that it looks like thin sheets of tin. Nearly microscopic detail, seen also in the hair, facial features, and landscape, combined with the multitude of saints and angels, produces a disturbing signal, much in contrast to the two Annunciations we have already discussed. Compelling but then repelling, this giant, writhing mass of figure and form is an unescapable presence.

The painting is undoubtedly indebted to the *Coronation* by Francesco di Giorgio, for it retains some of the latter's inventions in the flanking crowds, in the flying God the Father, and in several of the svelter female figures. The panoramic landscape probably derives from Umbrian painting, perhaps from Pintoricchio; the weird cliffs and strange buildings may be inspired by northern European

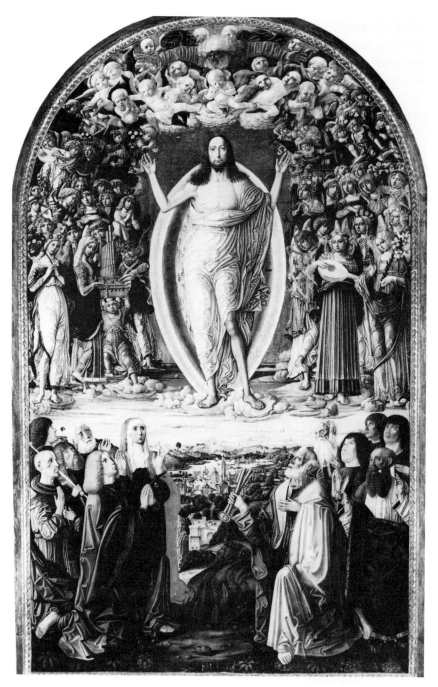

80. Benvenuto di Giovanni, *Ascension*. Siena, Pinacoteca.

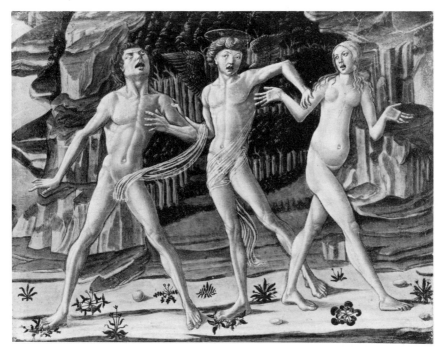

81. Benvenuto di Giovanni, *Expulsion of Adam and Eve*. Boston, Museum of Fine Arts.

engravings; and some of the figure types in the foreground are convincingly bor-
rowed from northern Italian painting. In this disturbing and neurotic *Ascension*,
Christ mysteriously floats above a deep greenish blue landscape. He is enclosed
in a multicolored mandorla, surrounded by scores of full-faced blond angels and
saints, and covered by a swirling cascade of tinlike drapery. As he raises his hands
in blessing, fixing the spectator with his stare, his presence is curiously still and
spectral, even hypnotic.

Toward the end of his painting career Benvenuto di Giovanni increasingly
collaborated with his son Girolamo.[25] A fine predella panel, the *Expulsion of
Adam and Eve* (Fig. 81), is perhaps the result of this collaboration: the design
Benvenuto's but the roundness of the figures and the details of face and hair the
product of his son's hand. In any case, superb balletic movement—as much
dance as drama—marks the little panel as one of the treasures of late Quattro-
cento Sienese painting. The rhythmic interplay of the figures and the subtle in-
tertwining of their arms create an alive, measured movement. The angularity and
agitation of the figures exactly express the heart of the story.

Set against weird rocky hills and a thick forest, the narrative is elevated into a realm of fantasy typical of the Sienese. This world is already glimpsed in Benvenuto di Giovanni's *Ascension*, in which strident color and vast crowds whirl before the onlooker. How different is this dreamlike drama from the sterner, more realistic Florentine narratives of the same time!

The *Expulsion* still stands squarely within the tradition of Sienese painting. Its emphasis on the unreality of the narrative and its refashioning of the natural world into a dreamscape are native to Sienese art from its inception in the thirteenth century. In fact, all the painters discussed in this chapter, from Matteo di Giovanni to Benvenuto di Giovanni, are the heirs of the highly original and particular style of painting that developed in Siena over several centuries. Like their forerunners, they were talented innovators who, within the elastic boundaries of the Sienese vision, carried on the remarkable style.

Yet, the dissolution of that tradition was near. True, Domenico Beccafumi would yet paint pictures that are in many ways the grand finale of the Sienese school, but the ancient bonds of Sienese art slowly began to loosen. For the first time in the long history of Siena, outside influences, which before had always been incorporated into the Sienese style, began to dominate.

FIVE

THE EARLY

SIXTEENTH CENTURY

The Dissolution of Tradition

Mᴜᴄʜ ᴏꜰ ᴛʜᴇ ʜɪꜱᴛᴏʀʏ of art in Siena is the response of the city's artists to the strong outside influence exerted on them. The painting and sculpture of nearby Florence played some role in the formation of every major Sienese painter. Occasionally, these outside influences were to be found within the city's walls. For example, Spinello Aretino and Donatello both left works that had an impact on Siena's style; in fact the latter's sculpture must be considered a major source of inspiration for several Sienese painters.

Yet, for such a small, insular, and relatively powerless city, Siena maintained an art remarkable for its strong tradition and innovation. Extremely self-sufficient, this art found most of its strength from its own past, a past usually only superficially indebted to outside sources. Why Sienese art was both so independent and so vital remains a mystery, but part of the answer surely lies in the tightly woven fabric of Sienese society and culture, a strange, self-propelling world.

Around 1500, however, this world began to show signs of considerable stress. Endemic political instability and a shrinking of the political elite modified the traditional patterns of Sienese government. Moreover, Sienese aristocrats began to abandon trade and commerce for agriculture. Instead of remaining merchants and bankers, they became a *rentier* class; instead of being the generator of

wealth, Siena became an impoverished consumer of goods and services from the countryside. Conspicuous consumption became common, as patronage shifted away from the public and corporate toward the glorification of the individual and his family. A series of mini-courts—to use Judith Hook's term—grew up around the major aristocratic clans. The great patrons, it appears, were now less sure of the rightness of the crumbling Sienese tradition and more willing to look outside the city for both inspiration and artists. One indication of this trend is the number and quality of foreign painters working in Siena around 1500. Unlike many of their predecessors, these artists made great and lasting inroads in the city—perhaps precisely because of the strain its institutions were undergoing—and caused substantial modifications in Siena's ancient traditions of image making.[1]

Luca Signorelli, an eclectic and eccentric artist, was one of the important figures of this time. In the 1490s he was given the commission for several paintings in the Bichi Chapel in Sant'Agostino, Siena. He produced an altarpiece (Fig. 82), and he began work on a fresco cycle but completed only several large roundels containing seated figures.[2] The remainder of the cycle, as we have seen, was finished by Signorelli's friend Francesco di Giorgio. In fact, Signorelli's altarpiece, now dismantled and scattered, was painted to enclose a statue, probably a St. Christopher carved by Francesco di Giorgio.[3]

Luca was born in Cortona and probably had his first training with no less an artist than Piero della Francesca. Through Piero and through study, especially of the painting of the Pollaiuolis, he became familiar with the basic principles of Florentine art. He was also probably influenced by Sienese painting, particularly the works of Matteo di Giovanni and of Francesco di Giorgio, but he cannot be classified as either a Florentine or a Sienese. Rather, he is a strongly individualistic artist who absorbed and transformed borrowings from a whole range of artists, stretching from Masaccio to Michelangelo; and some of the latter's massive figures may have, in turn, been lifted from Signorelli's early work.

Signorelli's paintings in the Bichi Chapel and his designs for frescoes in a splendidly painted room in the palazzo of Pandolfo Petrucci (also containing paintings by Pintoricchio and other well-known foreign artists) must have served as beacons for many Sienese painters.[4] The monumentality of Signorelli's figures, the scale and scope of his landscape, the amazing prophetic skill of his drawing, and his use of light to create atmosphere and pictorial unity impressed his Sienese colleagues mightily. Exactly what his contemporaries took from him is harder to define because Signorelli himself was indebted to living Sienese artists and also to the long tradition of the city of Siena, a tradition that had also influenced his putative teacher, Piero della Francesca.

Yet, it was not the form or composition of Signorelli's work that made the

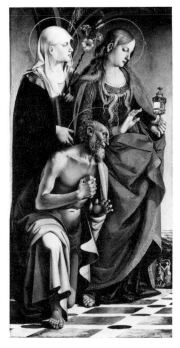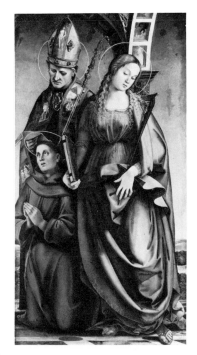

82. Luca Signorelli, Wings of the Bichi Altarpiece. Berlin, Staatliche Museen.

most lasting impression on Sienese artists, but his strange and eccentric spirit. His expressive, dynamic figures and the unworldly, often haunting, atmosphere of his painting would appeal to the Sienese sensibility.

A further influence on Signorelli may have been Perugino, another foreign figure who seems to have made an impact on Siena at a time when the city's artists were highly receptive to change.[5] This Umbrian artist was a talented representative of a flourishing school of painting centered in and around his birthplace, Perugia, for the greater part of the fifteenth century. Although his early training is not documented, it appears that Perugino spent some time in Florence, perhaps in the busy workshop of Andrea del Verrocchio. Perugino slowly moved away from the more rational and literal Florentine style. By the early years of the sixteenth century, he had developed a personal idiom that was, in turn, to influence and to be influenced by that of his famous pupil Raphael.

In 1502 Perugino is recorded in Siena (that may not have been his first stay there) in a document commissioning him to paint a large altarpiece (Fig. 83) for the Chigi chapel in Sant'Agostino, which is still in the church. This altarpiece presented Sienese painters with a pictorial world quite different from their own.

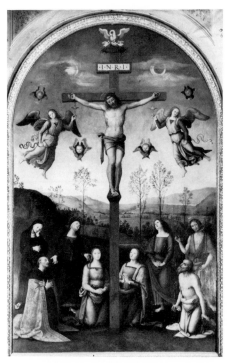

83. Perugino, Altarpiece.
Siena, Sant'Agostino.

Indeed, it de-emphasizes drama and stress, deactualizes the Crucifixion, and turns it into an object of contemplation. The crucified Christ seems more statue than flesh and blood. Arising from the array of standing and kneeling saints is the serene, meditative spirit that is the essence of many of Perugino's paintings and an attractive feature of his art.

Sienese artists must have been enchanted by the elegant landscape filling the background of the *Crucifixion*. Gentle, sun-drenched, fertile hills; slender, elegant trees; and a vast expanse of sky echo and reinforce the contemplative mood. The holiness of Christ is reflected and amplified by the radiant light of Perugino's natural world, which, like the actual Umbrian landscape, seems sacred and mystical.

The same Sienese painters would also have looked with interest at Perugino's drawing style. Like Signorelli's, it reflected the developments in Florentine painting around the turn of the century, although in a less-monumental, less rhetorical way. Drawing as problem solving, as a virtuoso exercise, are aspects of draftsmanship that interested the mature Perugino and that must have attracted the attention of the Sienese artists who visited his *Crucifixion* in Sant'Agostino.

Also in 1502, the same year in which Perugino was commissioned to paint

the *Crucifixion*, Pintoricchio, another Umbrian artist and a pupil of Perugino, was entrusted with the decoration of the Piccolomini Library.[6] This large structure, attached to the Siena Cathedral, was erected to house the manuscript collection of Pius II, the founder of Pienza and patron of Giovanni di Paolo, Vecchietta, and Matteo di Giovanni, among others. Although the library was his major work in Siena, it was just one of a number of frescoes and panels that Pintoricchio and his shop painted in the city during the early years of the sixteenth century.

The awarding of the Piccolomini Library decoration to an outsider follows a pattern of increasing patronage of foreign artists. Certainly, foreign artists had worked in Siena before, but the frequency of their appearance and the size of their commissions greatly increased in the early 1500s. Why was Pintoricchio, an artist far removed from the Sienese tradition, chosen over his Sienese contemporaries? Perhaps the faith of the Sienese in their own hallowed past had been shaken, not only with respect to the large commission for the Piccolomini Library but in many other instances as well. Pintoricchio was given the task of decorating the walls of the library with large scenes from the life of Pius II, the uncle of the patron, Francesco Todeschini Piccolomini, who became Pius III, but died shortly after ascending to the Throne of St. Peter.

The Departure of Enea Silvio Piccolomini for Basel (Fig. 84) starts the fresco cycle with a flourish. Before a stormy sky, Enea, mounted on a magnificent white charger, and his group move across the picture plane. Pintoricchio's rich treatment of costume, animals, the ships in port sheltering from the storm, and the charming hill town holds our attention. The cavalcade of figures and horses serves as an animated introduction to the fresco's most marvelous parts: the extensive views of land, sea, and sky. The landscape shimmers with light and is heavy with atmosphere. It resembles those of Perugino in type and scope, but it is less mystical, more joyous. Especially impressive is the great swatch of grey storm clouds hanging over the port. The clouds (probably created by wiping pigment on the wet plaster with a sponge or cloth) are active participants in the unfolding drama. A rainbow hanging above Enea Silvio suggests that this beginning is indeed auspicious and a fitting introduction to the depiction of the life of this humanist pope.

One problem faced by Pintoricchio and his helpers on this extensive cycle was the nature of the material to be illustrated. The episodes were based largely on the pope's own memories (the *Commentari*) and did not contain scenes of great dramatic moment.[7] Pintoricchio had to be a skillful storyteller to make Enea's unexciting departure for Basel into such a spirited and compelling narrative, and that feat would not have escaped the attention of the Sienese artists.

Pintoricchio has a light, festive palette. His whites, roses, reds, greens, and

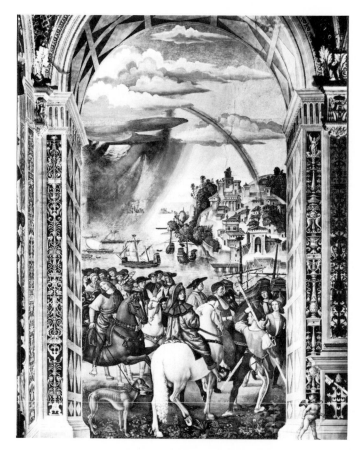

84. Pintoricchio, *The Departure of Enea Silvio Piccolomini for Basel*. Siena, Piccolomini Library.

blues seem to have floated onto the surface of the frescoes and reveal the wash-like nature of true fresco painting. In the library one is always conscious of the white ground of plaster over which the fluid pigment has been applied and, therefore, aware of the fresco medium and the painter's knowledge of its potential.

Perhaps the most remarkable landscape is found in the painting *Enea Silvio Piccolomini Delivering a Speech before King James of Scotland* (Fig. 85). This fresco pictures the land to which the future pope was sent on a diplomatic mission. Since Pintoricchio probably knew nothing about Scotland, other than that it was cold, he was free to give concrete form to his imagination. The scene is set in a loggia placed before a deep landscape of fantastic hills, distant mountains, and

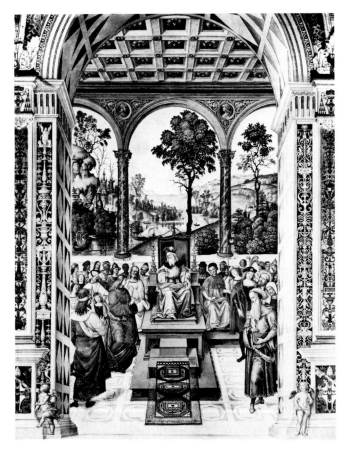

85. Pintoricchio, *Enea Silvio Piccolomini Delivering
a Speech before King James of Scotland*.
Siena, Piccolomini Library.

a wide, placid river flowing down to the sea. Populated by spired castles and tiny
boats, the lush, light-filled scene remains one of the artist's most distinguished
achievements. Here is a celebration of the world and a visual poem to its bounty
and beauty, which must have impressed the Sienese, because of their long and
celebrated landscape tradition.

The grouping of figures in the loggia seems to have been influenced by
Ghirlandaio's *St. Francis before the Sultan*, in the Sassetti Chapel in Santa Trinita,
Florence.[8] Here is a good case of the free interchange of ideas and composition
that occurred all through the central Italian peninsula at this time, making the
determination of stylistic influence and borrowing difficult, if not impossible.

For example, it is quite possible that Pintoricchio took the composition not directly from Ghirlandaio's fresco but from the work of another artist who, in turn, may not have taken it directly from Ghirlandaio.

The frescoes in the Piccolomini Library impressed the Sienese artists by their scale, color, landscape, and decorative detail, including the use of many antique-inspired grotesques and other ornamental patterns. Because of their innate interest in art as fantasy and decoration, the Sienese were predisposed to appreciate and utilize the triumphs of Pintoricchio's frescoes.

While Signorelli, Perugino, and Pintoricchio were all from southern Tuscany or Umbria, artists from more-distant locations on the Italian peninsula also came to work and live in Siena. The most notable was Giovanni Antonio Bazzi (1477–1549), called Il Sodoma, the Sodomite, a name he himself used. He had a bizarre personality (at least according to Vasari). He came from Vercelli, in the north, where he was trained by Spanzotti, although the major influence on his early style was certainly Leonardo.[9] When Sodoma arrived in Siena he was still a young man, and his work from the last years of the Quattrocento onward is really part of the history of sixteenth-century Sienese painting. In Tuscany, this impressionable artist was also influenced by Signorelli, Fra Bartolomeo, and Raphael, to name just three of the strongest pulls on his style.

This mix of late fifteenth-century styles appears as an overlay to Sodoma's own strong personal idiom in several of his earliest works in and near Siena, including an extensive series of frescoes (painted around 1508) at the abbey of Oliveto Maggiore. These frescoes were begun by Signorelli, who abandoned them after finishing only a few. The commissioning of Signorelli and Sodoma, both foreign painters, to execute such a major cycle is another indication of the increasing popularity of artists from outside Siena's walls in the late Quattrocento and early Cinquecento.

Sodoma's *Descent from the Cross* of 1502 (Fig. 86) is one of his first major commissions in the city. Large and imposing, the altarpiece demonstrates Sodoma's debt to Leonardo, especially in figure construction and expression, most notably in the Virgin and her attendants at the lower left. The detail and naturalism in the figures and landscape are characteristic of much painting from the north of Italy.

The sentiment of this painting is very different from the sweet and mystical Perugino, the gay and decorative Pintoricchio, or the more austere Signorelli. The melodramatic and rhetorical spirit of the *Descent* is common to many of the paintings executed by Sodoma in Siena. A dark, almost greasy, palette, which appears in most of his later work, is barely apparent here.

The Sienese, attuned as they were to the latest Florentine developments,

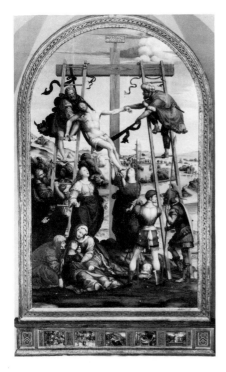

86. Sodoma, *Descent from the Cross*. Siena, Pinacoteca.

must have paid particular attention to this young artist who was so inspired by Leonardo. The combination of his Florentinism and his own strong style, which was much indebted to his northern teachers, could only have made the *Descent* more fascinating.

It has been customary to consider Sodoma a powerful influence on Sienese painting of the first quarter or so of the sixteenth century. But this notion is in need of some modification, for by nature Sodoma was spongelike and absorbed many styles. Certainly, he influenced a number of artists: his own students, close followers, and even an artist as distinguished as Domenico Beccafumi. Yet, he himself was equally affected by the powerful Sienese tradition he encountered while still a young artist, and, on balance, it appears that the Sienese influence on him was greater than his on Siena.

A good example of the change in style and interpretation wrought, in part, by foreign influence is the work of Andrea di Niccolò. He was an artist of modest talent who was active from the second half of the Quattrocento into the second decade of the new century.[10] An altarpiece (Fig. 87) now in the Siena Pinacoteca reveals him to be a rather watered-down follower of Neroccio and Matteo

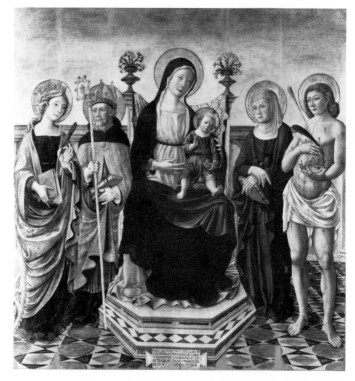

87. Andrea di Niccolò, Altarpiece. Siena, Pinacoteca.

di Giovanni. The enthroned Madonna and the rather awkward saints are reflections of the svelter, more gracious Neroccio and the more expressive Matteo di Giovanni. The throne and the floor pattern, in fact, the entire composition, still retain all the traditional elements of Sienese painting of the end of the fifteenth century; this altarpiece is a testament to Siena's confident belief in its own rich past.

Yet, just two years later, several substantial changes are seen in the same artist's work. In the *Crucifixion with Saints* (Fig. 88) the breadth and depth of the landscape, which fills the picture's surface and nearly dominates the narrative, owes its panoramic quality to paintings by Pintoricchio, Perugino, Sodoma, and Signorelli. The style of the landscape is still very much within the Sienese tradition; its principal inspiration seems to have come from Vecchietta, but its scope and importance are new. That is somewhat surprising, for Andrea di Niccolò was a conservative artist with limited powers of innovation and imagination. That he could so quickly alter his concept in such a basic way suggests his sus-

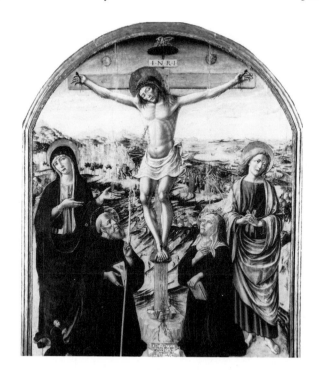

88. Andrea di Niccolò, *Crucifixion with Saints*. Siena, Pinacoteca.

ceptibility to outside sources, a susceptibility not shared by earlier painters of his ilk. Interestingly, his figures have not undergone much modification; their metallic hardness and immobility again recall Vecchietta.

In many ways, minor artists such as Andrea di Niccolò are more accurate indicators of stylistic and spiritual currents than their subtler and more-innovative contemporaries. The lesser talents are more obvious and straightforward in their borrowings, and their works allow us to draw a clearer picture of what was actually happening.

Pietro di Domenico, another minor figure[11] was active in Siena from the middle of the Quattrocento to about 1533. He produced a series of sometimes crude, but nearly always charming, pictures full of amusing detail and interest. His *Adoration of the Shepherds* (Fig. 89) shows him to have been an assiduous student of contemporary painting, for this picture is probably indebted to Ghirlandaio, particularly that artist's rendition of the same subject[12] in Santa Trinita, Florence. Pietro di Domenico was also swayed by Francesco di Giorgio and, for

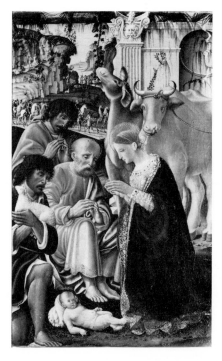

89. Pietro di Domenico,
 Adoration of the Shepherds.
 Siena, Pinacoteca.

his landscape, by Signorelli and Pintoricchio. But, even these stylistic influences did not submerge the artist's strong personality in this painting. The *Adoration* is rough and vigorous, almost folklike in its simplicity and naiveté. Pietro di Domenico and Andrea di Niccolò share a predilection for large areas of strong, unmodulated color. Bold and often grating, these fields of black, gold, white, blue, and red are perfect complements to the forceful, if unsubtle, forms.

Pietro di Domenico is not an unskillful composer; the deposition of the foreground figures in the *Adoration* displays a sensitive feeling for rhythm, which appears often in his work. The lively landscape presents weird rock formations and vistas, peopled by energetic little figures vigorously reacting to the miraculous birth of Christ.

A *Madonna and Child with SS. Jerome and Anthony of Padua* (Fig. 90) shows a seated Madonna with child, backed by two saints set within the confines of a narrow space. This type comes directly from Neroccio, who used it with powerful effect in a series of pictures. Pietro di Domenico has not produced a copy of a painting by Neroccio but a caricature of it. By elongating the Madonna and making her so large and massive, he has destroyed the balance between volume and flat shape that was a crucial part of Neroccio's panels. The space of Pietro di Domenico's painting has been opened up and its inhabitants made more monu-

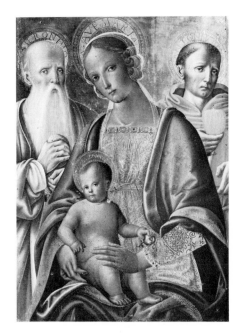

90. Pietro di Domenico, *Madonna and Child with SS. Jerome and Anthony of Padua*. Siena, Pinacoteca.

mental and palpable. Foursquare and immediate, it has lost the reticence and grace resulting from Neroccio's lighter touch.

Moreover, the space in the Pietro di Domenico painting does not create the confining, almost claustrophobic, atmosphere of Neroccio's work; Pietro di Domenico's saints seem to slip outside the frame easily. Also changed is the way in which gold is used: It no longer helps to reinforce the flatness or thinness of shape, but forms a tangible rear wall and makes the encrusted robe of the Virgin even heavier and more realistic.

Many of these differences can be credited to the artist's study of his foreign contemporaries. From them, especially from Signorelli, Pietro di Domenico learned to make large volumetric form that decisively occupies space. The ancient Sienese traditions of decorative form and exquisite shape were no longer strong enough to hold him and many of his fellow artists. So, what we see instead in the *Madonna and Child* is a recasting of the classic Sienese idiom. This reinterpretation of the past in the light of up-to-date, outside influences was something quite new to the art of Siena and a symptom of the eventual dissolution of the city's ancient tradition. The result, in Pietro di Domenico's picture at least, is that the old motifs are repeated but without any of the taut power and mystery of the originals.

91. Bernardino Fungai, Altarpiece. Siena, Pinacoteca.

Bernardino Fungai (1460–1516) was another highly impressionable Si-
enese painter working around the turn of the century.[13] Like Pietro di Dome-
nico, his close contemporary, he had only a modest talent and little invention.
He did, however, produce a string of pleasing, if not memorable, paintings that
reveal much about the state of art in Siena at the time.

In a signed altarpiece dated 1512 (Fig. 91), Fungai's style is based on that of
the great triad of Sienese painters active during the last quarter of the Quattro-
cento—Francesco di Giorgio, Matteo di Giovanni, and Neroccio de'Landi—al-
though Fungai's work is not as lofty as his predecessors'. There is nevertheless a
certain sweetness and docility about his charming panel of the Madonna and
child with saints and angels. For instance, the kneeling St. Jerome, clearly taken
from Matteo di Giovanni, has been divested of his fierceness and made into a

more fragile and rather timid old man. (Of course, much the same sort of modification to Matteo di Giovanni's style had already been done by Cozzarelli.) The gentleness of the altarpiece is reminiscent of Perugino's painting in Sant'Agostino in Siena.

There are also clear traces of other foreign artists here. The putti standing on the steps of the throne and the decoration of the front of the steps are borrowed from Pintoricchio's frescoes in the Piccolomini Library. That cycle not only furnished a new interpretation of landscape for the Sienese but also gave them access to new decorative motifs, many of which were based on the antique types then being discovered and studied in Rome. Throughout the Quattrocento, under the influence of the new humanistic learning, Siena, Florence, and other centers had been fascinated with antiquity.[14] But, by the early sixteenth century, this interest had become more discriminating and archeological; consequently, the grotesques on the ceiling and walls of the Piccolomini Library must have held a fresh fascination for Sienese painters and sculptors.

The vast landscape behind Fungai's pretty Madonna and tranquil saints was, without doubt, inspired by the Piccolomini Library frescoes and probably by Perugino as well. The fantastic, primordial rock formations and blue green distance show that Fungai had looked carefully at Umbrian landscape painting. In fact, he is so taken with the landscape that he almost makes it, not the holy figures, the subject of his altarpiece. The spectator's eye constantly returns to the splendid panorama of river valleys, meandering streams, tiny towns, and distant city-encrusted ridges. The figures are not integrated into the landscape but seem to exist outside it, perhaps because Fungai has not thought of landscape and figures together, as a whole, but as two separate entities, much the way figure and gold ground are usually two distinct parts of Sienese painting.

The surface of the altarpiece has recently been cleaned and reveals that Fungai has used either a very viscous tempera or, more likely, oil, to create many remarkably fluid and sketchy passages. In the freedom with which his brush places form and light, Fungai has moved away, on the surface of the work at least, from the much tighter treatment of the Quattrocento. He is tending toward the expressiveness of handling that was to become common in the Cinquecento, especially in the works of Domenico Beccafumi. The very looseness of Fungai's marks also helps to build a more sculptural and spontaneous picture. In fact, the surface of the work and the freedom of the brushwork are slightly at odds with the crisper, more reserved, composition and figure style. Fungai's altarpiece reflects the movement away from the Sienese style that evolved shortly after the middle of the Quattrocento, the strong influence from Umbrian and other outside sources, and the new treatment of surface. It is an interesting tran-

92. Bernardino Fungai, *Rescue of Hippo* (?). Houston, Museum of Fine Arts.

sitional work, suspended between the old Sienese tradition and the styles of the new century.

Fungai is seen in a less formal, more charming mood in a painting intended for a chest (*cassone*) or for a paneled wall. *The Rescue of Hippo* (?) (Fig. 92) effectively utilizes the wide horizontal format of the *cassone* type for an impressive panorama. The extended rectangle makes the great galleon seem to slide effortlessly across the most placid of seas. But our eyes are also drawn beyond, to the vast expanse of still water and gently rolling hills. Inspired by the landscapes of Umbrian painters, but even more elegant, this background helps form the sylvan mood. The quietude and ease of this narrative elevate it into the fantastic realm so familiar to Sienese painting. This enchanted world, with its flying clouds, glowing horizon, and verdant, graceful trees, is a fine and elegant product of Fungai's imagination.

The evocative quality of the *cassone* panel finds its counterpart in dozens of other Sienese mythological paintings of the Quattrocento. The Sienese vision that created the fantastic, otherworldly narratives of Giovanni di Paolo and Sassetta was especially suited to the imagining of mythological worlds. The many *cassone* panels and other objects decorated with scenes from ancient stories indeed conjure up a dreamland just outside the realm of our own experience. This attractive golden place revivifies the scenes and makes their magic believable, unlike the representations in many Florentine mythological pictures in which the gods seem to be acted by contemporaries in ancient costume. This Sienese power of imagination exists even in so minor a figure as Fungai.

Girolamo di Benvenuto's *Choice of Hercules* (Fig. 93) is another example of the Sienese penchant for mythology. Girolamo (1470–1524) was the son and collaborator of Benvenuto di Giovanni (see chapter 4),[15] and the two artists' hands seem to be equally evident on the last works to leave Benvenuto's shop.

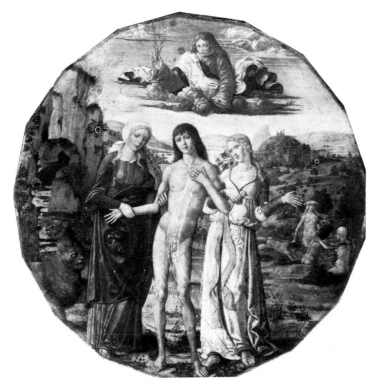

93. Girolamo di Benvenuto, *Choice of Hercules*. Venice, Ca' d'Oro.

Girolamo continued his father's business and pursued an active career in Siena into the 1520s. The *Choice of Hercules* seems to be an early work by Girolamo. It is painted on a salver that was probably meant to be given to a bride at her wedding. The delicacy and freshness of the lithe figures recall Benvenuto's work, but such traits are less evident in the paintings of Girolamo's maturity. The general construction, articulation, and relation of the figures are actually reminiscent of the former's *Expulsion of Adam and Eve* (Fig. 81).

Landscape plays an important narrative role in the salver because a severe, rocky terrain must appear behind the figure of Virtue, while a much more hospitable land must be seen behind Vice to warn the onlooker that it is easy to enter into that beckoning realm. Both elements of the landscape (which, in characteristic Sienese fashion of the early Cinquecento, is extensive) owe much to Perugino and Pintoricchio. But Girolamo di Benvenuto has not slavishly copied; rather, he has carefully shaped his landscape into a harmonious background. Fig-

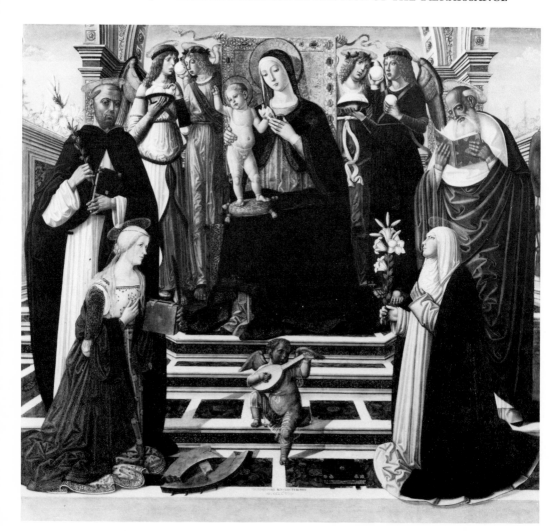

94. Girolamo di Benvenuto, *Madonna of the Snows*. Siena, Pinacoteca.

ures and landscape are skillfully interwoven into a decorative whole that takes the shape of the salver itself.

Girolamo's figures, which become progressively fuller and less metallic than his father's, are seen again in a major painting, the *Madonna of the Snows* (Fig. 94). This large altarpiece was commissioned for the Church of San Domenico in Siena and is signed and dated 1508. Its expressive lunette of the *Lamentation*, one of Girolamo's most powerful works, was discovered only in 1971.[16]

The basic composition of the altarpiece is conservative, recalling Matteo di Giovanni's late altarpiece of the Madonna, child, and saints (Fig. 66), although it is not as purposefully asymmetrical or unbalanced. Under the influence of his father and several contemporary Florentines including Ghirlandaio, Girolamo, a skilled draftsman, constructs figures of considerable expressive power. Especially noteworthy are the kneeling St. Catherines in the foreground, whose fervent gestures and portraitlike faces animate the entire picture. Farther back, the full-faced, golden-haired angels making the miraculous snowballs are a lively complement to the Madonna, whose hard, rigid form recalls the iconic Madonnas of the Duecento by Guido da Siena and his circle.

In this altarpiece, as in many other works, Girolamo di Benvenuto's palette is often dense and dark. Although it is relieved by brilliant white in the mantles and scarves, the general mood of the painting is somber. It lacks the brilliant and eccentric chords of color that distinguished much of earlier Sienese painting. Girolamo di Benvenuto was one of several Sienese artists of the early sixteenth century who moved away from the brilliant and eccentric coloring of Sienese Quattrocento painting either toward a more somber, less variegated palette or toward a crasser, less sophisticated arrangement of tone and hue. In the *Madonna of the Snows* the first signs of this shift appear in the dark purples, blacks, and deep golds.

Around the same time, Girolamo di Benvenuto painted the impressive *Portrait of a Young Woman* (Fig. 95), one of the rare Sienese portraits to survive from the Renaissance. Its form and style are indebted to Florentine models, mostly to those of Ghirlandaio and Botticelli. Like Neroccio's *Portrait of a Woman* (Fig. 69), also in the National Gallery, Girolamo's picture portrays a nearly half-length figure of a youthful woman dressed in what are obviously her finest clothes. In both portraits, the Sienese sense for abstract shape is seen not only in the forms of head, hair, and facial features but also in such details as the flowing veil or tumbling curls.

Girolamo di Benvenuto's portrait does not have the wonderful wistful spirit of Neroccio's painting. Girolamo's beautiful subject is much more self-conscious and reveals little about her emotional state. This stolid figure seems colder, partly because it is painted in the dense, almost metallic, style of the *Madonna of the Snows*; and it has the same immobility as the figures in that important altarpiece. Nonetheless, this arresting painting is one of the most distinguished portraits produced by a Sienese Renaissance artist.

In many ways, Girolamo di Benvenuto is an interesting figure, especially in his respect for the Sienese tradition. Although he was influenced by Signorelli and other foreign artists active in Siena during the late Quattrocento and early

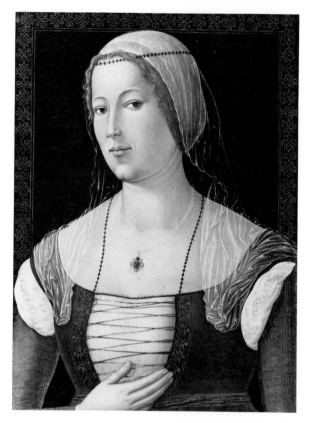

95. Girolamo di Benvenuto, *Portrait of a Young Woman*. Washington, National Gallery.

Cinquecento, Girolamo di Benvenuto's main sources of inspiration seem to have come from his father and from his own highly personal interpretation of religious drama.

Girolamo del Pacchia (1477–after 1533), a contemporary of Girolamo di Benvenuto, possessed a style both highly idiosyncratic and strongly influenced by painters working in Florence around 1500.[17] His *Annunciation and Visitation* of 1518 (Fig. 96) recalls, in its ponderous figures and architectonic massing of columns and arches, contemporary Florentine works by Fra Bartolomeo and Mariotto Albertinelli. But the solemnity of these Florentines is tempered by Girolamo del Pacchia's strange figural construction, his sense for color as decoration, and his weird interpretation of the *Annunciation*—an awkward, small-headed angel and a large Virgin, who shrinks into the right-hand corner. The rush of space along the floor and through the columns distracts our attention

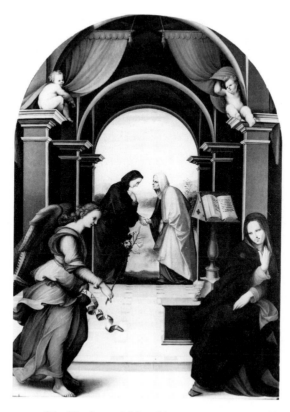

96. Girolamo del Pacchia, *Annunciation
and Visitation*. Siena, Pinacoteca.

from the sacred dramas and creates a considerable void in the center of the picture. This spatial construction and the strange mute dialogue between angel and Virgin owe much to the artist's innovative contemporary Domenico Beccafumi.

The bright reds of the drapery held by the putti-angels, of the angel's dress, and of the Virgin's tunic, form strong patterns that make the eye jump across the picture's surface rather than backward into space. Green, in various degrees of saturation, also plays the same role; it appears on the architecture, on the angel's outer robes (where it is acidic), and on the lining of the Virgin's blue mantel. Throughout the picture the stridency and liveliness of the color further de-emphasize and fragment a composition that, in the hands of the Florentines, was originally meant to display dignified, serious actions in a monumental environment. Girolamo del Pacchia's *Annunciation and Visitation* is a good example of the way Sienese hands tempered foreign elements and utilized them for new and sometimes quite different purposes.

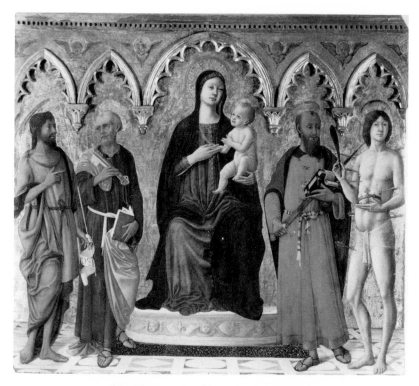

97. Giacomo Pacchiarotti, Altarpiece.
Buonconvento, Santi Pietro e Paolo.

Another example of the transformation of outside style is seen in the works of Giacomo Pacchiarotti (1474–1540?), a talented painter active in Siena during the early years of the sixteenth century.[18] His origins are mysterious, but he certainly fell under the sway of Matteo di Giovanni, whose influence is apparent in Pacchiarotti's altarpiece (Fig. 97) in the Church of Santi Pietro e Paolo in Buonconvento. In both figural construction and facial type, the four saints flanking the Matteoesque Madonna reveal the deep impression that Matteo made on Pacchiarotti. Although it was probably painted around 1510, the altarpiece is essentially a late Quattrocento Sienese painting. Certainly, the space and articulation of the figures are more stable and less idiosyncratic than in Matteo's work, but the spirit of the work belongs to the last quarter of the fifteenth century; it is, in other words, still free of the foreign styles that transformed Sienese painting during the early 1500s.

This confidence in ancient Sienese traditions is also apparent in the first of

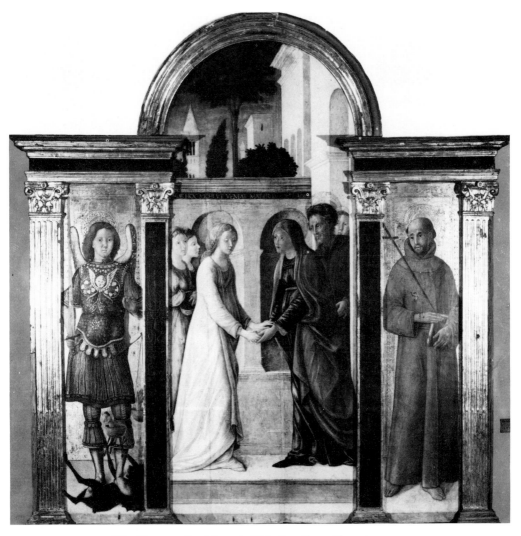

98. Giacomo Pacchiarotti, *Visitation*. Siena, Pinacoteca.

two *Visitation* altarpieces by Pacchiarotti (Fig. 98). Flanked by SS. Michael and Francis, the Visitation unfolds before an arcade separating the protagonists from a garden and several towers. According to the eighteenth-century author Della Valle, Pacchiarotti's *Visitation* was almost an exact copy of a famous fresco by Ambrogio and Pietro Lorenzetti on the facade of the hospital of the Scala in Siena.[19] There is no reason to doubt this statement, as borrowings from early

Trecento art are found in other works by Pacchiarotti. But what is amazing is the vitality of the Sienese tradition, which around 1510 allowed Pacchiarotti to copy almost literally a painting done nearly two centuries before. This utilization of the past demonstrates not an uncreative decadence but a deep respect for images still considered vital and worthy of imitation. In fact, this mining of the past and reverence toward it were the major characteristics of Sienese painting up to the sixteenth century.

Even in the format of the *Visitation* Pacchiarotti holds to an old tradition. The saints at the sides are separated from the main panel and appear more like independent wings than part of the Visitation. Their distancing from the central scene is even greater than in many triptychs of the fourteenth century, especially those from the circle of Ambrogio and Pietro Lorenzetti. This highly traditional use of the triptych format (although the framing of the picture is fashionable early sixteenth century) and the strict borrowing from an ancient prototype suggest that Pacchiarotti's direct source was not the hospital facade itself but some other altarpiece, most likely a triptych, by the Lorenzetti or a follower, which reproduced the Scala *Visitation* on its center panel.

Pacchiarotti's figures and the atmosphere surrounding them, however, are far removed from their Trecento prototypes, whose influence is in motif only. Mary and Elizabeth are wraiths whose silent meeting is both decorous and beautiful. Pacchiarotti's panels all contain a race of soft, full-faced, handsome men and women with light touch and easy stance. Pacchiarotti was probably trained by Girolamo del Pacchia, but he was also strongly influenced by Matteo di Giovanni and Neroccio de'Landi. He embodies a lyricism and grace that trace their origins all the way back to Duccio, an artist whom he also seems to have studied with care, especially for instruction in the articulation and grouping of figures.

These same elegant beings appear again in the second *Visitation* (Fig. 99), which is also in the Siena Pinacoteca. But here a basic shift in idiom has taken place. Certainly, there is the same gracefulness, but the figures seem heavier and more monumental. They are more under the influence of such Florentines as Fra Bartolomeo and Andrea del Sarto, who were at work around 1515, when this panel was probably painted. Contemporary Florentine painting probably inspired the architectonic massing of the compositional elements, both figural and architectural, and the use of the dominating, Roman-inspired triumphal arch.

How different is this rendition from the earlier, more traditionally Sienese, vision of the *Visitation*. Not only has the triptych form been replaced by a large single-field painting, in which space forms a convincing unit, but also the ease of the earlier panel has given way to a more rigid, more academic placement of figures and architecture. Now every element is carefully and mechanically balanced

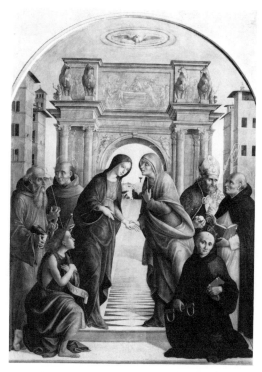

99. Giacomo Pacchiarotti, *Visitation*. Siena, Pinacoteca.

by another to form an almost oppressive symmetry, very distant from the compositions, especially those of Matteo di Giovanni, that so influenced the young Pacchiarotti.

In the second *Visitation* Pacchiarotti's palette remains subtle and original, although the colors seem a little denser; and large fields of brown, grey, and black, necessitated by the habits of the Franciscans and Dominicans, are much in evidence. This picture does not have the singing color of the Quattrocento, but is more restrained, in perfect harmony with its monumental, sedate forms.

Pacchiarotti is not an overly emotional painter; he lacks much of the tenseness of Matteo di Giovanni and the luminous grace of Neroccio de'Landi, but his narratives and images radiate sweetness and tranquility. These qualities are apparent in his *Ascension of Christ* (Fig. 100), probably one of his last works. Filled with figures and movement, the *Ascension* is an arresting painting. The landscape and figures, especially the awestruck group of the Virgin and apostles watching the shining Christ ascend, are infused with the spirit of Perugino; one has only

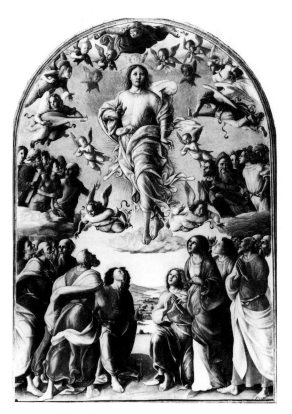

100. Giacomo Pacchiarotti, *Ascension of Christ*. Siena, Pinacoteca.

to remember the Sant'Agostino *Crucifixion* (Fig. 83) to realize how close at hand was a splendid example of that artist's work. But Pacchiarotti has also felt the tug of Signorelli's powerful style, perhaps also from a work in Sant' Agostino, the Bichi altarpiece (Fig. 82).

Neither of these influences, however, can overshadow the Sienese quality of this remarkable painting, for which many important Sienese prototypes served as models. The whirling upper realm of the *Ascension*, with its ranks of saints, flying angels, and cherubim, harks back to Benvenuto di Giovanni and Francesco di Giorgio and even reflects the many contemporary versions of the story. The ancient Sienese traditions are carried on in its multiplicity of form, delineation of strange character, variety of color—golden yellow, orange red, cool grey, sparkling white—and in the combination and chording of that color. The concerns for hue, shape, form, and the decorative nature of painted drama that so

shaped earlier Sienese painting resurface in Pacchiarotti's work. Their appearance demonstrates how deeply rooted they were even in an artist whose style, as the second Pinacoteca *Visitation* attests, could fall so completely under the sway of another visual tradition.

In Pacchiarotti's work and in the painting of all the other artists discussed in this chapter, the outside influences so prominent in Siena around 1500 caused substantial modifications to Sienese art. In fact, the basic direction of that art was changed from the highly formal, decorative, and mystical to the more rhetorical, realistic, and academic. Yet, the tug of old and venerable styles and paintings was always felt by Sienese painters, right up to the last days of the school. Sienese traditions and inventions could still play a major role, even in a period of strong foreign influence, as we shall see in the works of the last great Sienese artist, Domenico Beccafumi.

NEW DIRECTIONS

Beccafumi and His Contemporaries

THE SHIFTING CURRENTS of style and imagery that charac-
terize Sienese painting of the first years of the sixteenth cen-
tury led not only to a dissolution of the city's artistic traditions but to doubt in
the minds of many Sienese painters, doubt that blurred the ancient guideposts
so effectively utilized by earlier generations of artists. Part of this doubt was
caused by a decline of confidence in the city's ancient institutions, which were
under attack from both inside and outside its walls. Siena was also a part, al-
though a minor part, of the great political struggles raging in the early Cinque-
cento within the Italian peninsula as well as in much of Europe. In the first half
of the century the city was occupied by Imperial troops who began to build a
fortress to intimidate the Sienese. But the people pulled it down before it was
finished. Finally, in 1555, the city was conquered by the Florentines under the
Medici. This defeat was the end of a treasured Sienese independence, which had
been kept alive since the commune was founded centuries before.[1]

One might speculate whether these events affected the art of Siena. Cer-
tainly, the slackening of Sienese tradition and the concomitant invasion and last-
ing influence of foreign styles (for example, within several years Signorelli, Peru-
gino, Pintoricchio, and other non-Sienese were at work in the city) occurred at
the same time as the city's political and institutional problems. Perhaps the loss

of confidence in ancient institutions and the increasing domination of outside forces caused artists and patrons of Siena to lose faith in their own long heritage and to turn to foreign styles that they thought were more vital and perhaps more appropriate then their own. Of course, art and life do not always mesh so neatly, and such a suggestion ignores the fact that artists usually respond in individualistic ways to political and social changes. Nevertheless, it is tempting to see here, in this one isolated case, a reaction, both dispirited and uncertain, arising from events that must have profoundly shaken every sensitive Sienese of the first half of the 1500s.

Out of this chaos arose an artist whose surpassing and original painting marks him as one of the most remarkable figures in the long history of Sienese painting. Domenico di Giacomo di Pace, called Beccafumi, was born near Siena in 1486.[2] Little is known about his early life and his artistic training. Vasari says that he was apprenticed to an obscure artist, but does not bother to mention his name. Certainly, it was someone like Pietro di Domenico or Girolamo di Benvenuto, who were running large, active shops around 1500, when Beccafumi entered his mid-teens. Even Beccafumi's early work does not offer many clues. One can discern traces of the styles of Sodoma and of several Sienese artists working during the last quarter of the Quattrocento, most notably Matteo di Giovanni, but they are so assimilated that little can be said about them. Like many highly original artists, Beccafumi transforms his sources and borrowings so that they are often unrecognizable.

A large altarpiece, the *Stigmatization of St. Catherine* (Fig. 101), is one of Beccafumi's earliest extant works. It was probably painted around 1515 for the convent of the Benedictine sisters of Monte Oliveto, near Siena. It includes St. Benedict, the founder of the order, and St. Jerome.

At first glance, the *Stigmatization* seems indebted to the rhetorical, monumental style of Florence of the first decade of the Cinquecento. Beccafumi obviously studied carefully the works of contemporary Florentines, which he must have seen in Florence and perhaps in Siena. The strict architectonic arrangement of both figure and architecture, the figural construction, and the gesture are all indebted to Florentine prototypes. Yet, the picture is very different from anything painted in Florence. The central space is not really held in check. In many ways, the most compelling part of the *Stigmatization* is the great tunnel of space rushing back from the foreground, along the orthogonal lines of the floor, past the kneeling saint, into the sun-filled plane, and then dissolving in the luminous sky. In a way, the center of the action, the heart of the drama, is made of light and air. This spatial excavation of the central areas is characteristic of Beccafumi and appears frequently in his later works.

Tranquility does not prevail in Beccafumi's *Stigmatization*. The rhythm of the

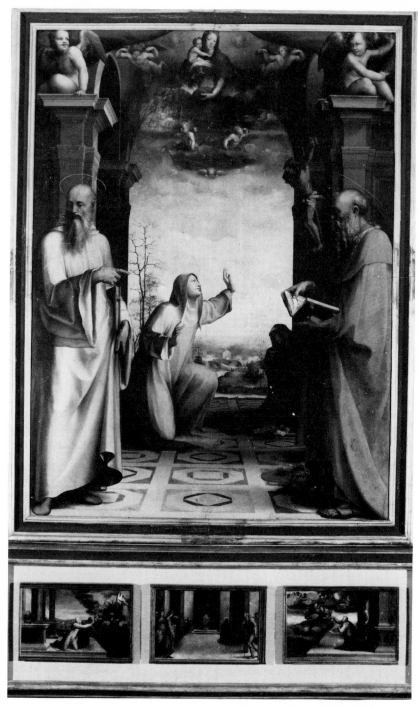

101. Beccafumi, *Stigmatization of St. Catherine*. Siena, Pinacoteca.

architectural and figural forms is disturbed by the coloristic imbalance so care-
fully planned by the artist: the strong orange red of the superbly painted robe of
St. Jerome stands out like a beacon or flare, upsetting the symmetrical arrange-
ment of creams, whites, and browns in the rest of the picture. This use of stri-
dent color to disrupt an essentially balanced composition is, of course, quite Si-
enese and is frequently seen in the works of Giovanni di Paolo and Matteo di
Giovanni, to name just two painters.

At the top of the picture, the Madonna is surrounded by contorted angels.
Several of these creatures, who seem to be architectural ornaments come to life,
hold acidic green drapery swags. The upper part of the altarpiece is animated,
with the Madonna and child, the flying angels (who are ultimately derived from
Francesco di Giorgio and Neroccio de'Landi), and the plump little figures sitting
on the columns helping to moderate the ordered, almost frozen, composition.

As early in his career as the *Stigmatization*, Beccafumi shows himself to be an
independent and precocious artist with considerable skill. He rethinks his sources
and incorporates them in cogitated works of considerable novelty and interest,
both in their formal and in their contextual aspects. The drawing of the figure of
St. Catherine; the remarkably conceived robes of the two standing saints, painted
with an abstraction breathtaking for the early sixteenth century; and the spar-
kling landscape, influenced by Fra Bartolomeo and Perugino, demonstrate Bec-
cafumi's remarkable ability to manipulate the building blocks of painting.

Around the same time, Beccafumi completed a most interesting and un-
usual work, the *St. Paul Enthroned* (Fig. 102), now in the Museo dell'Opera del
Duomo, in Siena. Images of a single saint, either enthroned or standing, were
common during the Duecento but infrequent thereafter. It is therefore unusual
and surprising to find an early sixteenth-century painting with such an old-
fashioned image. Perhaps Beccafumi's *St. Paul* was made to replace an ancient
painting that had been destroyed; such conscious archaizing is not uncommon in
Renaissance art.[3] Whatever the reason, his altarpiece seems to copy the older im-
ages, which almost always depicted a central saint surrounded by scenes from his
or her life and, on occasion, crowned by a heavenly apparition.

But, the gridlike stability of the older altarpieces is not present in the swirl-
ing grandeur of Beccafumi's *St. Paul*. The imposing figure of the saint (obviously
borrowed from Michelangelo's Sistine sibyls) perched on a pedestal, neither en-
throned nor standing, furnishes the picture with a large unstable center.[4] He
holds his sword in one hand and reads a book held in the other. The awkward
hunched figure, dressed in a voluminous orange red robe, is part of an axis that
runs from the base of the pedestal, through the saint's body, to the heavenly ap-
parition, which seems almost to rest on Paul's head. This upward rhythm is

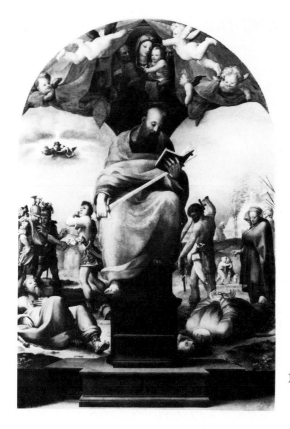

102. Beccafumi, *St. Paul En-
throned*. Siena, Museo
dell'Opera del Duomo.

countered by a second axis composed of a frieze of agitated figures moving across the center of the altarpiece.

Further disturbing rhythms are created by the individual scenes that make up the frieze: to the left, the conversion of Paul; to the right, his beheading. In both scenes Paul's body is placed at a diagonal to the observer, thus creating a movement back into space at odds with both the vertical and the horizontal axes. This daring composition is typical of the level of organization of Beccafumi's entire career.

The originality of color, which so distinguished the *Stigmatization*, is seen again in the *St. Paul*. Strong, often sharp greens (the color of the heavenly curtain held by the angels), orange reds, blues, purples, and roses vibrate and clash before our eyes. Color, like form, is strewn across the picture, creating both movement and excitement. The palette is, in the ancient Sienese tradition, also decorative; color exists not only to emphasize form but also as an invigorating independent element.

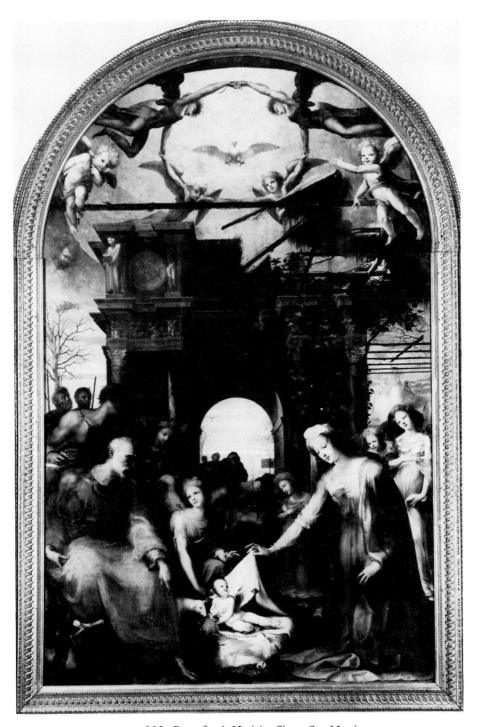

103. Beccafumi, *Nativity*. Siena, San Martino.

Sheer visual excitement also characterizes Beccafumi's large altarpiece of the *Nativity* (Fig. 103), painted around 1524. This vision of the subject is exceedingly personal; and while it is certainly influenced by other artists' versions of the story, this painting speaks to us with a language now wholly Beccafumi's own. The *Nativity* has an almost hallucinatory, visionary quality that, while it is dissimilar in form, recalls the emotional and spiritual character of Giovanni di Paolo and Sano di Pietro. The child, bathed in a supernatural pinkish white light, and the great circle of angels, who link hands to make a living crown for him, bring to mind similar figures in Sassetta's *Madonna of the Snows* (Fig. 28). The luminescent golden aurora in which these heavenly figures hover reminds one of the mysterious light of many paintings by Giovanni di Paolo and Sassetta and their followers, paintings that Beccafumi probably studied with considerable care.

A large disintegrating triumphal arch, probably inspired by Beccafumi's interest in antique art, is introduced into the center of the picture as a symbol of the decadent old order and as the central compositional element. No mere archeological copy of something that Beccafumi had seen in Rome or elsewhere, it is volumetric, expressive, and dominating. Its opening funnels the space into the far background, with its freely brushed hills and isolated trees. Beccafumi is interested in the poetic, associative qualities of the looming Piranesi-like arch, which is slowly being destroyed by nature and man. This melancholy ruin, bathed in shadow, and the memory of the powerful but now lost world that built it are almost Romantic; that is extremely unusual for the early sixteenth century, when antique art was often valued for its vitality and monumental form.

Just as striking and unusual is the foreground frieze. The large handsome figures are skillfully constructed and placed in space. Beccafumi is not particularly interested in foreshortening his figures or in making them anatomically correct or convincing. Instead they are built up with large, heavily loaded brushstrokes that indicate planes rather than analyze a passage of a robe or a foot. It is almost as though color and form have slid onto the surface of the panel. Oil as the principal medium for altarpiece painting was still in its infancy in Siena during the first decades of the sixteenth century. Beccafumi was an early and accomplished user of the new material, and the *Nativity* shows a wonderful utilization of a viscous slow-drying oil. In the *Nativity* Beccafumi again demonstrates his sensitivity to color and tone. The greens, blues, bright yellows, and golds—not quite as acidic as in the earlier altarpieces—are modulated with white to make the entire picture flicker with a mysterious illumination.

Around 1524 Beccafumi was commissioned to paint an altarpiece of the *Fall of the Rebel Angels* for the Church of San Niccolò al Carmine in Siena. According to Vasari, Beccafumi's first attempt, now in the Siena Pinacoteca, was

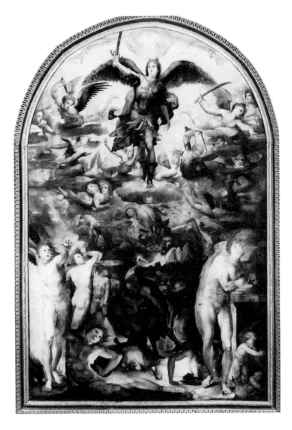

104. Beccafumi, *Fall of
the Rebel Angels*.
Siena, Pinacoteca.

abandoned before it was finished. Unfortunately, Varsari does not say why it was not completed.[5] The later version, now in the Carmine, seems to have been painted by Beccafumi as a replacement.

The Pinacoteca altarpiece (Fig. 104) is a graphic demonstration of Beccafumi's spontaneous approach to painting. The large forms are quickly and energetically placed with a sure command of the brush. From the unfinished state, we sense the rapidity and fervor of creation; perhaps it was the painting's revelation of its own genius that saved it from destruction. Beccafumi once again shifts the focus away from the center, here occupied by dark, writhing demons. The real center of action is at the top, where a victorious Michael, trailing large wings and a wind-swept cloak, drives the rebel angels into the pit of hell. Flanking this huge warrior are two scimitar-wielding angels, whose flight into space recalls the smaller, less vigorous putti-angels around the Madonna in the *St. Paul*.

Beccafumi's penchant for the diagonal movement of contorted figures into

and out of space is apparent here, although in a larger and more dramatic fashion, afforded both by the subject and by his increasing maturity and sophistication. Several of these figures vividly express the horror of their condemnation at the left and the right of the *Fall*.[6] They are obviously inspired by Michelangelo and thus reveal that Beccafumi was aware of contemporary Florentine and Roman developments. It is a mistake, however, to call him a mannerist, as is so often done; although he surely knew and utilized forms and motifs from all the leading Florentine figures of the early sixteenth century, his art in its totality is unlike anything produced in Florence. Moreover, while it is still within the boundaries of Sienese sensibility and interpretive tradition, it is as inventive as anything produced by Rosso, Pontormo, or Bronzino. Perhaps it is the relative unpopularity of later Sienese art, often regarded as backwater, that has obscured Beccafumi's notable accomplishments.

The invigorating confusion of the first *Fall* is not apparent in the second, more tempered and tightly organized version in the Carmine (Fig. 105). Here the pride of place is given to the impressive figure of God the Father, who sits enthroned above Michael and commands the fallen angels to hell. He towers above all the action, his face cast in deep shadow and his orange red robe vibrating with light and color. God, not the warrior angel below him, is the hub around which the drama revolves.

Perhaps because Beccafumi so played down the role of God the Father in his first version—he appears only as a rather vague figure at the top—that picture was rejected even before it was finished. It is possible that the friars of the Carmine felt that too much emphasis had been placed on the role of Michael, which, of course, had been given to him by God and had not been assumed independently. The friars may also have been disturbed by the considerable amount of nudity, of which even Vasari makes special mention.

In the second *Fall* the upper part of the altarpiece is occupied by God the Father and the semicircular ranks of adoring angels, which both flank and enfold him. This area is electrified by Beccafumi's brilliant and original colors, some of the most remarkable in the entire history of Sienese painting: bright orange red, lemon yellow, pale blue, brown, and purple hues combine and recombine in dazzling patterns of celestial light.

In the void below all is dark; only hell-fires illuminate the fallen angels, who metamorphose into demons before our eyes. Wings and claws sprout as the fallen angels hurtle downward, doomed to the very pit of hell, where the fires illuminate pools of bubbling lava and shattered architecture. Beccafumi stabilizes and connects these various realms through the vertical axes formed by the mouth of hell, the belligerent angels in rippling robes of pink and yellow, and the majestic figure of God the Father dominating the scene from above.

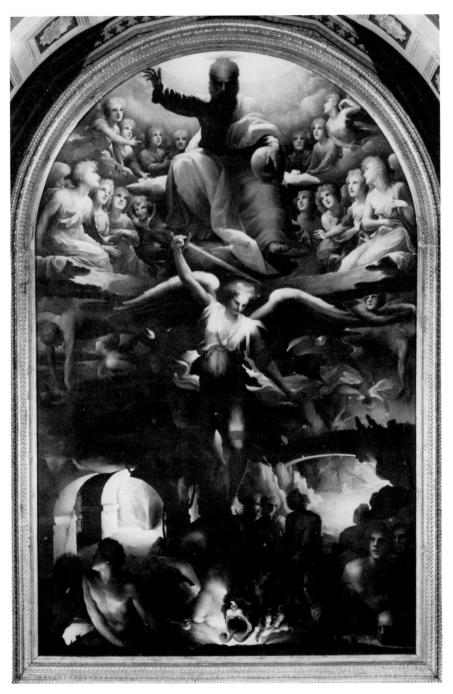

105. Beccafumi, *Fall of the Rebel Angels*. Siena, San Niccolò al Carmine.

In the second verson of the *Fall* Beccafumi has more control of tonality. Light from the aura surrounding God the Father, from the brilliant colors, and from the flickering hell-fires casts a rippling, shifting pattern of color over the altarpiece's entire surface. So modulated and diffused is this illumination that the Fall seems to be glimpsed through a palpable film of supernatural light from above and through clouds of smoke billowing up from the inferno below. One senses the heat and almost smells the acrid smoke of this incandescent painting. Beccafumi's *Fall* remains a moving version of the subject, a visionary and hallucinatory image in keeping with the Sienese interpretation of religious drama but far more nightmarish than the ephemeral visions of the past.

Around 1535, Beccafumi's skills—as a composer of figures and as a designer of paintings that are both convincing narratives and highly decorative ensembles—were tested again. The artist was commissioned to do a series of frescoes on the ceiling of the Sala del Concistoro in the Palazzo Pubblico of Siena. Didactic and allegorical wall paintings in the Palazzo Pubblico[7] had been a Sienese tradition for two centuries, starting with the famous fresco cycle of Good and Bad Government in the Sala della Pace by Ambrogio Lorenzetti. Beccafumi's scenes were taken from Roman history and depict examples of heroic and correct civic behavior. They were meant to impress and serve as examples for the members of the Sienese government, who met in the Sala del Concistoro.[8]

In these frescoes Beccafumi again demonstrates his innovative approach to composition, color, and the handling of his medium. Throughout his career, he reveals his empirical and often prophetic ability. His daring, complex use of space and the deposition of the figures within it rival and often surpass the Florentine mannerists; his novel and exciting palette is modified and adapted to the changing needs of size, content, and commission; and his extraordinary use of both oil and fresco fully realized the potentials (and respected the limitations) of both mediums.

This last point is especially evident in the Palazzo Pubblico frescoes, where the white ground of the *arriccio* (the final coat of plaster) plays a prominent role in the overall tonality and color of the individual paintings (Fig. 106). In many passages the watery, fresh colors—there are many light yellows, pinks, tans, greens, and blues—seem almost poured onto the grainy white wall. The liquidity and spontaneous nature of fresco are evident everywhere; Beccafumi's paintings are almost as much about process and materials as they are about subject.

The artist's construction of space and the relation of that space, especially in the octagonal fields, to the spectator standing below anticipate some of the remarkable late-Renaissance and Baroque ceilings. In the octagonal fields the wall

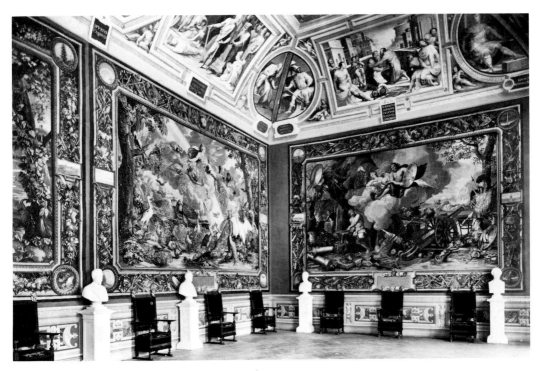

106. Beccafumi, Sala del Concistoro. Siena, Palazzo Pubblico.

seems to have been dissolved and replaced by deep space. The entire ceiling is covered with beautifully painted figures quickly brushed into spatial settings of extreme complexity and daring. From below, as in *Death of Marcus Manilius* (Fig. 107), we see figures hurtling into our space, tumbling out of the painted world into our real one. Beccafumi delights in fooling our eye and making the unreal seem plausible. There had never been fresco painting quite like this in Siena, or for that matter, in Florence either.

Beccafumi's experience with the frescoes in the Palazzo Pubblico prepared him to paint a varied, highly distinguished series of independent tondos, each with figures and colors remarkably adapted to the circular shape. Each panel is different, for Beccafumi refused to repeat compositions even if, as is the case here, they were perfect solutions to the complex problem of setting figures within a circle.[9] It is as if he rethought the composition every time he began it anew. This original approach to types is seen in many Sienese artists before Beccafumi, and it is always a hallmark of creative and original pictorial thought.

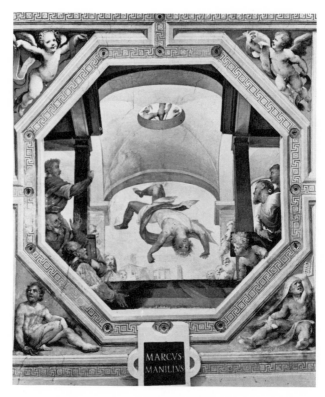

107. Beccafumi, *Death of Marcus Manilius*. Siena,
Palazzo Pubblico, Sala del Concistoro.

One of the most brilliant of the series is the *Holy Family* (Fig. 108), of about
1535, in which the five figures—Mary, the infant Christ, the baby St. John the
Baptist, Joseph, and a middle-aged bearded figure who has been called a donor,
but is probably a saint—are wonderfully intertwined and adjusted to the circular
format.

Knit together by shape, size, color, and tonality, the *Holy Family* exhibits
the solidity and confidence of the mature Beccafumi. Flickering light and glow-
ing colors make the picture something more than a simple representation of five
figures; they transform the painting into a dream unfolding before the worship-
per's eyes. The men emerging from the dark background are wrapped in a mys-
tery that may ultimately be derived from Leonardo, perhaps via Sodoma, but is
here made Beccafumi's own.

Beccafumi's highly personal and imaginative interpretation of religious

108. Beccafumi, *Holy Family*. Florence, Horne Museum.

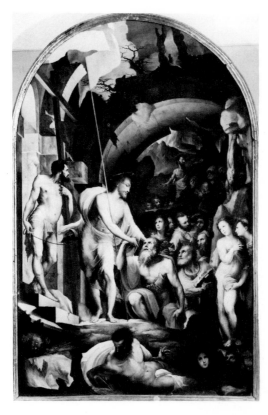

109. Beccafumi, *Christ in Limbo*. Siena, Pinacoteca.

drama is seen at its best in his large *Christ in Limbo* (Fig. 109). The visitor coming upon this altarpiece is first struck by its light-dappled surface and glowing colors. The center and source of this illumination is Christ. His white body, partially wrapped in billowing cloth of clear blue violet highlighted with brilliant white, illuminates the imploring inhabitants of this nether world. The flickering tonality of the second *Fall of the Rebel Angels* is recalled by *Christ in Limbo*, although the luminosity in the later picture is more unified and brilliant, as the divine light from Christ floods the altarpiece.

Rapid and profound movement into the far center of the picture, the central spatial focus of the early *Stigmatization of St. Catherine* and many of Beccafumi's later pictures, is also apparent in *Christ in Limbo*. From the reclining figure in the near foreground, probably borrowed from an antique river-god type, through the supplicants below the shattered arch, then back to the distant, glowing mountains, there is a rush of space through the center of the altarpiece. The excitement of backward movement is countered by the diagonal slope running

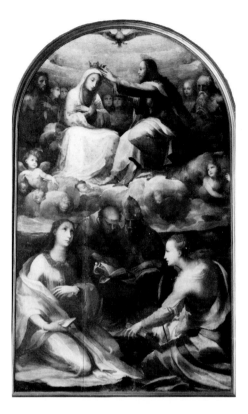

110. Beccafumi, *Coronation of the Virgin*. Siena, Santo Spirito.

from the good thief, behind Christ, to the elegantly posed female with nearly fluorescent pink skin at the right edge of the picture. This quick, forceful rhythm animates the picture and creates a visual excitement equal to the remarkable light, color, and figures.

Spectral and haunting, these figures of various ages and physical types recall the apparitions in paintings by Giovanni di Paolo or Matteo di Giovanni. Of course, Beccafumi and the other Sienese artists of his generation were more fascinated by the spatial and volumetric problems involved with the figure, but the strangeness and wildness of the people in Limbo link Beccafumi with his visionary and mystical past.

Beccafumi's extreme sensitivity to light and tone is seen once again in a moving painting, the *Coronation of the Virgin* (Fig. 110). The picture is divided into two realms. Below are the earthbound figures of four saints: two males (Anthony of Padua and Pope Gregory), intently poring over a text, and two comely females (the Magdalen and Catherine of Alexandria), occupying the immediate

left and right foreground respectively. These four figures establish a large semicircle, which moves the viewer's eye back into space toward the mountains dotting the distant horizon. Isolated and placed in a deserted, barren landscape, the four saints seem intently preoccupied and, with the exception of the kneeling figure at the left, unaware of the heavenly event above.

Seated on a cloud bank, Christ crowns his mother before a surrounding rank of angels and saints. Such use of semicircular groupings of large numbers of figures is familiar from Beccafumi's Carmine *Fall of the Rebel Angels*, but its origin goes back before Beccafumi, to Francesco di Giorgio's remarkable Pinacoteca *Coronation* (Fig. 75).

Between the two realms of heaven and earth there is a decided shift in color. The figures below are covered with hot red oranges, yellows, and mauves, all applied with such liquidity that they seem to float on the surface. Standing bright in the strong light, they animate and warm the lower part of the *Coronation*; above, however, a much cooler palette of pale greens and whites dominates, bathing the heavenly realm in a cold, limpid, and unearthly light.

Throughout this painting, and in many other works by the mature Beccafumi, the artist's mastery of his medium both delights and astounds. The freedom of the application of oil paint—the way it is manipulated by the brush, its often startling crumbly impasto, and its washlike quality in certain areas—is prophetic of the brushwork of the seventeenth century. The power of Beccafumi's vision and his use of color and light to demarcate the two realms of the *Coronation* place this work among his most profound achievements.

In a small *Madonna and Child with the Young St. John the Baptist* (Fig. 111), Beccafumi has conjured up a background of large faceted rocks dramatically bathed in a warm twilight. A single twisted barren tree makes a striking silhouette against the swirling clouds. Such an evocative landscape is rare in early sixteenth-century Tuscany and is prophetic of the visions of Romantic artists, such as Friedrich.

Beccafumi's daring brush creates great liquid swirls and rivulets of oil paint, seemingly floated onto the surface, that magically define or suggest skin, drapery, and landscape. The entire surface of the work comes alive under his magic touch. Employing a subdued range of warm colors with a particular use of pinks and greens in the central figure of the Madonna, Beccafumi has reinforced the intimacy and isolation of the holy figures.

Even in this late work (c.1540), substantial debts to previous Sienese painting still remain. Beccafumi's feeling for the abstract shapes of the figures and the adjustment and interlocking of these units are legacies from the earliest days of Siena. Moreover, his ability to create striking colors and combine them in fresh

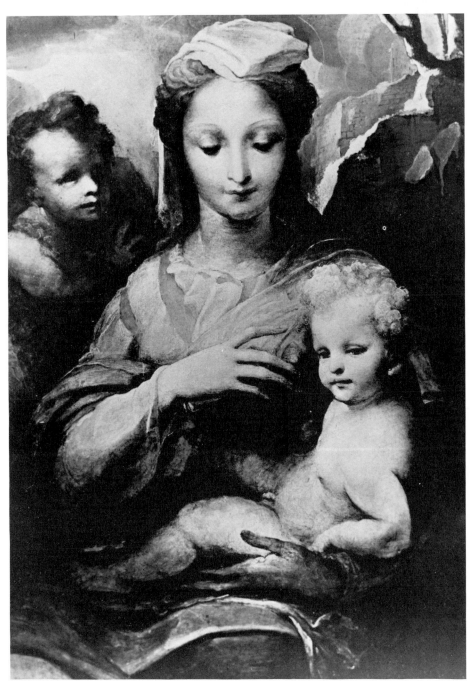

111. Beccafumi, *Madonna and Child with the Young St. John the Baptist*. Rome, Galleria Nazionale d'Arte Antica.

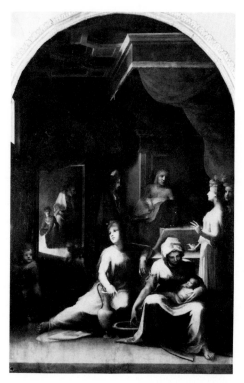

112. Beccafumi, *Birth of the
Virgin*. Siena, Pinacoteca.

ways is something he learned by studying Siena's past. That is where Beccafumi
found the particular quality of his pinks and greens for the Madonna; their com-
bination, modulation, and vibration of hue alone mark his color as Sienese.

The same tremulous, warm light that illuminates the *Madonna and Child*
animates another nearly contemporary work, Beccafumi's famous *Birth of the
Virgin* (Fig. 112). All the components of this altarpiece are to be found in a panel
of the same subject by Pietro Lorenzetti, which was in the Duomo during Bec-
cafumi's lifetime but is now in the Cathedral Museum of Siena.[10] Because of its
exalted location, its antiquity, and the renown of its author, Pietro's altarpiece
was famous even in the sixteenth century, when its style must have been nearly
incomprehensible. The very fact that Beccafumi could turn to this ancient work
and base part of his painting on it attests to the lasting strength of the Sienese
tradition. He was not the first to utilize Pietro's compositional inventions. Many
paintings profited from this great altarpiece, including Francesco di Giorgio's re-
cently discovered fresco of the same subject (Fig. 77), a work probably well
known to Beccafumi.[11]

Of course, Beccafumi did not simply copy Pietro's model but has used its elements to forge something very different in style and interpretation. He has recreated the narrative by shifting the entire picture around and compressing the three sections of Pietro's altarpiece into one. Instead of paralleling the picture plane, space moves forcefully from the foreground, back past the bed, into the room where Joachim dozes before a fire that casts flickering shadows over his body. Much thought has been given to the maids who cluster around the front of the bed; beautifully drawn and painted, these substantial bodies emerge from the dancing light and deep shadow. Beyond them lies Anne, her reclining form spotlighted against the bed's headboard, the edge of which forms one of the principal foci of the picture.

But more than the form or the warm, subdued palette reminiscent of Beccafumi's *Madonna and Child*, it is the mysterious light that both informs and amalgamates the *Birth*. The artist's fascination with light in its myriad varieties and moods is evident in all his pictures; illumination is always of paramount importance in giving them emotional and formal impact. From the heavenly illumination of the San Martino *Nativity*, to the hell-fire haze of the Carmine *Fall of the Rebel Angels*, to the polar *Coronation*, Beccafumi demonstrates his masterly control over light and tone. In the lambent *Birth of the Virgin*, light and inky darkness impart mystery and a transitory feeling unequaled in the history of Sienese art.

About three years before his death, Beccafumi painted a splendid *Annunciation* (Fig. 113) for the Church of San Martino in Sarteano, a small hill town not far from Siena. This lyrical altarpiece, which probably dates from around 1550, is a high point of his art. Based perhaps on Trecento models by Simone and Ambrogio Lorenzetti, it is a worthy heir to Beccafumi's revered artistic ancestors.

In subtlety and variation of the palette, the *Annunciation* is breathtaking. In the angel's robe alone the range of color runs from a brilliant pinkish white highlight to a deep olive green with yellow, orange red, and, where the artist has glazed extensively, combinations of all these colors. Before the spectator's eyes, the hues of the robes shift and change as one merges with another, bringing the image to restless life. As in *Birth of the Virgin*, form emerges and recedes in flickering shadow and brilliant illumination, which play over the panel's surface, animating it and giving it energy, an energy matched and enhanced by the remarkable palette.

Returning to a composition he had utilized as early as the *Stigmatization of St. Catherine*, Beccafumi empties the center of the composition with a rush of space sent hurtling backward from the foreground, through the mighty barrel vault, over a cliff, and out to a storm-tossed sea. The dark cubic architecture, the

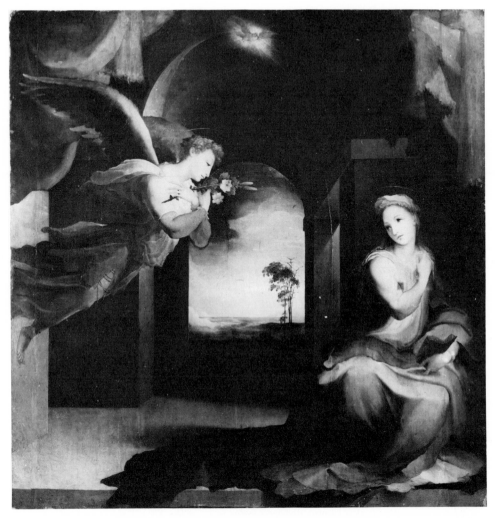

113. Beccafumi, *Annunciation*. Sarteano, San Martino.

brilliant palette with its smoky, dappled light, and the strange vista at the end of the spatial tunnel formed by the arch all originated in Beccafumi's fertile imagination. Even the angel, hovering nearly vertically, and the shrinking Virgin, with her trailing, voluminous robe, are visions never seen before in Sienese art. Certainly, the echoing rhythms of their bodies and the elegant void between their forms would have been appreciated by every Sienese artist from Simone Martini onward (see Fig. 2), but the nature of this remarkable *Annunciation* is unique to

Beccafumi. In this disturbing vision, he has profoundly expressed the cosmic mystery of the Annunciation.

What strange place is this, where great waves break over a distant shore occupied only by a few stately trees? What subtle and complex thoughts fill the minds of these elegant but troubled protagonists? The deeply moving scene is derived from the mainstream of Sienese art, yet detached from it—a shimmering mirage with a luminous, promising sky and dark, massive architecture. This riveting, unforgettable vision is the crown of Beccafumi's dazzling painter's life.

Beccafumi's painting had considerable impact on his Sienese contemporaries, even on older artists who were trained before Beccafumi began to work. The winds of stylistic and narrative change were already blowing strongly in Siena as foreign artists' influence continued to be felt during the first half of the sixteenth century. Because Beccafumi's style and narrative interpretation were based on strong Sienese tradition yet took into account the latest Florentine and Roman developments, they proved immediately attractive to several receptive artists of talent. His art must have been considered fashionable and up-to-date, qualities that for the first time were motivating Sienese artists.

Sodoma was one of the first to come under Beccafumi's sway. Originally, he had influenced the young Beccafumi; but in an age in which imitation was still considered the only proper way to learn and develop, such a reversal would be taken as a matter of course and viewed without surprise.

In Sodoma's haunting bier head with the Madonna, child, and angels (Fig. 114), the overall tonality is furnished by the fleeting, smoky light found in many of Beccafumi's panels. Here it is especially effective because it makes the four figures eerie and unsubstantial. In this panel Sodoma shifts from his usual coarse and clashing color toward the more-refined palette of Beccafumi. Hues derived from Beccafumi include the green and blue of the Madonna's headdress and the orange red of her gown. Even the loose application of the paint and the subtle modeling of the skin tones appear to stem from Beccafumi. The facial types, with their simplified features and particular expression, also recall his work.

In so many ways—conception, execution, color, and light, to name the most important—Beccafumi was a revolutionary artist. He was able to create original narratives with a highly personal style without forsaking his Sienese heritage. Unlike many of his contemporaries, he did not abandon the Sienese past in favor of a more modern style, but pointed the way toward the modification of that style for new spiritual and emotional needs. This aspect of Beccafumi's art was less understood than its formal aspects, and after the middle of the sixteenth century, with a few exceptions, only lip service was paid to the ancient traditions.

Foremost among those still indebted to the Sienese past was Andrea del

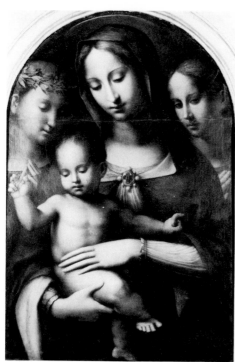

114. Sodoma, Bier head.
 Siena, Pinacoteca.

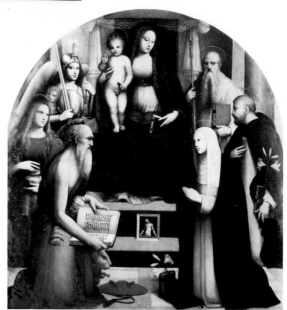

115. Andrea del Brescianino,
 Altarpiece. Siena,
 Pinacoteca.

Brescianino. He and his father, a Brescian dancing master, arrived in Siena about 1505. Brescianino may have been a pupil of Pacchia. He proved to be quite open to stylistic influences from both Florence and Siena.[12]

A large altarpiece (Fig. 115) of around 1522, originally from Monte Oliveto a Porta Tufi, is a striking demonstration of Brescianino's respect for Sienese tradition. The composition, focusing around the Madonna and child, and the intense, still saints flanking her are much indebted to Matteo di Giovanni and Neroccio de'Landi. The spirit of the large saint-filled altarpieces of the last quarter of the Quattrocento is felt in Brescianino's splendid painting; but it also reveals the depth of Beccafumi's influence in the holy figures.

However, Brescianino was a talented artist in his own right, and the elegance and smoothness of shape are completely his own. A meticulous painter, he constructed forms held rigidly in check by line. He was also a subtle colorist, and the harmony of line and shape in this altarpiece is gently echoed by the color—which is all white, grey, and black on the saints at the left and red orange, green, and gold on those to the right. At the center, the Madonna is vivified by her rose gown and the contrasting green of its lining—colors that recall Beccafumi. The balance of color and delicacy of chording here reappear in many of Brescianino's paintings.

A panel of *Charity* (Fig. 116) by Brescianino in the Siena Pinacoteca, along with companion panels of *Hope* and *Fortitude* in the same museum, was probably meant to ornament a room in a Sienese palazzo, perhaps a study or a bedroom. In this picture, which probably dates after his large altarpiece, the artist is concerned with very up-to-date matters of style, such as the effortless linking of the figures. The bodies are now more volumetric and worked out; drapery reveals form in a manner alien to the way Brescianino worked in large devotional panels. In the *Charity* Brescianino demonstrates his acquaintance with Andrea del Sarto,[13] as well as with Beccafumi, whose sway is felt in the puffy faces of the infants and in the dappled light on the emerging figures. Here the new spirit of art as both form and problem to be judged and appreciated by the educated connoisseurs is much in evidence.

Like the art of Brescianino, the painting of Bartolomeo Neroni, called Il Riccio, was a fascinating amalgam of native Sienese tradition, the strong influence of both Sodoma and Beccafumi as well as the Florence of Michelangelo and Leonardo, and a substantial measure of idiosyncratic style.[14] Riccio was an accomplished painter, documented between 1505 and 1571. He seems to have been trained in Sodoma's shop, where he was much impressed by the master's figural types.

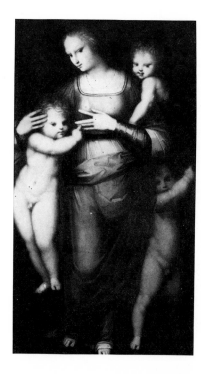

116. Andrea del Brescianino,
 Charity. Siena,
 Pinacoteca.

However, by the time Riccio painted the *Coronation of the Virgin* (Fig. 117), his style and palette were distanced from those of Sodoma. In its profusion of images and in the celestial glory filled with ranks of angels, this large altarpiece is reminiscent of the Coronations of the last quarter of the Quattrocento, especially one by Francesco di Giorgio (Fig. 75). The latter seems to have inspired the ecstatic saints and cloud-holding angels as well as some of the colors—the bright yellow of Catherine's robe and the dazzling red orange that appears throughout the work.

Yet, the slickness and artifice of Riccio's figures and their arrangement differentiate them from their prototypes. The profusion of saints, the flying angels, and the heavenly host do not overwhelm the viewer, as in the paintings of Francesco di Giorgio, Neroccio de'Landi, or, closer in date, Beccafumi. The mannered, artificial quality of this *Coronation* suggests that its artist is not really part of the Sienese tradition but an imitator who takes the surface but not the substance or spirit of the past. Riccio and a number of the painters who came after him moved off the ancient path followed by so many Sienese artists after Duccio.

Yet Riccio's *Coronation* is a noteworthy painting in its own right, arresting in its utilization of Beccafumi's light and angel types and in its skillful drawing.

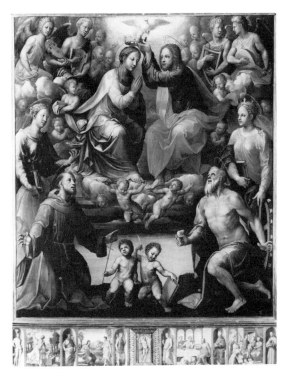

117. Il Riccio, *Coronation of the Virgin*. Siena, Pinacoteca.

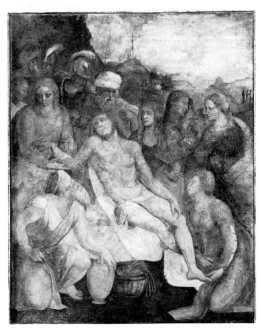

118. Il Riccio, *Lamentation*. Siena, Monte dei Paschi.

The delicate palette is especially beautiful and still very Sienese. The Virgin's blue green robe and lilac tunic are distinguished, as is the overall color balance; the color, in true Sienese fashion, is highly decorative.

Riccio, however, has not been able to avoid the coarse facial type and surface treatment developed by his teacher, Sodoma. The degree of crudity and awkwardness in Riccio's work is unusual in Sienese painting. Much the same can be said about his other paintings, both on panel and in fresco; although at times, in the detached *Lamentation* fresco (Fig. 118), for example, the artist creates images of considerable power and beauty.[15]

The dissolution of the Sienese tradition that began with the increasing popularity of foreign styles and artists continued throughout the sixteenth century. Only Beccafumi, although strongly swayed by the new currents in painting, stayed firmly within his own tradition. Like Sassetta and Francesco di Giorgio, he was a highly inventive artist who could transform the past without breaking with it. An unusual aspect of his art was his sensitive respect and understanding of art from all periods of Sienese history. He must have felt very much a part of the narrow but deep stream of Sienese pictorial imagery. Yet, his work is the Indian summer of Sienese painting, for after him the art of Siena would no longer be so independent and self-sustaining, but more an imitation of the major trends in the rest of the Italian peninsula.[16] It would no longer have a strong, personal vision, nor would it be so distinguished in form, although it never lost its remarkable color. Siena would become truly provincial: a small hill town far away, both physically and spiritually, from the large artistic centers. Instead of generating unique images, it would act as the nostalgic caretaker of a precious legacy of paintings and sculptures produced in a lost Golden Age.

Notes

INTRODUCTION

1. Sienese painting of the Trecento: B. Cole, *Sienese Painting from Its Origins to the Fifteenth Century* (New York, 1980); E. Carli, *La pittura senese del Trecento* (Milan, 1981).

2. Important pioneering studies: B. Berenson, *A Sienese Painter of the Franciscan Legend* (London, 1909); J. Pope-Hennessy, *Sienese Quattrocento Painting* (Oxford, 1947); C. Brandi, *Quattrocentisti senesi* (Milan, 1949); E. Carli, *La pittura senese* (Milan, 1955).

1. TRANSFORMATIONS: 1375–1430

1. Surveys of fourteenth-century Sienese painting: B. Cole, *Sienese Painting from Its Origins to the Fifteenth Century* (New York, 1980); E. Carli, *La pittura senese del Trecento* (Milan, 1981).

2. Duccio: Cole, pp. 24–67; J. White, *Duccio* (London, 1979).

3. Simone Martini: Cole, pp. 68–102; G. Paccagnini, *Simone Martini* (Milan, 1955).

4. Ambrogio and Pietro Lorenzetti; Cole, pp. 103–179.

5. Giotto: B. Cole, *Giotto and Florentine Painting 1280–1375* (New York, 1976).

6. Giovanni Pisano: M. Aytron, *Giovanni Pisano Sculptor* (New York, 1969); J. Pope-Hennessy, *Italian Gothic Sculpture* (London, 1972), pp. 175–176.

7. Sienese painting in the second half of the Trecento: C. De Benedictis, *La pittura senese 1330–1370* (Florence, 1979); Cole, pp. 180–208; Carli, pp. 216–256.

8. Bartolo di Fredi: E. Carli, *Bartolo di Fredi a Paganico* (Florence, 1968); Cole, pp. 195–199; E. Carli, *La pittura senese del trecento* (Milan, 1981), pp. 236–238.

9. Gentile da Fabriano: E. Micheletti, *L'Opera completa di Gentile da Fabriano* (Milan, 1976); B. Cole, *Masaccio and the Art of Early Renaissance Florence* (Bloomington, 1980), pp. 63–67; K. Christiansen, *Gentile da Fabriano* (Ithaca, 1982).

10. Paolo Uccello: J. Pope-Hennessy, *The Complete Work of Paolo Uccello* (London, 1969).

11. Barna da Siena: O. Nygren, *Barna da Siena* (Helsingfors, 1963); S. Delogu Ventroni, *Barna da Siena* (Pisa, 1972); Cole, *Sienese Painting*, pp. 181–188.

12. Paolo di Giovanni Fei: M. Mallory, *The Sienese Painter Paolo di Giovanni Fei (1345–1411)* (New York, 1976); Cole, *Sienese Painting*, pp. 192–194; A. Guiducci, "Paolo di Giovanni Fei," *Il gotico a Siena* (Florence, 1982), pp. 295–298.

13. Taddeo di Bartolo: S. Symeonides, *Taddeo di Bartolo* (Siena, 1965); N. Rubinstein, "Political Ideas in Sienese Art: The Frescoes by Ambrogio Lorenzetti and Taddeo di Bartolo in the Palazzo Pubblico," *Journal of the Warburg and Courtauld Institutes* 21

(1958): 179–207; Cole, *Sienese Painting*, pp. 199–201; Carli, *La pittura*, pp. 248–253; G. Dini, "Taddeo di Bartolo," *Il gotico*, pp. 335–337.

14. Agnolo Gaddi, Spinello Aretino, Antonio Veneziano: Cole, *Masaccio*, pp. 36–71.

15. Barnaba da Modena: A. Venturi, "Barnaba da Modena," in U. Thieme and F. Becker, eds., *Allgemeines Lexikon der bildenden Künstler* (Leipzig, 1908).

16. Palazzo Pubblico: E. Southard, *The Frescoes in Siena's Palazzo Pubblico 1289–1539: Studies in Imagery and Relations to Other Communal Palaces in Tuscany* (New York, 1979); A. Cairola and E. Carli, *Il Palazzo Pubblico di Siena* (Rome, 1963).

17. Altichiero: G. Melini, *Altichiero e Jacopo Avanzi* (Milan, 1965).

18. Drawing: B. Cole, *The Renaissance Artist at Work* (New York, 1983), pp. 95–103.

19. Andrea di Bartolo: O. Francisci Osti, "Andrea di Bartolo," *Dizionario biografico degli italiani*, III, (Rome, 1961), pp. 74–75; B. Berenson, *Italian Pictures of the Renaissance: Central Italian and North Italian Schools* (London, 1968), pp. 5–9.

2. FOREIGN VISTAS

1. Giotto: B. Cole, *Giotto and Florentine Painting 1280–1375* (New York, 1976).

2. Sienese influence in Trecento Florence: ibid., pp. 114–118.

3. Masaccio, Donatello, and the art of early Quattrocento Florence: B. Cole, *Masaccio and the Art of Early Renaissance Florence* (Bloomington, 1980).

4. Siena Baptistery Font: J. Pope-Hennessy, *Italian Gothic Sculpture* (London, 1972), pp. 210–211.

5. Donatello: H. Janson, *Donatello* (Princeton, 1979); J. Pope-Hennessy, *Italian Renaissance Sculpture* (London, 1971), pp. 5–22.

6. Domenico di Bartolo: D. Gallavotti, "Gli affreschi quattrocenteschi della Sala del Pellegrinaio nello Spedale di Santa Maria della Scala in Siena," *Storia dell'arte* 13 (1972): 5–42; P. Torriti, *La pinacoteca nazionale di Siena*, I (Genoa, 1977), pp. 344–349.

7. Santa Maria della Scala: V. Morandi and A. Cairola, *Lo spedale di Santa Maria della Scala* (Siena, 1975).

8. Stylistic currents after Masaccio: Cole, *Masaccio*, pp. 183–211.

9. Vecchietta: G. Vigni, *Lorenzo di Pietro detto il Vecchietta* (Florence, 1937); H. W. van Os, *Vecchietta and the Sacristy of the Siena Hospital Church* (The Hague, 1974).

10. Pius II: C. Ady, *Pius II* (London, 1913); R. Mitchell, *The Laurels and the Tiara: Pope Pius II 1458–1464* (London, 1962).

11. Pienza: E. Carli, *Pienza: La Città di Pio II* (Siena, 1966); I. Petri, *Pienza* (Genoa, 1976); P. Torriti, *Pienza: La città del rinascimento italiano* (Genoa, 1980).

12. Piero della Francesca: K. Clark, *Piero della Francesca* (London, 1969).

13. Fra Bartolomeo, Andrea del Sarto, and painting in early sixteenth-century Florence: S. Freedberg, *Painting in Italy 1500–1600* (London, 1975).

14. Masaccio's Pisa altarpiece: Cole, *Masaccio*, pp. 126–147.

15. Vecchietta's sculpture: Pope-Hennessy, *Italian Renaissance Sculpture*, pp. 306–307; C. Del Bravo, *Scultura senese del Quattrocento* (Florence, 1970), pp. 60–89.

16. Ghiberti: R. Krautheimer and T. Krautheimer-Hess, *Lorenzo Ghiberti*, 2 vols. (Princeton, 1970); J. Pope-Hennessy, *Italian Gothic Sculpture* (London, 1972), pp. 204–209.

3. THE VISIONARIES AND THEIR FOLLOWERS

1. Sassetta: B. Berenson, *A Sienese Painter of the Franciscan Legend* (London, 1909); J. Pope-Hennessy, *Sassetta* (London, 1939); E. Carli, *Sassetta e il Maestro dell'Osservanza* (Milan, 1957); J. Pope-Hennessy, "Rethinking Sassetta," *Burlington Magazine* 98 (1956): 364–369.

2. See especially the example by Matteo di Giovanni in P. Torriti, ed., *Mostra di opere d'arte restaurate nelle province di Siena e Grosseto*, III (Genoa, 1983), pp. 130–134. See also Girolamo di Benvenuto, Fig. 94, in the present volume.

3. Carmelite Altarpiece, Siena Pinacoteca: B. Cole, *Sienese Painting from Its Origins to the Fifteenth Century* (New York, 1980), pp. 110–115.

4. Reconstruction of the Sansepolcro altarpiece: Carli, pp. 50–80; M. Davis, *National Gallery Catalogues: Earlier Italian Schools* (London, 1961), pp. 502–512. The *Madonna* panel and *Sts. John the Evangelist* and *Anthony of Padua* are in the Louvre, Paris. The *St. Francis in Ecstasy, Beato Ranieri*, and *St. John the Baptist* are in the Berenson Collection, Florence. The scenes of the life of St. Francis are in the National Gallery, London, with the exception of the *Mystical Marriage*, which is in the Musée Condé, Chantilly. A *St. Francis before the Crucifix*, originally placed over the *St. Francis in Ecstasy*, is now in The Cleveland Museum of Art.

5. Sansepolcro St. Francis: H. W. van Os, "St. Francis of Assisi as a Second Christ in Early Italian Painting," *Simiolus* 7 (1974): 3–20.

6. Legends of St. Francis: *St. Francis of Assisi: Writings and Early Biographies*, edited by M. Habig (Chicago, 1973).

7. Piero della Francesca: K. Clark, *Piero della Francesca* (London, 1969); P. Murray and P. de Vecchi, *The Complete Paintings of Piero della Francesca* (New York, 1967).

8. Master of the Osservanza: Carli, 1957.

9. Sano di Pietro: E. Gaillard, *Sano di Pietro* (Chambéry, 1923); J. Truebner, *Die stilistische Entwicklung der Tafelbilder des Sano di Pietro* (Strasbourg, 1925); Carli, 1957.

10. Renaissance artists' shops: B. Cole, *The Renaissance Artist at Work* (New York, 1983).

11. Sienese Saints and *beati*: I. Origo, *The World of San Bernardino* (New York, 1962); G. Kaftal, *The Iconography of the Saints in Tuscan Painting* (Florence, 1952); V. Meattini, *Santi senesi* (Poggibonsi, 1974).

12. Pienza: Chapter 2, note 11.

13. Fra Filippo Lippi: G. Marchini, *Filippo Lippi* (Milan, 1975); Fra Angelico: J. Pope-Hennessy, *Fra Angelico* (London, 1974).

14. San Quirico d'Orcia: G. Naldi, *San Quirico d'Orcia e dintorni* (Siena, 1981).

15. Giovanni di Paolo: J. Pope-Hennessy, *Giovanni di Paolo* (London, 1937); C. Brandi, *Giovanni di Paolo* (Florence, 1947); J. Pope-Hennessy, "Giovanni di Paolo," *Encyclopedia of World Art*, 1962(6): 357.

16. Pecci altarpiece cleaning: *Mostra di opere d'arte restaurate nelle province di Siena e Grossetto*, II (Genoa, 1981), pp. 72–74.

17. Masaccio's Madonnas: B. Cole, *Masaccio and the Art of Early Renaissance Florence* (Bloomington, 1980), pp. 108–125.

18. Cast-shadows in Renaissance painting: M. Meiss, "Some Remarkable Early

Shadows in a Rare Type of Threnos," *Festschrift Ulrich Middeldorf* (ed. A. Kosegarten), (Berlin, 1968), pp. 112–118.

19. The guild of the Pizzicaiuoli and Giovanni di Paolo altarpiece: F. Zeri, *The Metropolitan Museum of Art: Italian Paintings: Sienese and Central Italian Schools* (New York, 1980), pp. 24–27.

20. Abbey of San Galgano: A. Canestrelli, *L'Abbazia di San Galgano* (Florence, 1896).

21. Donatello's San Lorenzo Pulpits: J. Pope-Hennessy, *Italian Renaissance Sculpture* (London, 1971), pp. 266–268.

22. Pietro di Giovanni: C. Brandi, *Quattrocentisti senesi* (Milan, 1949), pp. 133–142; J. Pope-Hennessy, *Sassetta* (London, 1939), pp. 159–168.

4. The Last Quarter of the Quattrocento

1. Matteo di Giovanni: F. Hartlaub, *Matteo da Siena und seine Zeit* (Strasbourg, 1910); C. Brandi, *Quattrocentisti senesi* (Milan, 1949), pp. 141–148; J. Pope-Hennessy, "Matteo di Giovanni's Assumption Altarpiece," *Proporzioni* 3 (1950): 81–85.

2. Pius and Pienza: See chapter 2, note 11.

3. Andrea del Castagno: G. Richter, *Andrea del Castagno* (Chicago, 1943); M. Salmi, *Andrea del Castagno* (Novara, 1961); M. Horster, *Andrea del Castagno* (Ithaca 1980).

4. Antonio and Piero del Pollaiuolo: A. Sabatini, *Antonio e Piero del Pollaiuolo* (Florence, 1944): L. Ettlinger, *Antonio and Piero Pollaiuolo* (New York, 1978).

5. Decorative nature of early Sienese painting: B. Cole, *Sienese Painting from Its Origins to the Fifteenth Century* (New York, 1980), pp. 1–22.

6. Ghirlandaio: J. Lauts, *Ghirlandaio* (Vienna, 1943).

7. Filippino Lippi: K. Neilson, *Filippino Lippi* (Cambridge, Mass., 1938); L. Berti, *Filippino Lippi* (Florence, 1957).

8. Piero di Cosimo: L. Douglas, *Piero di Cosimo* (Chicago, 1946); M. Bacci, *Piero di Cosimo* (Milan, 1966).

9. Guidoccio Cozzarelli: B. Berenson, *Essays in the Study of Sienese Painting* (New York, 1918): pp. 81–94; B. Berenson, *Italian Pictures of the Renaissance: Central Italian and North Italian Schools*, II (London, 1968): pp. 97–101.

10. For the north Italian artists Liberale da Verona and Girolamo da Cremona see: H. J. Eberhardt, *Die Miniaturen von Liberale da Verona, Girolamo da Cremona und Venturino da Cremona in Chorbüchern des Doms von Siena* (Munich, 1983). The influence of these two artists, both of whom worked in Siena for about six years, has been, wrongly in my view, seen as crucial for the development of Sienese painting of the later Quattrocento.

11. Neroccio de'Landi: G. Coor, *Neroccio de'Landi 1445–1500* (Princeton, 1961).

12. Renaissance portraits: J. Pope-Hennessy, *The Portrait in the Renaissance* (Princeton, 1979).

13. On Leonardo da Vinci: K. Clark, *Leonardo da Vinci*, (London, 1959).

14. Examples of bier heads: P. Torriti, *La Pinacoteca Nazionale di Siena*, II (Genoa, 1978): pp. 105–107, 182–184.

15. Neroccio's sculpture: Coor, *passim.*

16. Francesco di Giorgio: S. Brinton, *Francesco di Giorgio Martini of Siena* (London, 1934); A. Weller, *Francesco di Giorgio* (Chicago, 1943); B. Fredericksen, *The Cassone Paintings of Francesco di Giorgio* (Los Angeles, 1969).

17. Detailed analysis of the *Coronation's* complicated iconography: Weller, pp. 97–106.

18. Renaissance *cassoni*: P. Schubring, *Cassoni, Truhen und Truhenbilder der italien-ischen Frührenaissance*, 2 vols., (Leipzig, 1915).

19. Discovery of Bichi frescoes: M. Seidel, "Die Fresken des Francesco di Giorgio in S. Agostino Siena," *Mitteilungen des Kunsthistorischen Institutes in Florenz*, 23 (1979): 3–108.

20. Signorelli's Bichi altarpiece: See chapter 5, note 3.

21. Signorelli's paintings: See chapter 5, note 2.

22. Perugino: See chapter 5, note 5; Pintoricchio: see chapter 5, note 6.

23. For these artists and their styles: S. Freedberg, *Painting of the High Renaissance in Rome and Florence*, 2 vols. (New York, 1972).

24. Benvenuto di Giovanni: J. Pope-Hennessy, *Sienese Quattrocento Painting* (London, 1947), p. 30; C. Brandi, pp. 148–153.

25. Girolamo di Benvenuto: See chapter 5, note 15.

5. THE EARLY SIXTEENTH CENTURY

1. Many of my ideas on society in Siena around 1500 derive from the excellent and original discussion of the city's later history in Judith Hook, *Siena: A City and Its History* (London, 1979), pp. 148–195.

2. Luca Signorelli: M. Cruttwell, *Luca Signorelli* (London, 1907); M. Salmi, *Luca Signorelli* (Novara, 1953); P. Scarpellini, *Luca Signorelli* (Milan, 1964).

3. Bichi Altarpiece: M. Ingendaay, "Rekonstruktions-Versuch der 'Pala Bichi' in San Agostino in Siena," *Mitteilungen des Kunsthistorischen Institutes in Florenz* 23 (1979): 109–126.

4. Painted room in the Palazzo Petrucci: M. Davies, *National Gallery Catalogues: The Earlier Italian Schools* (London, 1961), pp. 472–479; F. Santoro, "Ricerche senesi 2: Il Palazzo del Magnifico Pandolfo Petrucci," *Prospettiva* 29 (1982): 24–31; G. Agosti, "Pre-cisioni su un 'Baccanale' perduto del Signorelli," *Prospettiva* 30 (1982): 70–77.

5. Perugino: W. Bombe, *Perugino* (Stuttgart and Berlin, 1914); C. Castellaneta and E. Camesasca, *L'opera completa del Perugino* (Milan, 1969).

6. Pintoricchio: C. Ricci, *Pintoricchio* (Philadelphia, 1902); E. Carli, *Il Pintoricchio* (Milan, 1960); A. Cecchi, *The Piccolomini Library in the Cathedral of Siena* (Florence, 1982).

7. The *Commentari*: C. Ady, *Pius II* (London, 1913).

8. Ghirlandaio's *St. Francis Before the Sultan*: J. Lauts, *Domenico Ghirlandaio* (Vienna, 1943), fig. 37. Ghirlandaio's composition is, in turn, borrowed from Giotto's fresco of the same subject in the Bardi Chapel in Santa Croce, Florence.

9. Sodoma: R. Hobart-Cust, *Giovanni Antonio Bazzi* (London, 1906); E. Jacobsen, *Sodoma und das Quattrocento in Siena* (Strasbourg, 1910); E. Carli, *Mostra delle opere di Giovanni Antonio Bazzi detto il Sodoma* (Vercelli, 1950); E. Carli, *Il Sodoma a Sant'Anna in Camprena* (Florence, 1974).

10. Andrea di Niccolò: B. Berenson, *Italian Pictures of the Renaissance: Central Italian and North Italian Schools*, I (London, 1968), pp. 10–11.

11. Pietro di Domenico: Ibid., p. 343.

12. Ghirlandaio's *Adoration of the Shepherds*: Lauts, fig. 49.

13. Bernardino Fungai: P. Bacci, *Bernardino Fungai* (Siena, 1947).

14. Siena and Antiquity: J. Hook, *Siena: A City and Its History* (London, 1979), pp. 148–171.

15. Girolamo di Benvenuto: Berenson, pp. 186–188; B. Fredericksen and D. Davisson, *Benvenuto di Giovanni, Girolamo di Benvenuto* (Malibu, 1966).

16. Lamentation Lunette: F. Zeri, "Girolamo di Benvenuto: Il completamento della 'Madonna della Nevi,'" *Antologia di belle arti*, 3 (1971): 48–54.

17. Pacchia: Berenson, pp. 306–308.

18. Pacchiarotti: Ibid., pp. 308–310; S. Padovani and B. Santi, *Buonconvento: Museo d'arte sacra della Val d'Arbia* (Genoa, 1981), pp. 42–44. Recently, it has been suggested that the paintings grouped under the name Pacchiarotti actually belong to an obscure Sienese painter named Pietro di Francesco Orioli, who died in 1496. The detachment of Pacchiarotti's name from the body of paintings associated with it seems to me to be plausible, although the case for the reattribution to Orioli presents some problems, most notably the early death date, which would make all the works date before the unlikely year 1496. No matter what his real name, I have followed the traditional practice of calling this artist Pacchiarotti to avoid unnecessary confusion. For the artist's name see: F. Santoro, "Richere senesi 1: Pacchiarotti e Pacchia," *Prospettiva* 29 (1982): 14–23; A. Angelini, "Da Giacomo Pacchiarotti a Pietro Orioli," *Prospettiva* 29 (1982): 72–78; A. Angelini, "Pietro Orioli e il momento 'urbinate' della pittura senese del Quattrocento," *Prospettiva* 30 (1982): 30–43.

19. Supposed relation between Pacchiarotti's painting and the Scala frescoes: G. Marchini's review of A. Peter's *Pietro es Ambrogio Lorenzetti egy elpusztult Fresco-ciklusa* in *Rivista d'arte* 17 (1938): 304–314.

6. NEW DIRECTIONS

1. Political and social situation in Siena in the first half of the sixteenth century: J. Hook, *Siena: A City and Its History* (London, 1979), pp. 172–195.

2. Beccafumi: J. Judey, *Domenico Beccafumi* (Freiburg, 1932); D. Sanminiatelli, *Domenico Beccafumi* (Milan, 1967); G. Briganti and E. Baccheschi, *L'opera completa del Beccafumi* (Milan, 1977).

3. Archaizing: B. Cole, "Old in New in the Early Trecento," *Mitteilungen des Kunsthistorischen Institutes in Florenz* 17 (1973): 230–248.

4. Michelangelo's Sistine frescoes: H. Hibbard, *Michelangelo* (New York, 1974), pp. 99–147.

5. Life of Beccafumi: G. Vasari, *Le vite de'più eccellenti pittori, scultori ed architettori*, ed. G. Milanesi (Florence, 1878), vol. 5, pp. 633–654; *The Lives of the Painters, Sculptors and Architects by Giorgio Vasari*, trans. A. Hinds (London, 1927) vol. 3, pp. 140–150.

6. Here Beccafumi's figures remind one of Michelangelo's in the *Last Judgment* fresco in the Sistine Chapel, which was painted around 1540. If Beccafumi took these figures from the *Last Judgment*, the Pinacoteca *Fall* would have to date around the middle

of the fourth decade of the sixteenth century and antedate the *Fall* in the Carmine, which Vasari calls the second of the two altarpieces. Vasari knew Beccafumi, so one should be cautious in questioning his word.

7. Decoration of the Palazzo Pubblico: E. Southard, *The Frescoes in Siena's Palazzo Pubblico, 1289–1539: Studies in Imagery and Relations to Other Communal Palaces in Tuscany* (New York, 1979).

8. Imagery in the Sala del Concistoro: Ibid., pp. 394–416.

9. Beccafumi's tondos: Briganti and Baccheschi, *passim*.

10. Pietro Lorenzetti's *Birth of the Virgin*: B. Cole, *Sienese Painting from Its Origins to the Fifteenth Century* (New York, 1980), fig. 69.

11. Bichi Chapel: chapter 4, note 19.

12. Brescianino: B. Berenson, *Italian Pictures of the Renaissance: Central Italian and North Italian Schools*, I (London, 1968), pp. 65–67; S. Padovani and B. Santi, *Buonconvento: Museo d'arte sacra della Val d'Arbia* (Genoa, 1981), pp. 45–58.

13. Andrea del Sarto: chapter 4, note 23.

14. Riccio: P. Toritti, *La Pinacoteca Nazionale di Siena*, II (Genoa, 1978): A. Cornice, "Bartolomeo Neroni detto Il Riccio," *L'arte a Siena sotto i Medici 1555–1609* (Rome, 1980), pp. 27–47.

15. Riccio's *Lamentation*: Ibid., p. 44, fig. 15.

16. Later Sienese painting: Ibid., passim,; P. Riedl, *Disegni dei barocceschi senesi (Francesco Vanni e Ventura Salimbeni)* (Florence, 1976); A. Bagnoli, *Rutilio Manetti* (Florence, 1978).

Selected Bibliography

This bibliography lists general books on Sienese history, society, and art. Books and articles on individual Sienese Renaissance painters are found in the notes to the individual chapters.

HISTORY

Ady, C. *Pius II*. London, 1913.
Douglas, L. *A History of Siena*. London, 1902.
Dundes, A., and A. Falassi. *La Terra in Piazza*. Berkeley, 1975.
Hicks, D. "Sienese Society in the Renaissance." *Comparative Studies in Society and History* 4 (1960): 412–420.
Hook, J. *Siena: A City and Its History*. London, 1979.
Larner, J. *Culture and Society in Italy 1290–1420*. London, 1970.
Misciatteli, P. *The Mystics of Siena*, translated by M. Peters-Roberts. Cambridge, 1929.
Mitchell, R. *The Laurels and the Tiara: Pope Pius II, 1458–1464*. London, 1962.
Origo, I. *The World of San Bernardino*. New York, 1962.
Rombai, L., ed. *I Medici e lo stato senese*. Rome, 1980.
Schevill, F. *Siena: The History of a Medieval Commune*. New York, 1964.

HISTORY OF ART

Bacci, P. *Fonti e commenti per la storia dell'arte senese*. Siena, 1944.
Bellosi, L. *Arte in Valdichiana dal XIII al XVIII secolo*. Cortona, 1970.
De Benedictis, C. *La pittura senese 1330–1370*. Florence, 1979.
Berenson, B. *Essays in the Study of Sienese Painting*. New York, 1918.
———. *The Italian Painters of the Renaissance*. New York, 1959.
———. *Italian Pictures of the Renaissance: Central Italian and North Italian Schools*, 3 vols. London, 1968.
Borghesi, S. and L. Banchi. *Nuovi documenti per la storia dell'arte senese*. Siena, 1898.
Brandi, C. *La Regia Pinacoteca di Siena*. Rome, 1933.
———. *Quattrocentisti senesi*. Milan, 1949.
Brogi, F. *Inventario generale degli oggetti d'arte della Provincia di Siena*. Siena, 1897.
Cairola, A., and E. Carli. *Il Palazzo Pubblico di Siena*. Rome, 1963.

Carli, E. *Mostra della antica scultura lignea senese*. Florence, 1949.
———. *Dipinti senesi del contado e della Maremma*. Milan, 1955.
———. *La pittura senese*. Milan, 1955.
———. *Sienese Painting*. Greenwich, 1956.
———. *Musei senesi*. Novara, 1961.
———. *Arte senese nella Maremma grossetana*. Grosseto, 1964.
———. *Pienza: Città di Pio II*. Rome, 1967.
———. *Il Duomo di Siena*. Genoa, 1979.
———. *La pittura senese del Trecento*. Milan, 1981.
———. *Sienese Painting*. Florence, 1982.
Cole, B. *Masaccio and the Art of Early Renaissance Florence*. Bloomington, Indiana, 1980.
———. *Sienese Painting from Its Origins to the Fifteenth Century*. New York, 1980.
Crowe, J., and G. B. Cavalcaselle. *A New History of Painting in Italy*, 3 vols. London, 1864. (Later German, Italian, and English editions.)
Davies, M. *The Earlier Italian Schools* (National Gallery Catalogues). London, 1961.
Douglas, L. *Storia d'arte senese*. Bologna, 1975.
Edgell, G. *A History of Sienese Painting*. New York, 1932.
Hartt, F. *History of Italian Renaissance Art*. New York, n.d.
Heywood, W., and L. Olcott. *Guide to Siena*. Siena, 1904.
Jacobsen, E. *Das Quattrocento in Siena*. Strasbourg, 1908.
———. *Sodoma und das Cinquecento in Siena*. Strasbourg, 1910.
Kaftal, G. *The Iconography of the Saints in Tuscan Painting*. Florence, 1952.
Marle, R. van. *The Development of the Italian Schools of Painting*, 19 vols. The Hague, 1923–1938.
Meiss, M. *Painting in Florence and Siena after the Black Death*. New York, 1964.
Milanesi, G. *Documenti per la storia dell'arte senese*, 2 vols. Siena, 1854–1856.
Morandi, V., and A. Cairola. *Lo spedale di Santa Maria della Scala*. Siena, 1975.
Oertel, R. *Early Italian Painting to 1400*. New York, 1968.
Os, H. van. *Marias Demut und Verherrlichung in der sienesischen Malerei, 1300–1450*. 's-Gravenhage, 1969.
———. *Sienese Paintings in Holland*. Leiden, 1969.
Perkins, F. *Pitture senesi*. Siena, 1933.
Pope-Hennessy, J. *Sienese Quattrocento Painting*. London, 1947.
———. *Italian Renaissance Sculpture*. London, 1971.
———. *Italian Gothic Sculpture*. London, 1972.
Previtali, G., ed., *Il gotico a Siena*. Florence, 1982.
Sandberg-Vavalà, E. *Sienese Studies*. Florence, 1953.
Schubring, P. *Die Plastik Sienas im Quattrocento*. Berlin, 1907.
Southard, E. *The Frescoes in Siena's Palazzo Pubblico 1289–1539: Studies in Imagery and Relations to Other Communal Palaces in Tuscany*. New York, 1979.
Torriti, P. *La Pinacoteca Nazionale di Siena. Vol. I, I dipinti dal XII al XV secolo*. Genoa, 1977.
———. *La Pinacoteca Nazionale di Siena. Vol. II, I dipinti dal XV al XVIII secolo*. Genoa, 1978.
———. ed. *Mostra di opere d'arte restaurate nelle province di Siena e Grosseto*. 3 vols. Genoa, 1979, 1981, 1983.

Valle, G. Della. *Lettere sanesi*, 3 vols. Venice and Rome, 1782–1786.
White, J. *Art and Architecture in Italy 1250–1400*. Baltimore, 1966.
Zeri, F. *Italian Paintings: A Catalogue of the Collection of the Metropolitan Museum of Art. Sienese and Central Italian Schools*. New York, 1971.

Index